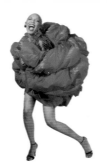

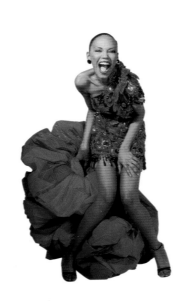

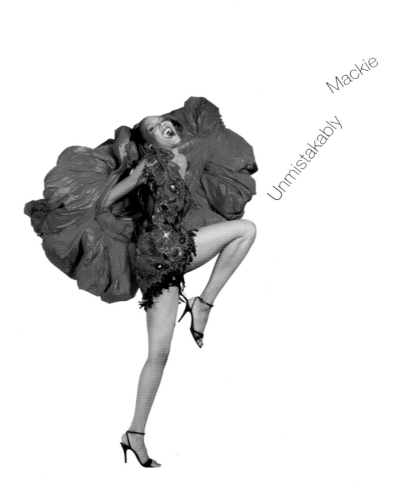

Unmistakably Mackie

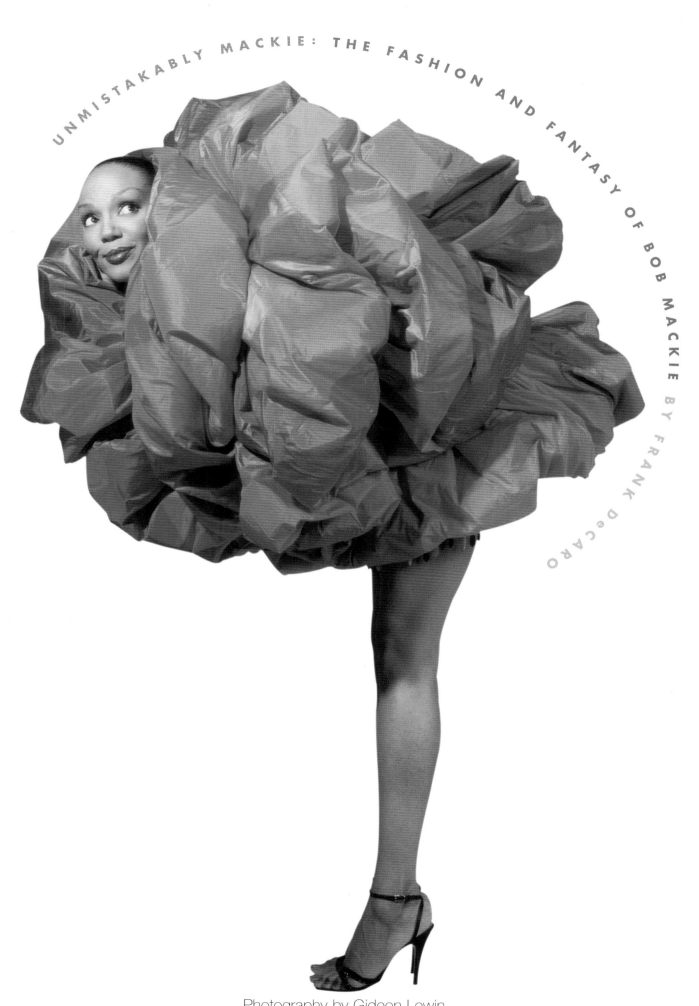

UNMISTAKABLY MACKIE: THE FASHION AND FANTASY OF BOB MACKIE BY FRANK DeCARO

Photography by Gideon Lewin

Universe

First published in the United States of
America in 1999
by UNIVERSE PUBLISHING
A Division of Rizzoli International
Publications, Inc.
300 Park Avenue South
New York, NY 10010

99 00 01 02 / 10 9 8 7 6 5 4 3 2 1
Design by Paul Guayante
Printed in England
Library of Congress Catalog Card
Number: 99-71281

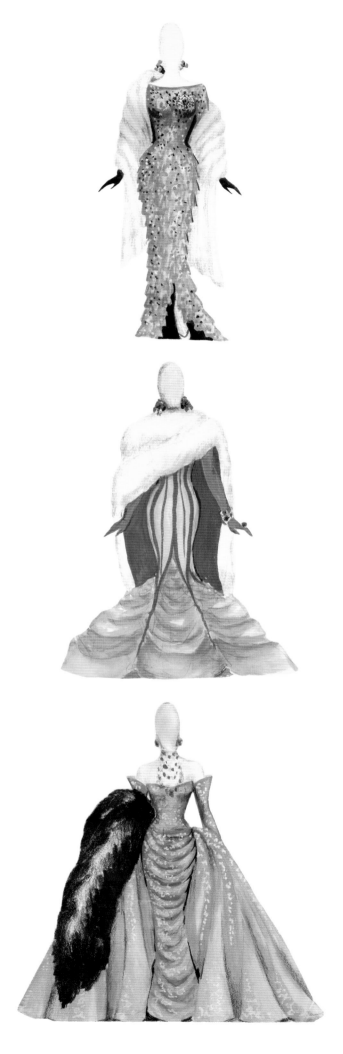

Bob Mackie's designs have come to epitomize American glamour. He is a gifted fashion designer who has created clothes for television, movies, theater and opera. His dramatic designs for Cher—especially her unforgettable Oscar dress—and his brilliant costumes for eleven years of *The Carol Burnett Show* reflect his grasp of the power of fashion in the media. The glitter of Mackie's famous dresses has sometimes obscured the breadth of his talents; often his designs have contributed to the development of characters. He once explained to me, "It is also a challenge to make someone look ugly!"

In association with this book, the Museum at the Fashion Institute of Technology is delighted to present a thirty-year retrospective of Bob Mackie's illustrious career in the fall of 1999. The museum has produced a series of exhibitions on important American designers, but none has been met with as great enthusiasm as Bob Mackie. As his high school sketches attest, Mackie has always loved to design. From Cher to Carol, from Vegas to Barbie, every dress sparkles with his exuberance and wit. His sense of style and glamour is unparalleled, *Unmistakably Mackie!*

Dorothy Twining Globus
Director
The Museum at the Fashion
Institute of Technology

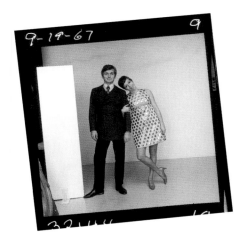
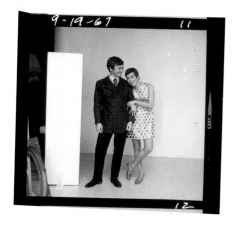

forewor**D**

It was 1967. My husband, Joe Hamilton, and I had agreed with CBS to do a one-hour variety show beginning in the fall. All the production ducks were in place: our choreographer, our writers, our scenic designer, our musical director . . . **O**ne key person was missing. Who would design the costumes? We would be doing several musical numbers and comedy sketches each show. This person would not only have to design "pretty," he or she would have to come up with concepts, ideas, and out-and-outrageous getups for the various looks that not only I, but our cast and—on occasion—our guest stars would have to wear. **J**oe and I went to Las Vegas to see Mitzi Gaynor's night club act and I was blown away by her outfits. Not only were they beautiful, but when she cut loose in the comedy sketches, she was adorned in wit and humor. Then we watched *Alice Through the Looking-Glass* on TV. Same thing. And what/who was the common denominator? Somebody named Bob Mackie. **W**e called and he came over. The doorbell rang, I opened it, and in walked this twelve year old. After a few minutes, we knew we were meant for each other. **S**ome very misinformed people mistakenly think Bob only does "diva" dresses. Wrong. That doesn't cover one-tenth of his talent. In the eleven-year run of our show, he designed fifty costumes each week, including the wigs and makeup for each character. He saved me and many a comedy sketch by coming up with wonderfully funny "character" outfits that not only enhanced the writing, but many times gave me the clue as to what the character I was playing was all about. He designs like a writer, director, and producer. **T**here is nobody who can do what he does. No one. And there's no one who has done what he has done. Nobody can come close to his resume. **I** love him as a talent, and best of all . . . as my friend.
Carol Burnett

INTRODUCTION

Bob Mackie: Making Fantasies Real

When it comes to designing for popular culture, Bob Mackie has done something no other fashion designer has done. He has reached the consciousness of the American masses—not just the fashion world—and turned them on to a stylish fantasy that is purely his own. Ask virtually anyone what Cher wore to the Oscars in 1986 and he or she will have no trouble recalling the Indian headdress, the exposed navel, and the looks on people's faces when she made her entrance. Ask that same person about Carol Burnett's "Went With The Wind" dress, and they'll tell you it was a green velvet Southern Belle costume made from the mansion's drapes—with the curtain rod still attached. Funny and outrageous, these two ensembles remain among the most instantly recognizable garments ever designed. And yet, they're only two of a myriad of costumes Mackie has indelibly etched into our minds. Is it any wonder the man has won seven Emmy Awards and been nominated thirty times?

Since getting his start in 1963 as an assistant to the acclaimed costume designer Ray Aghayan on *The Judy Garland Show*, Mackie has become synonymous with glamour.

His moniker is a byword for fantasy fashion, bugle-beaded deliciousness, Americana as exotica, and the ultimate in allure. Having designed for television, film, dance, the opera, Broadway, and Las Vegas, Mackie is the only living costume designer whose name the average person has bothered to learn. His name has been dropped even on *The Simpsons*: when one character boasted, "This is a Bob Mackie original," everyone, even your father, knew what it meant.

By creating larger-than-life fashion identities for some of the century's greatest performers, Mackie has become not just a designer but also an artist—a movie-mad, sequin-happy throwback to the days of Edith Head, Adrian, and the Golden Age of Hollywood. Whether designing for a Vegas showroom, the stage of Carnegie Hall, or a Seventh Avenue runway—yes, he does ready-to-wear, too—his is a singular vision of glamour. With his costumes for *The Carol Burnett Show*, *The Sonny and Cher Comedy Hour*, and later, *Cher* (the singer's post-divorce solo effort), Mackie established himself as TV's preeminent designer in the 1970s. In 1974, as Mackie was hitting the

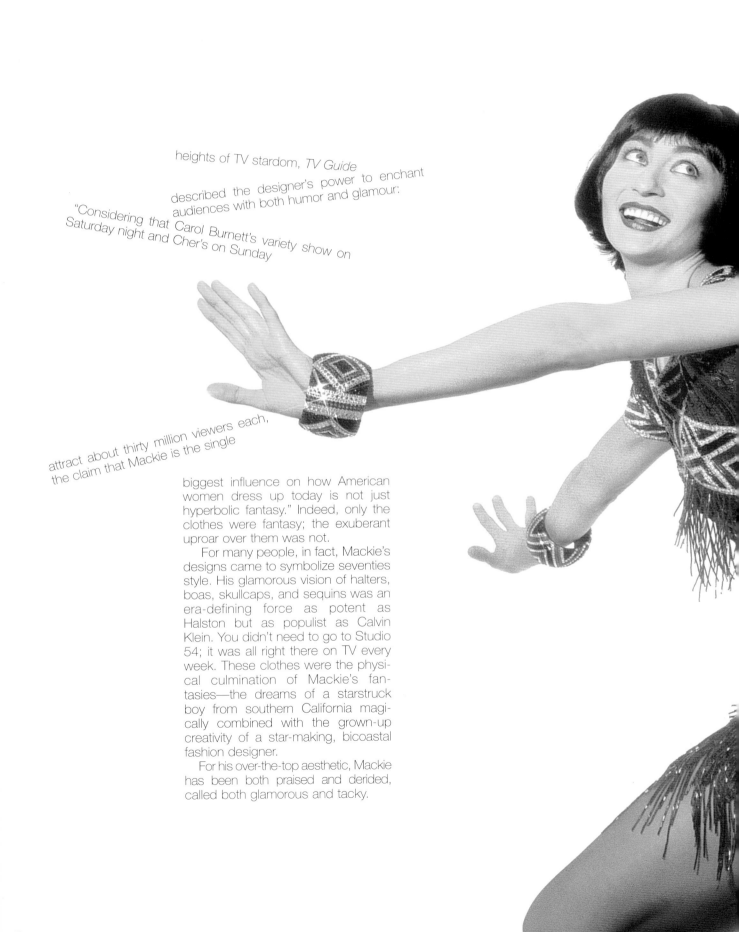

heights of TV stardom, *TV Guide* described the designer's power to enchant audiences with both humor and glamour: "Considering that Carol Burnett's variety show on Saturday night and Cher's on Sunday

attract about thirty million viewers each, the claim that Mackie is the single

biggest influence on how American women dress up today is not just hyperbolic fantasy." Indeed, only the clothes were fantasy; the exuberant uproar over them was not.

For many people, in fact, Mackie's designs came to symbolize seventies style. His glamorous vision of halters, boas, skullcaps, and sequins was an era-defining force as potent as Halston but as populist as Calvin Klein. You didn't need to go to Studio 54; it was all right there on TV every week. These clothes were the physical culmination of Mackie's fantasies—the dreams of a starstruck boy from southern California magically combined with the grown-up creativity of a star-making, bicoastal fashion designer.

For his over-the-top aesthetic, Mackie has been both praised and derided, called both glamorous and tacky.

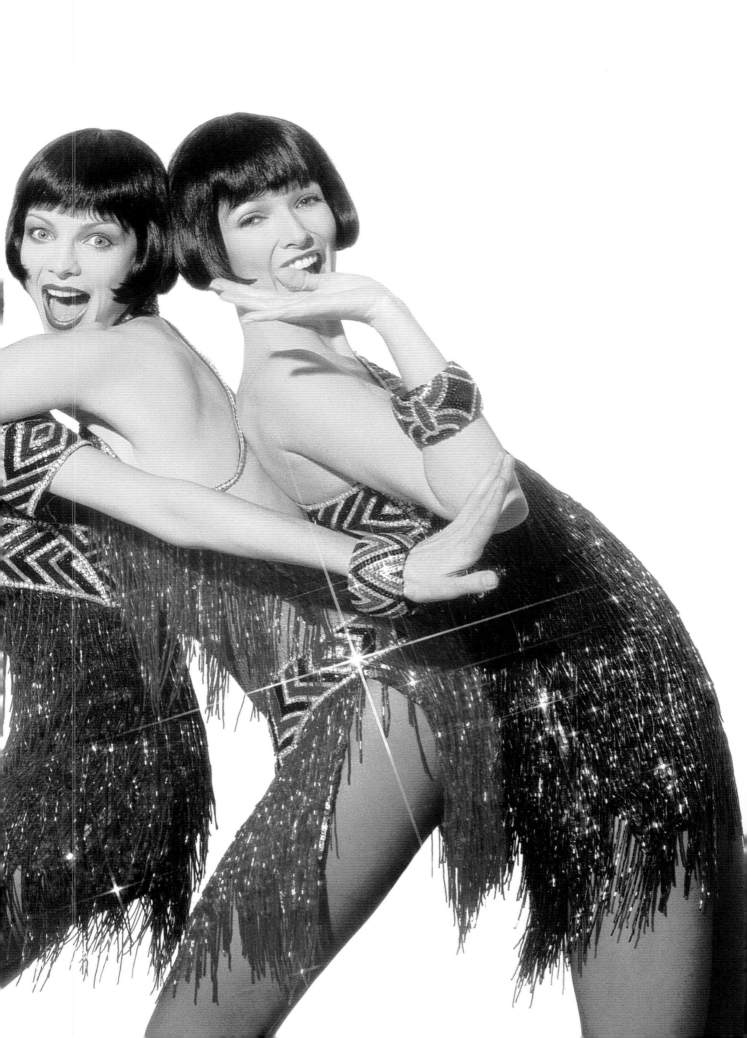

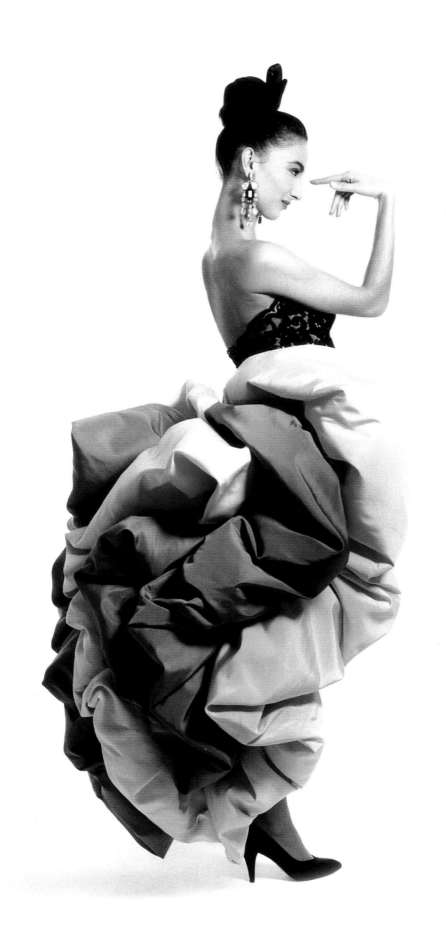

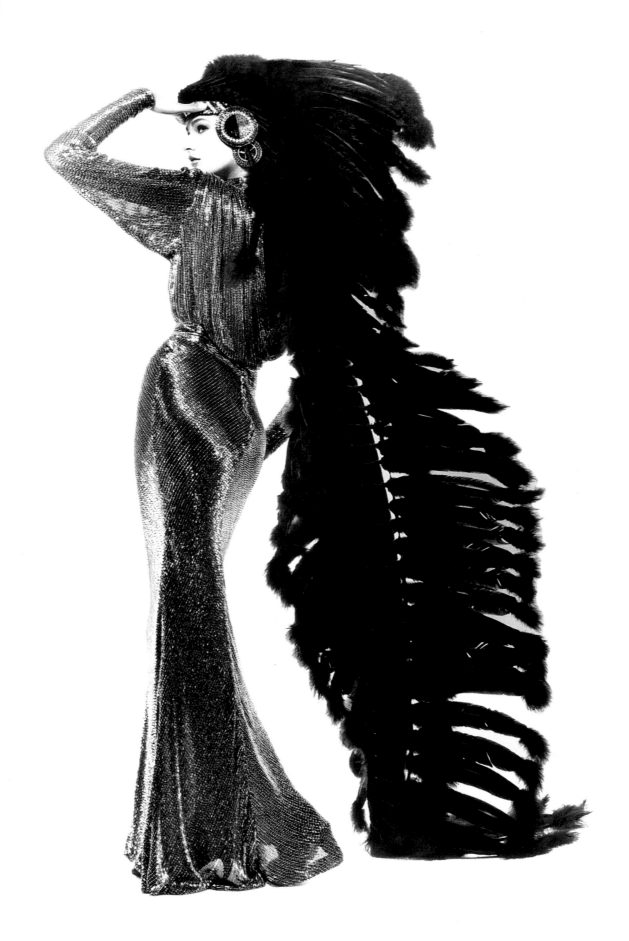

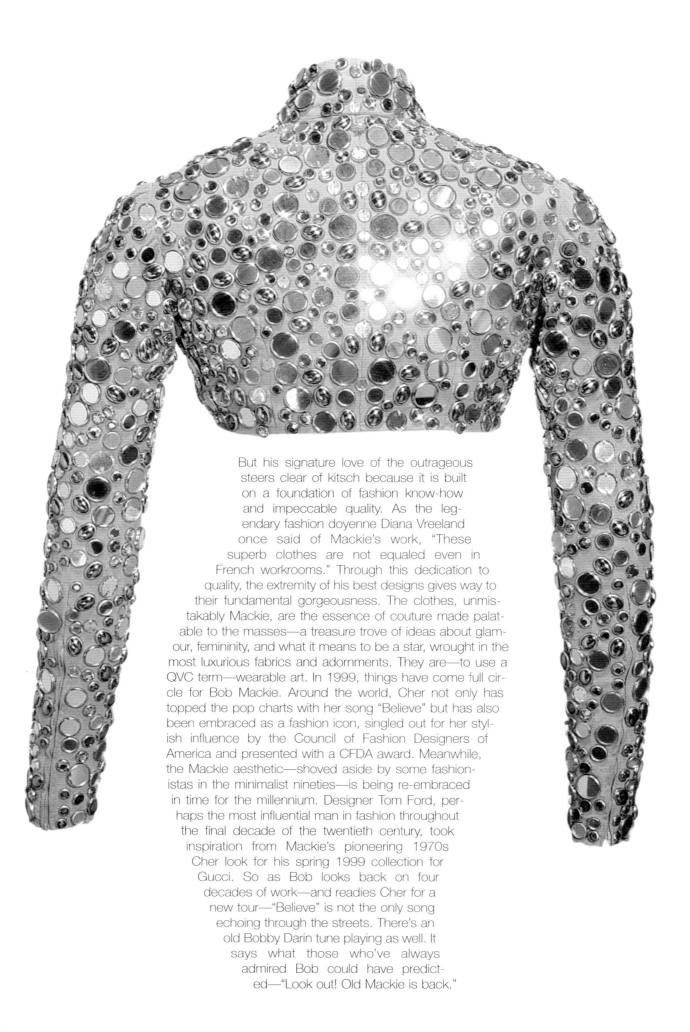

But his signature love of the outrageous steers clear of kitsch because it is built on a foundation of fashion know-how and impeccable quality. As the legendary fashion doyenne Diana Vreeland once said of Mackie's work, "These superb clothes are not equaled even in French workrooms." Through this dedication to quality, the extremity of his best designs gives way to their fundamental gorgeousness. The clothes, unmistakably Mackie, are the essence of couture made palatable to the masses—a treasure trove of ideas about glamour, femininity, and what it means to be a star, wrought in the most luxurious fabrics and adornments. They are—to use a QVC term—wearable art. In 1999, things have come full circle for Bob Mackie. Around the world, Cher not only has topped the pop charts with her song "Believe" but has also been embraced as a fashion icon, singled out for her stylish influence by the Council of Fashion Designers of America and presented with a CFDA award. Meanwhile, the Mackie aesthetic—shoved aside by some fashionistas in the minimalist nineties—is being re-embraced in time for the millennium. Designer Tom Ford, perhaps the most influential man in fashion throughout the final decade of the twentieth century, took inspiration from Mackie's pioneering 1970s Cher look for his spring 1999 collection for Gucci. So as Bob looks back on four decades of work—and readies Cher for a new tour—"Believe" is not the only song echoing through the streets. There's an old Bobby Darin tune playing as well. It says what those who've always admired Bob could have predicted—"Look out! Old Mackie is back."

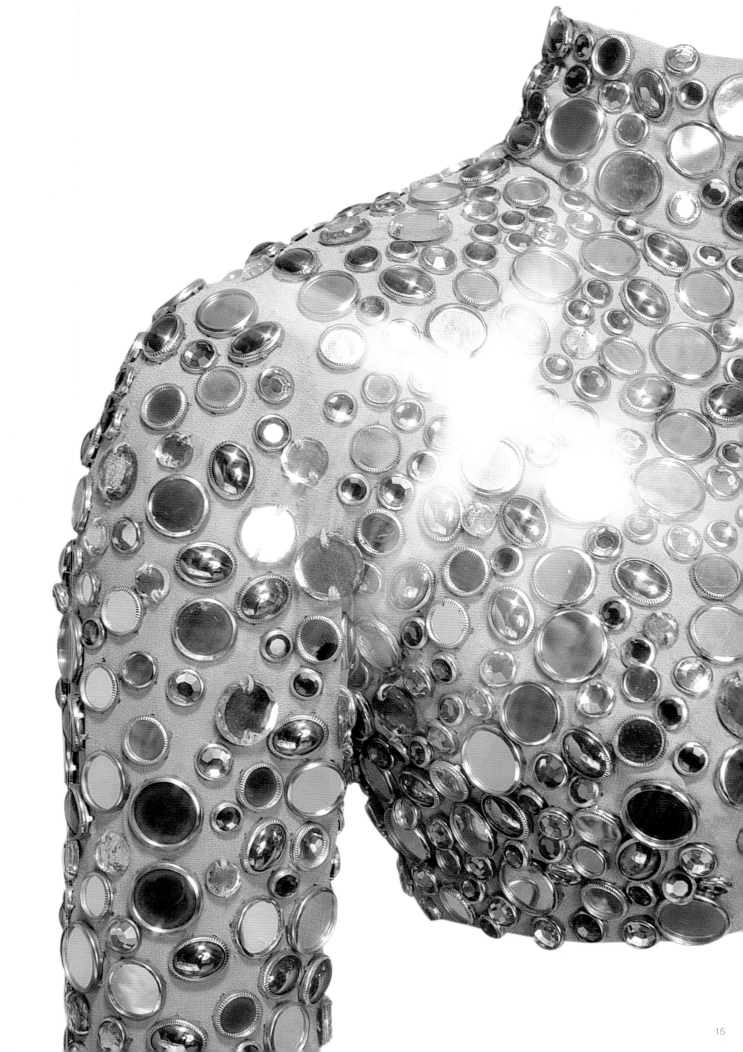

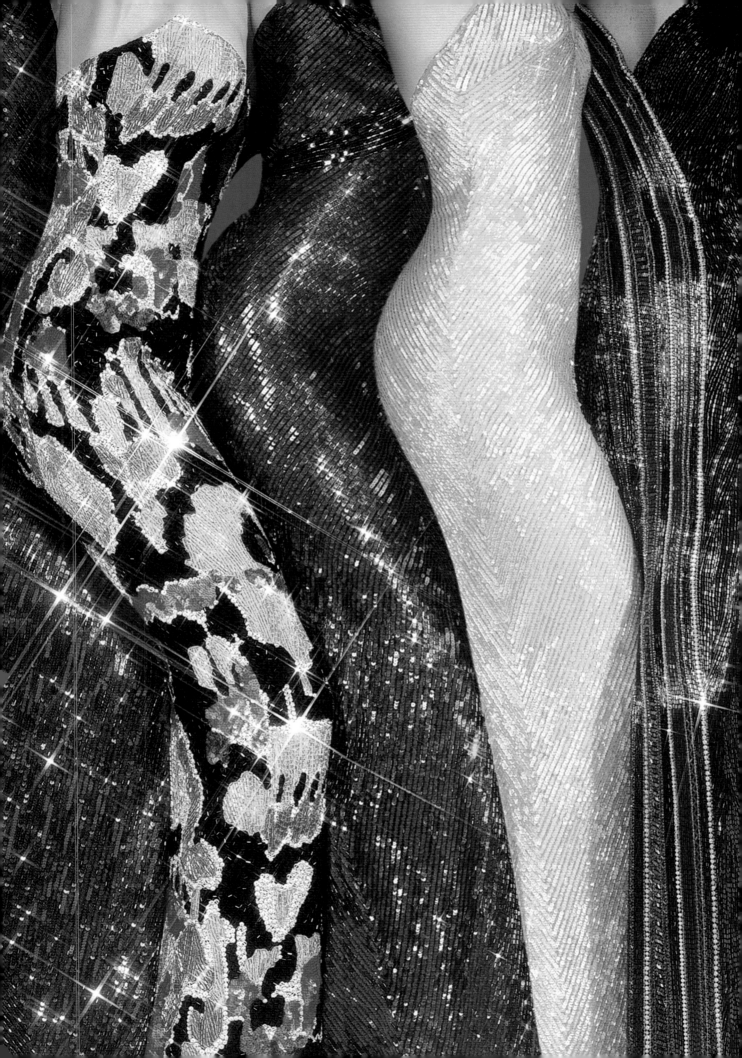

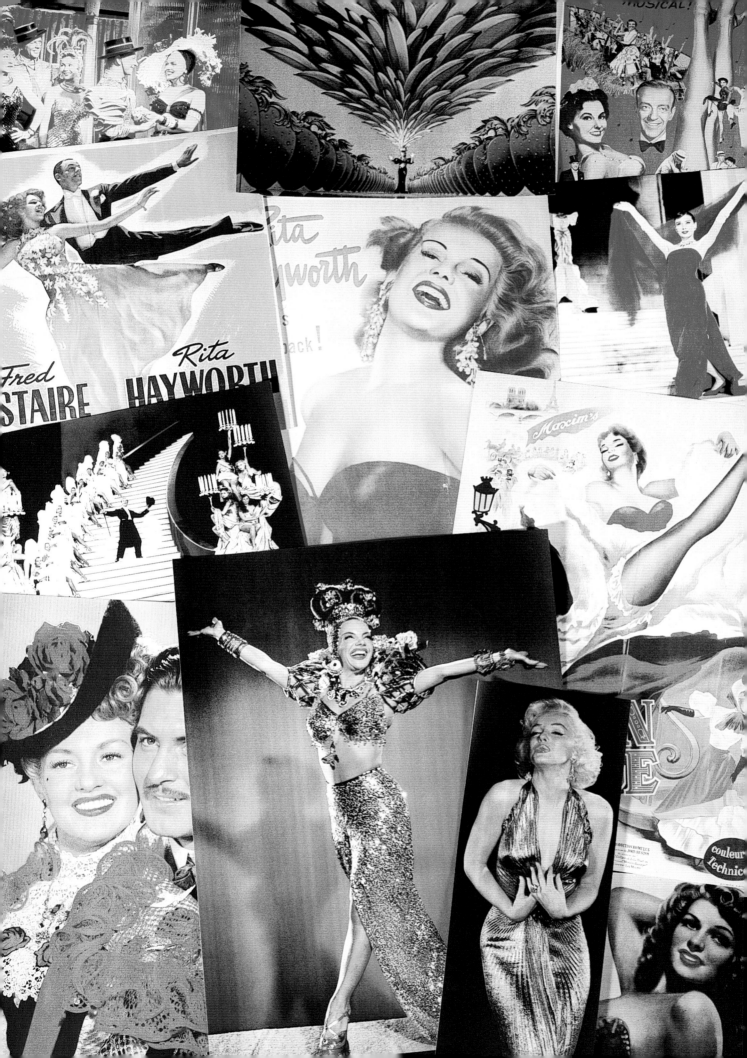

Fred
STAIRE

Rita
HAYWORTH

Maxim's

MUSICAL!

couleur
Technic

Bob Mackie has two scars on his chin. He got them when he fell down the stairs. He was five years old and dressed as Carmen Miranda at the time. Such are the hazards of being starstruck in kindergarten. It was the same thirst for glamour that led him to such Technicolor extravaganzas as "Down Argentine Way," which landed him on his face. Five years later, defying the conventions of the Los Angeles suburbs in which he was born on March 24, 1940, Mackie discovered art. The results were nearly as catastrophic as his discovery of platform shoes and plastic fruit. "When I was ten years old," Mackie recalls, "I went to school on Halloween dressed and painted up

The Allure of Technicolor: Growing Up at the Movies

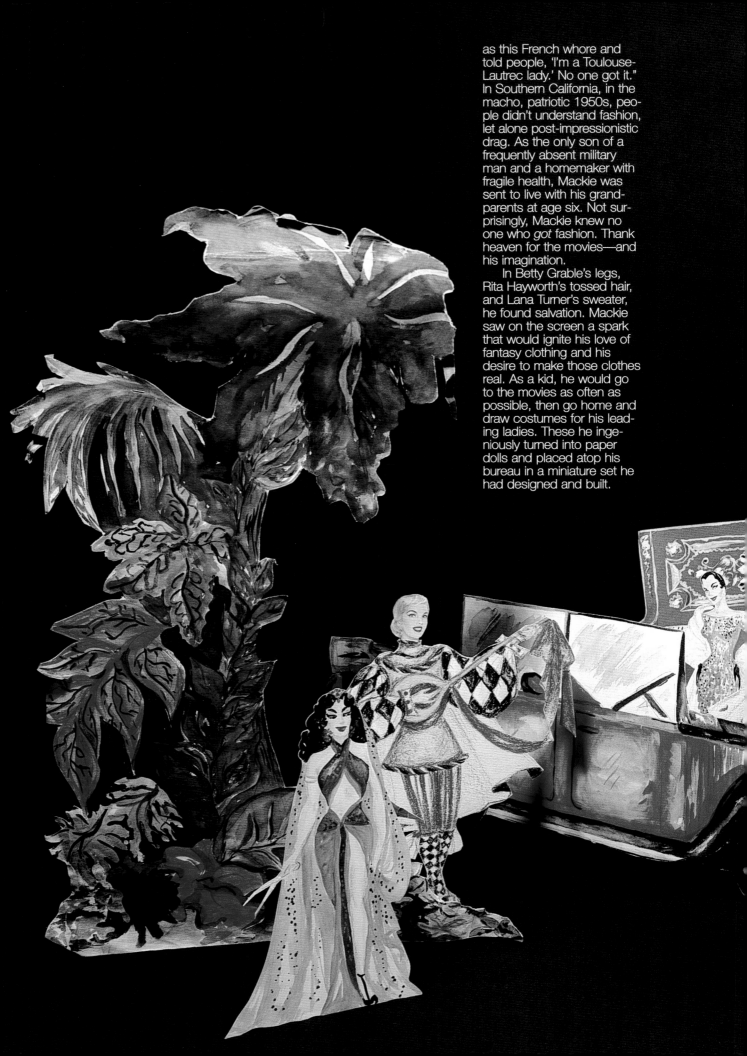

as this French whore and told people, 'I'm a Toulouse-Lautrec lady.' No one got it." In Southern California, in the macho, patriotic 1950s, people didn't understand fashion, let alone post-impressionistic drag. As the only son of a frequently absent military man and a homemaker with fragile health, Mackie was sent to live with his grandparents at age six. Not surprisingly, Mackie knew no one who *got* fashion. Thank heaven for the movies—and his imagination.

In Betty Grable's legs, Rita Hayworth's tossed hair, and Lana Turner's sweater, he found salvation. Mackie saw on the screen a spark that would ignite his love of fantasy clothing and his desire to make those clothes real. As a kid, he would go to the movies as often as possible, then go home and draw costumes for his leading ladies. These he ingeniously turned into paper dolls and placed atop his bureau in a miniature set he had designed and built.

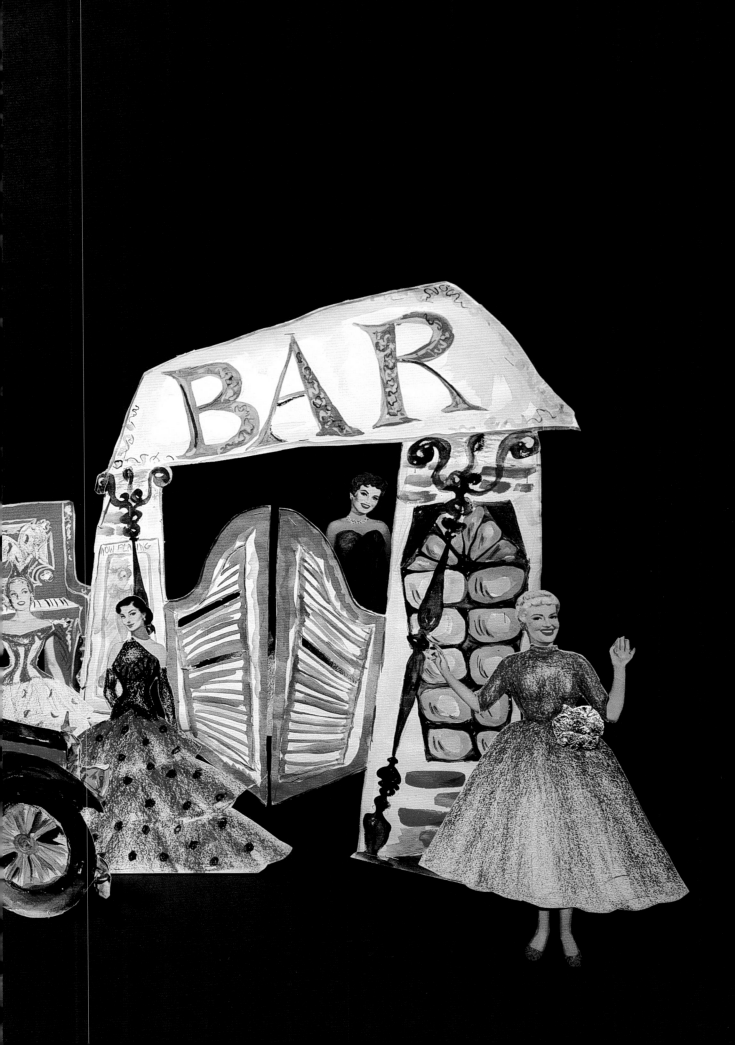

Sadly, but not unexpectedly, his creativity wasn't rewarded. "I remember my teacher saying,

'Why don't you leave that to your sister?'" says Mackie, recalling the day he got caught

sketching in his school notebooks. At the time, however, he had no idea what the killjoy

was talking about. His sister couldn't draw to save her life. Why should he leave it to her?

Undaunted, he continued to indulge his cinematic passions. In 1951, after seeing Vincente

Minnelli's An American in Paris, he stayed behind to see who had designed the costumes

for the ballet sequence—Irene Sharaff, as it turned out—and realized someone actually got

paid to do that. "I announced to the family that I was going to be a costume designer and

everybody fell over," the designer recalled in the October 18, 1975, issue of TV

Guide. Mackie had found his calling. "The minute I got to high school

I was designing everybody's costumes," he remembers.

"We did a lot of shows in high school—musicals, variety shows—and I would design the clothes and mothers would make them." They didn't always turn out as he had planned. "The necklines were always higher, the hemlines a little longer. I would look at them and go, 'That's not exactly what I had in mind.' But every now and then one would come out good." While in high school, he lived with his father in Rosemead, another Los Angeles suburb. He never missed watching *The Dinah Shore Show*, a TV variety series known as much for the star's glamorous wardrobe as for her singing. He never dreamt he would one day get to dress Shore—Mackie would go on to design a special for her early in his career—or that in his thirties he would be asked to appear on her syndicated talk show on numerous occasions. Watching her channeled his creativity.

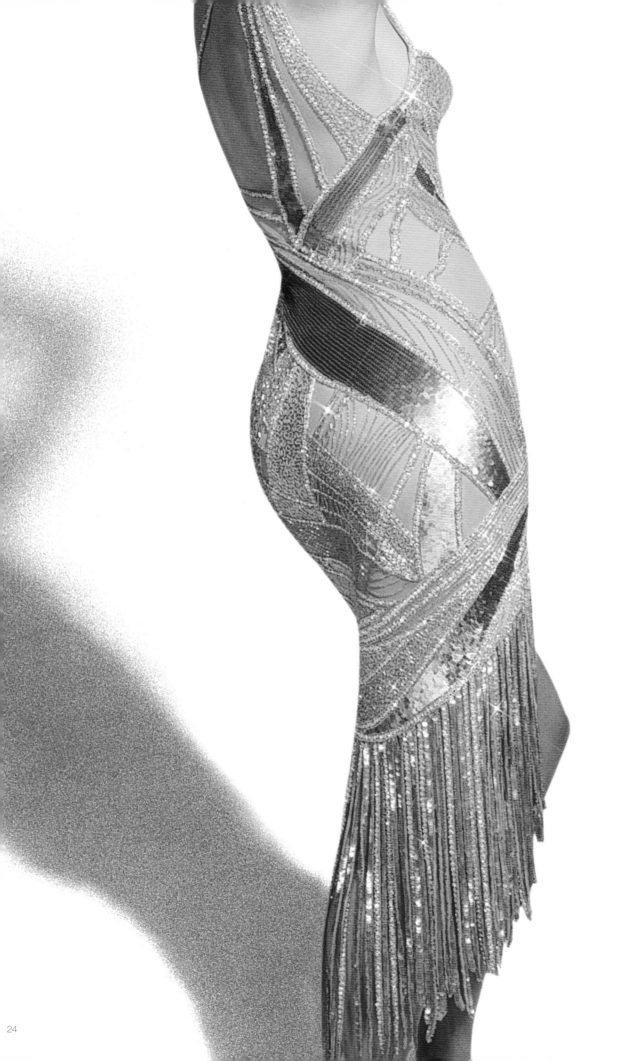

After graduating from high school, he enrolled in Pasadena City College as an advertising art and illustration major. Two years later, portfolio in hand, he won a scholarship to Chouinard Art Institute and plunged into costume design with the enthusiasm of someone who'd been waiting his whole life to work with fabric. He was clearly jazzed by the encouragement he received at Chouinard. "Every time there was a costume contest or a show at the school, there was nobody who was interested in doing anything like that. They wanted to do fashion. So I would jump on it like it was the best thing." His biggest opportunity to distinguish himself came when his sewing teacher suggested the class design a showgirl costume for the annual student fashion show. "He knew that I'd be the one to do it," Mackie says. "Everybody else was interested in sportswear. A showgirl was the last thing anybody was interested in." At the fashion show, actress Abby Dalton, a former student of the school, modeled Mackie's design and earned him his first raves. In his junior year, the successful actress (and famous bombshell) Jayne Mansfield was named queen of the Art Student's Ball. Students were asked to design clothes for her to wear to it. Again, Mackie's enthusiasm paid off. "I didn't submit one sketch for Jayne Mansfield, I submitted twenty," he remembers. "The theme was 'Rites of Spring.' I had her Grecian, I had her turn-of-the-century, like a Gibson girl with a big bonnet and flowers. I had her every way I could think of for spring." Mackie won the contest, of course, with a low-cut gold number with major slits. Rather than bask in the glory, however, he took this endorsement as a sign that he was ready to leave Chouinard. "I didn't stay for my last year even though I was on scholarship. I thought I was ready to be out there designing for the theater and stuff," he says. He was right. Within months, Mackie got his first job, with the costume designer Frank Thompson at Paramount Studios. "It was a delight to get to a point where I could walk into a work room with a sketch and somebody knew how to do it. I could make it right and fit it properly and make a woman look like I wanted her to look," he says. But it wasn't as exciting as he had hoped.

"I was sketching pictures of Glenn Ford in a Levi's jacket for a week," he told *Women's Wear Daily* in 1999. Worse yet, the first picture he worked on, *Love is a Ball*, was a bomb. After Thompson, he went to work for Jean Louis, who was designing the gowns for what became Marilyn Monroe's final picture, *Something's Got To Give*. Next, Mackie worked with Edith Head, whom he met while working at Paramount. "I was getting no credit and making something like $125 a week," Mackie told *Women's Wear Daily*. "But on my lunch hours, I could go to any stage where they were shooting and just stand back in the dark and watch."

But even working with the most famous costume designer of them all wasn't enough for the young sketch artist. He was still resigned to the back room and he wanted more. Mackie realized, at that point, that movies were changing. The spectacular musicals his mother had taken him to on their weekends together—films dripping in the most lavish costumes, the ones he liked best—were no longer being made in great abundance. "By the time I got there, they weren't doing those kinds of movies anymore. It had gone over to TV," Mackie says. Staying true to his dream of creating those kinds of clothes, he followed the glamour into that newer medium. There he found the opportunities he'd always deserved and the fame he'd always wanted.

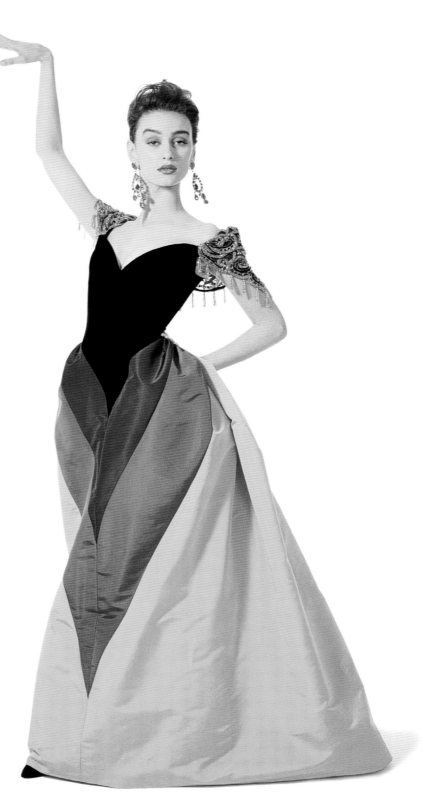

a conversation with Ray Aghayan

Bob was your assistant on *The Judy Garland Show* beginning in 1963, you opened Elizabeth Courtney Costumes together in 1968, and you've worked together ever since. How has your relationship changed over the years?
In the beginning, he was a great help to me. He was very young and enormously talented, really quite brilliant. I was in the middle of my career—when there's always a slump—and he gave it a wonderful boost. I guess after a while I've done the same for him. I've usually seen to it that everything he wanted to do was somehow within reach. Once we really got going and had our place, I really took over the business end, except when it came to *Lady Sings the Blues* and *Funny Lady*, which we did together. We haven't "worked together" really as much as we have simply helped each other.

What has been the secret to Bob's longevity?
Perseverance and talent—and the fact that he couldn't imagine doing anything else. If you're a doctor, you're a doctor; there's nothing else you can do. We both have a great sense of quality and that helps a great deal. Our work certainly doesn't bring in a lot of money, because you can't slop it together or mass-produce it. But because it looks good and it's top-drawer, it keeps you going.

Did it ever bother you that he's better known than you are?
It was a matter of one person having to come out of this whole thing as the star—the one who is recognizable—and Bob certainly was the one to do it. He's been lucky enough to do some of everything. He's done movies, TV, Vegas, Broadway.

How would you describe Mackie style?
It's very left field. It's something very beautiful that makes you smile when you see it. It makes people have a good time. He has an enormous sense of humor, which has really helped him, even with his regular dresses and couture dresses. One of the finest things he does is to make what otherwise would obviously be a costume look more like a dress. He's able to marry those two very distinct things, and the result is pure entertainment.

What is the design process like for Bob?
It has to do with a pencil, a hand, and an idea. When the hand can do on paper what the head is thinking, which is a rare talent, it just comes out. Not that there isn't a lot of thinking and suffering. Bob often thinks he can't do something and then you talk to him and con him into it and he just does it. He's really quite complete in his talent.

Is designing costumes different than designing clothes?
If it's anything theatrical it all happens very quickly, and he has great fun doing it. With the collection and the clothes, the process is much more complicated and much longer. He's not as comfortable, you might say. He'll do 150 to 200 sketches and we'll end up with thirty pieces. He just sits at the drawing table. We often leave him in the studio and lock up, and he'll stay until seven, eight, or nine o'clock—or until his back gives out. It's a long process he goes through. But he really likes to work. He really enjoys it.

He's very exacting.
He's a perfectionist to the point of insanity. You can't get away with a thing. It's natural for him. His feeling seems to be: "If you have to do something, why not do it as well as it can be done." I would say if you really pay attention to him 85 percent of the time, you're better off.

Glamour Girls (and Boys)

From Ethel
Merman to
Mama Cass to
Madonna, Bob
Mackie has
dressed the
world's most
fabulous enter-
tainers over the
last three
decades,
upping their
personal glam-
our quotient
through a mix-
ture of sartorial
artistry, techni-
cal wizardry,
and a bit of
psychology.
"You have to
know who the
person is, what
makes them
special, how
they got there,
and why people
like them—then
you just
enhance that."
He makes it
sound so easy.
But when
you've dressed
everyone from
Totie Fields to
Sharon Stone,
you're allowed
to be a little
jaded. So who's
his favorite?
"How can I
choose one?"
Mackie asks.
"Everybody's
different. I'm
not being diplo-
matic, it's true."

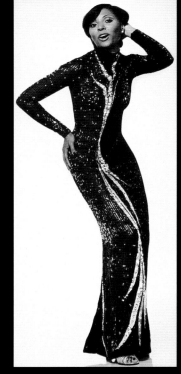

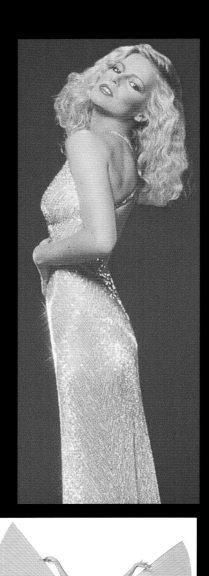

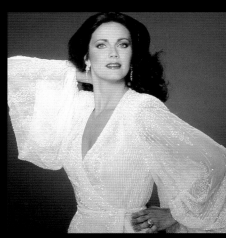

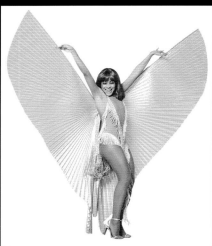

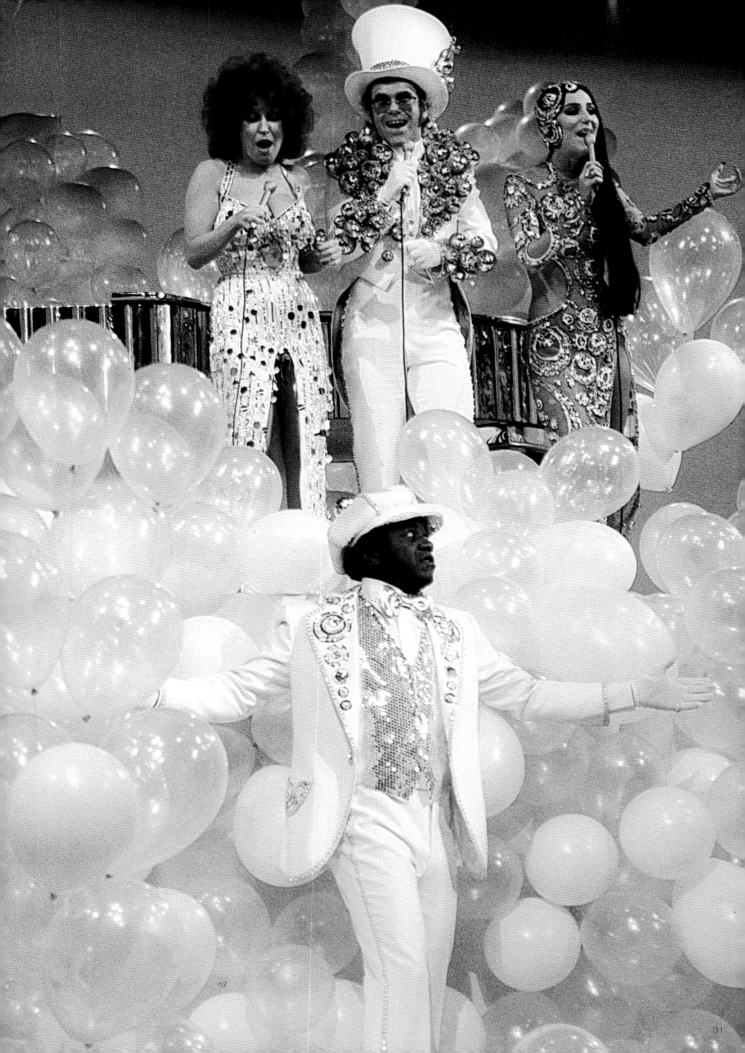

Bob Mackie on…

I have always loved doing **Mitzi Gaynor's** clothes because she is a whole different kind of girl. It's like ruffles and feathers and pink and turquoise and orange. It's like designing a bouquet of flowers every time she does a show. That exuberance! It's just the opposite of Cher. You couldn't be more opposite in terms of an approach to performing.

You have to get a lot of rest before going into a project with **Bette Midler** because she won't let anybody just slide by. She's always questioning everything and wanting it to be more than it possibly could be. But there's a good kind of crackle and excitement going on at the same time.

I met **RuPaul** in drag at the opening of Henri Bendel in New York and he said, "Someday, you're going to do clothes for me." And I said, "When you're ready, I'm ready." With him, it's like dressing Barbie on steroids—that really tall, long-legged proportion and that blond, blond hair. He's a cross between Tina, Diana, Cher, and Barbie. It's like, "How many icons can you squeeze into one body?"

Everyone in the **King Family** looked like Doris Day—a squeaky-clean blond look—except for one brunette sister-in-law. We knew she wasn't really related. They wanted it all cute and wholesome, but it was strange. At the end of the day, you'd hear the director yell, "Strike Grandma!" And a stage hand would wheel her out.

Lucille Ball scared the hell out of me from the beginning. She walked around with that low voice and a cigarette hanging out of the side of her mouth. She always called me Mackie: "Hey Mackie!" The first time I worked with her was on a Danny Thomas special. They asked her if she would fly on a wire dressed as a butterfly. She was already in her fifties then. But Mary Martin was flying all over the country as Peter Pan so I think Lucy just decided she could do it. It was very painful in those days to wear that whole harness thing—you're just hanging there by your crotch. But she flew back and forth and did flips above the audience. When they shot it, we thought no one would believe it was really Lucy. She had these big wings that she was flapping around and she did it. But the language she used about that harness was amazing—some pretty good words.

I met **Liza Minnelli** when she was on her mother's show. She was this hyper little girl—just so excited. You know how Liza's personality is anyway, and then to be seventeen and have everything new, she was singing and dancing all over the place. She hadn't yet found that Liza look we all know. She had long, stringy hair. The next time I saw her was well into the sixties when she came on Carol's show. She was wearing these little sixties dresses and her hair was short. She had found her whole look and all of a sudden that was Liza! The best advice she ever got was to cut all her hair off. Then it all worked.

The first time I saw **Bernadette Peters**, she was maybe twenty-one and doing *Dames at Sea* on Broadway. She was like a kewpie doll. If people think she looks like a kewpie doll now, they should have seen her at that age. She was just adorable with just a bit of baby fat on her. She had on sort of thrift shop clothes and she had a little doggy in her purse and everybody fell in love with her. She ended up being on *The Carol Burnett Show* many, many times. The audience loved her. Then she lost her baby fat and she got this wonderful, fabulous little figure that she still has. She became one of my regular ladies. I knew exactly what to do with her.

Lynda Carter is a big girl, very voluptuous, almost like old-time Hollywood in her appeal. She has these incredibly beautiful blue eyes and black hair. It's all about beauty with her. She has a tiny, tiny waist and a large bosom and there's no way to de-emphasize that. It's just there. And, let's face it: when you've got it, you show it.

Cheryl Ladd is tiny— a perfect miniature, just a step up from Barbie as far as size goes. She always reminded me of those little girls from the forties, like Lana Turner or Jane Powell, who used to work at MGM. As long as you proportion it right, she has the perfect body.

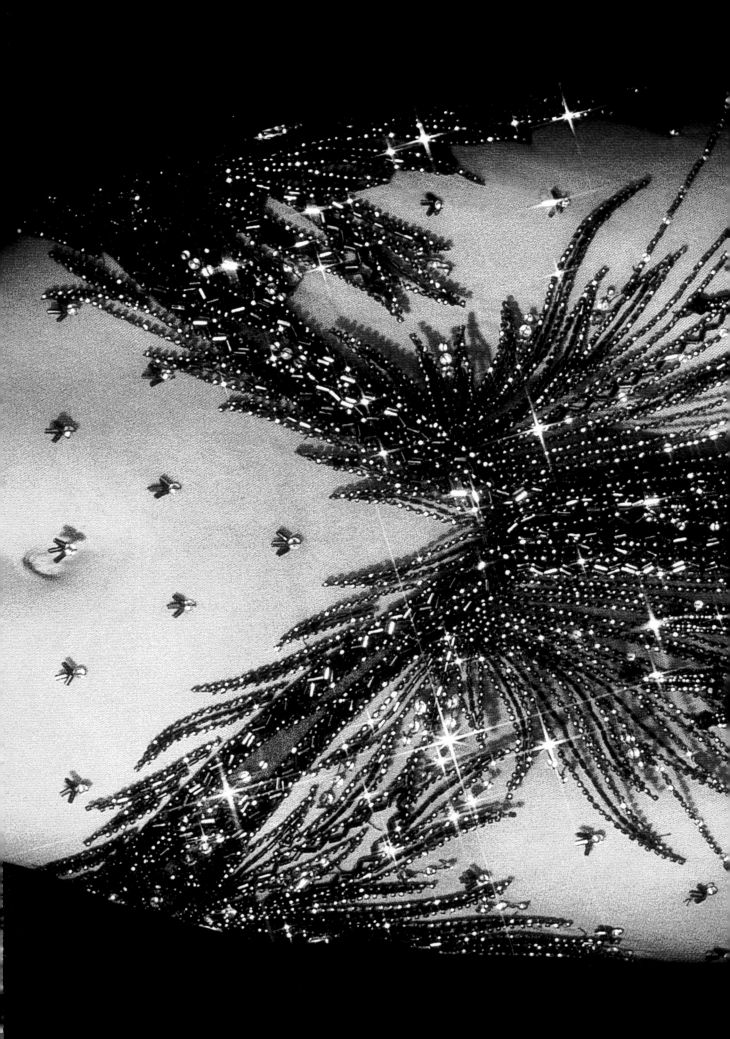

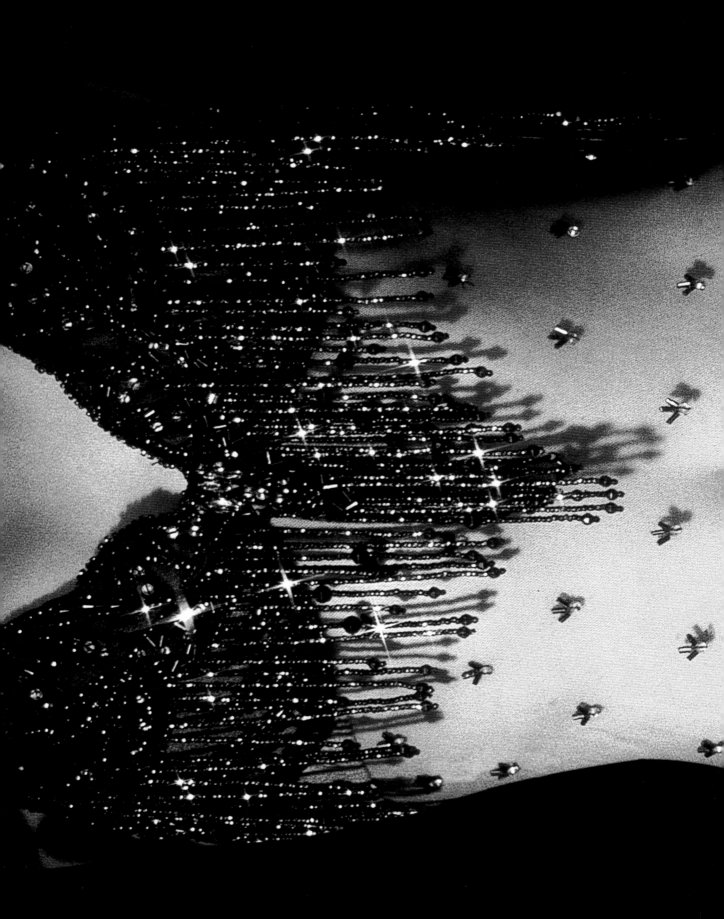

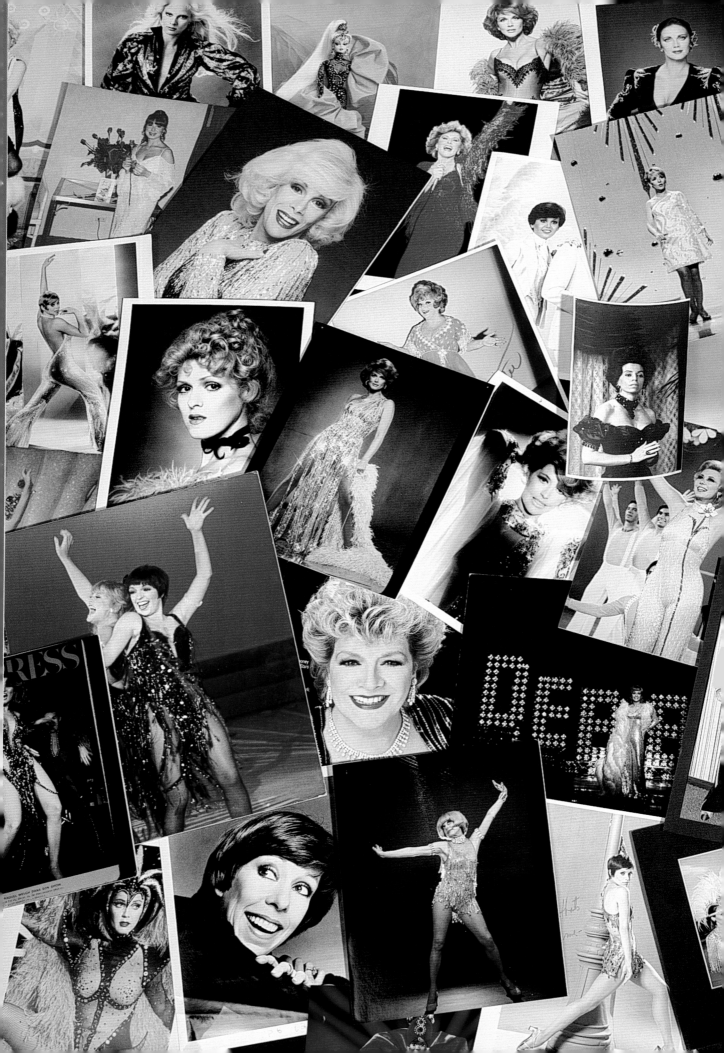

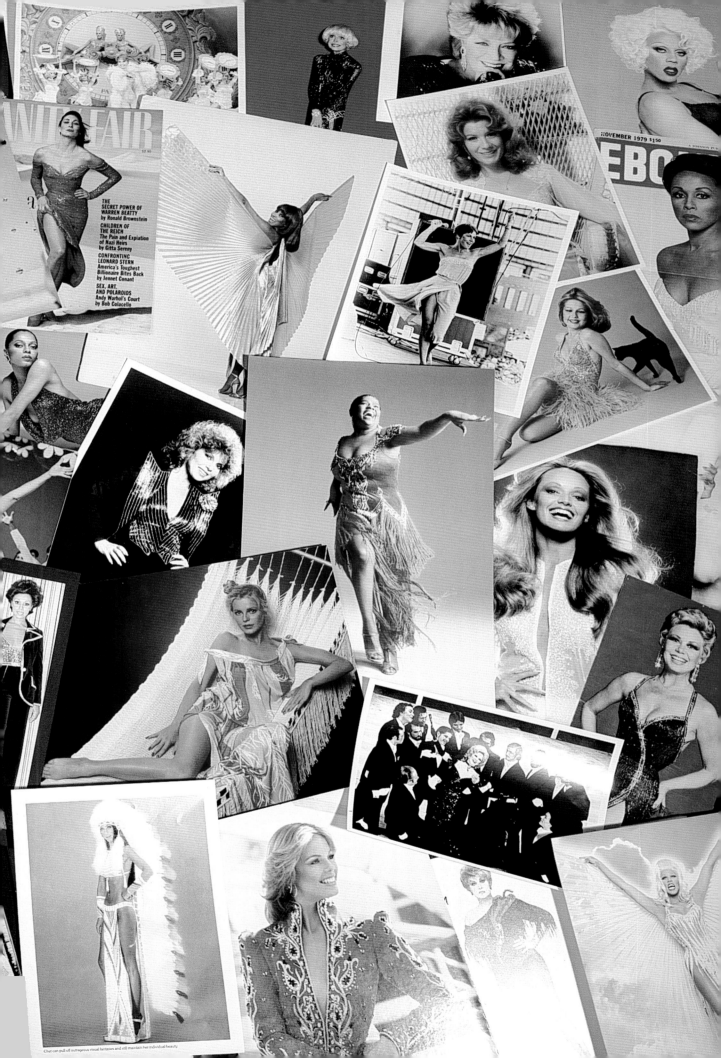

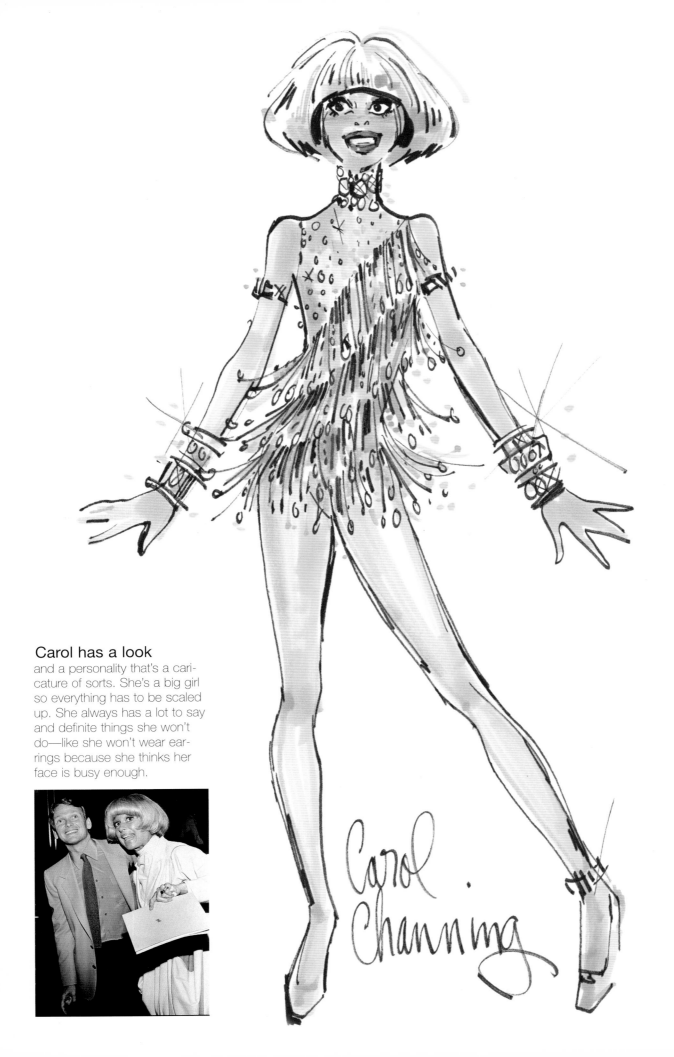

Carol has a look

and a personality that's a caricature of sorts. She's a big girl so everything has to be scaled up. She always has a lot to say and definite things she won't do—like she won't wear earrings because she thinks her face is busy enough.

Carol Channing

juliet prowse

had an incredible body. The more naked she was, the better she looked, because her body was so toned and so wonderful. And what she could do with it!

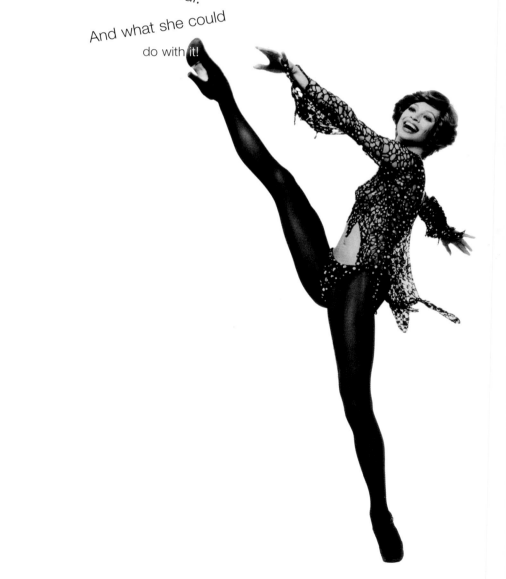

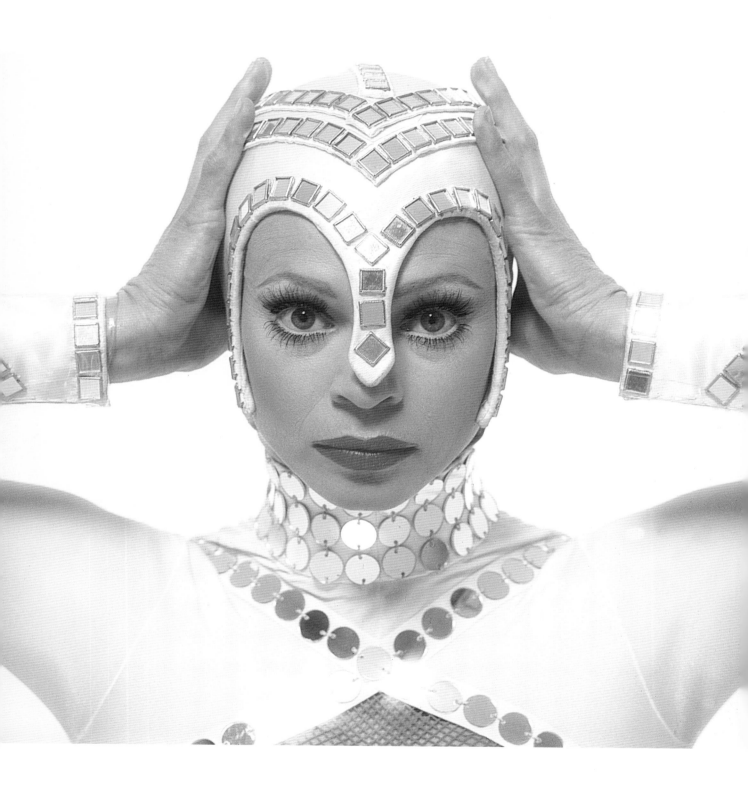

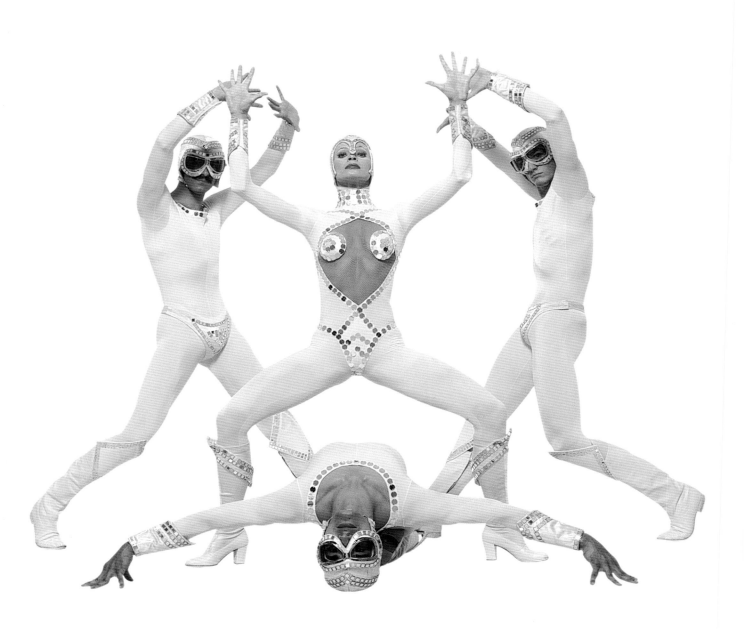

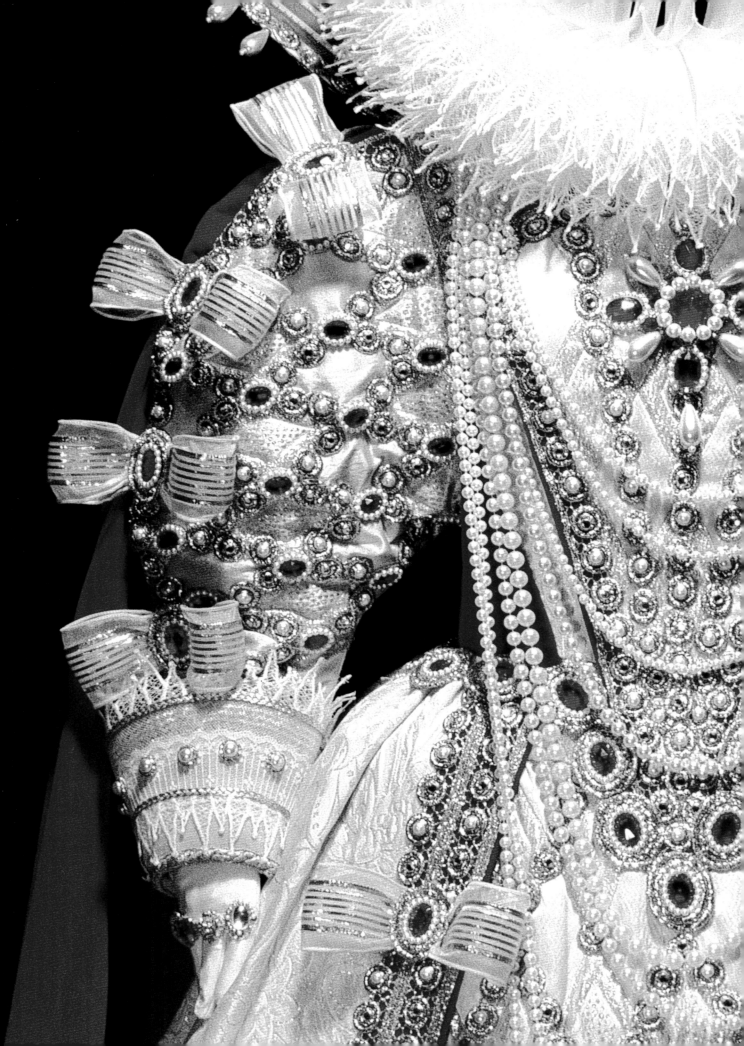

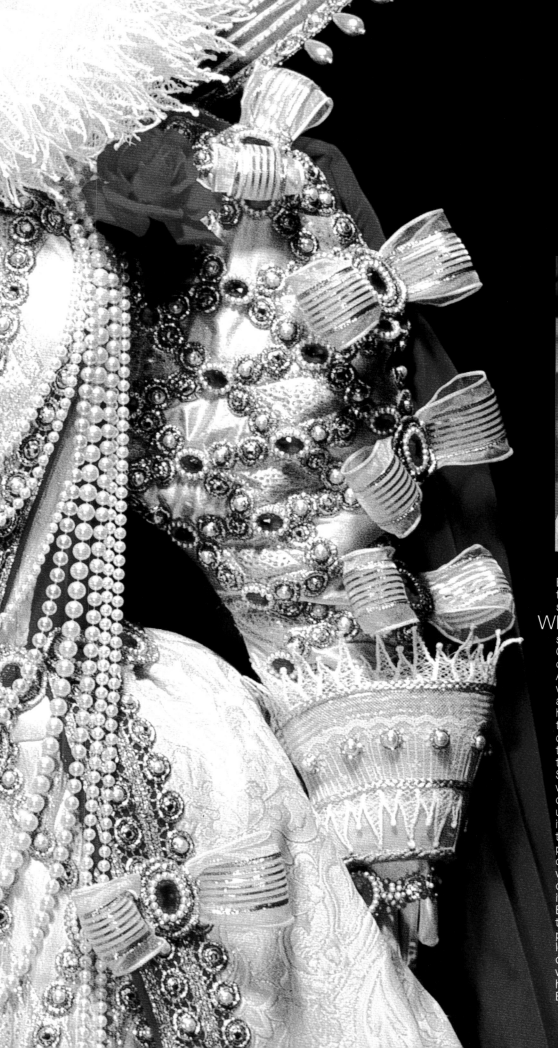

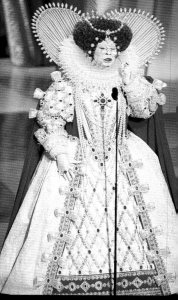

Bruce Vilanch, the comedy writer supreme, decided that **Whoopi Goldberg** should be dressed as Queen Elizabeth I to open the Academy Awards in 1999. Ray was working with her and asked me to help him out because that's the kind of thing I love doing. For the first fitting, we had the costume all but finished. She put it on and went walking up and down the halls to get used to the weight of it. With all the jewels, the brocade, the pearls, the big velvet cape, and that collar, it was quite a get-up. I don't know how much it cost. I never asked. But it worked, and that's the important part. If you spend a lot of money and it doesn't work that's when everybody gets his nose out of joint. But this worked.

After I did his clothes for the first *Cher* special, Elton John said, "I'd like you to do me some clothes," and I said, "What sort of thing would you like?" He said, "The kind of thing you do for Cher." I thought, "OK, if that's what you want." So I made him jumpsuits with little side cutouts and big marabou fur capes that went across the stage. There were a lot of fun looks that I did for him: his sequined Dodgers uniform, Minnie Mouse and Donald Duck, a sultan costume with a big turban, and a lot of funny jackets with bananas and fruit on them and matching hats. I'd show Elton, say, ten sketches, thinking he was going to pick two, but he'd pick all ten.

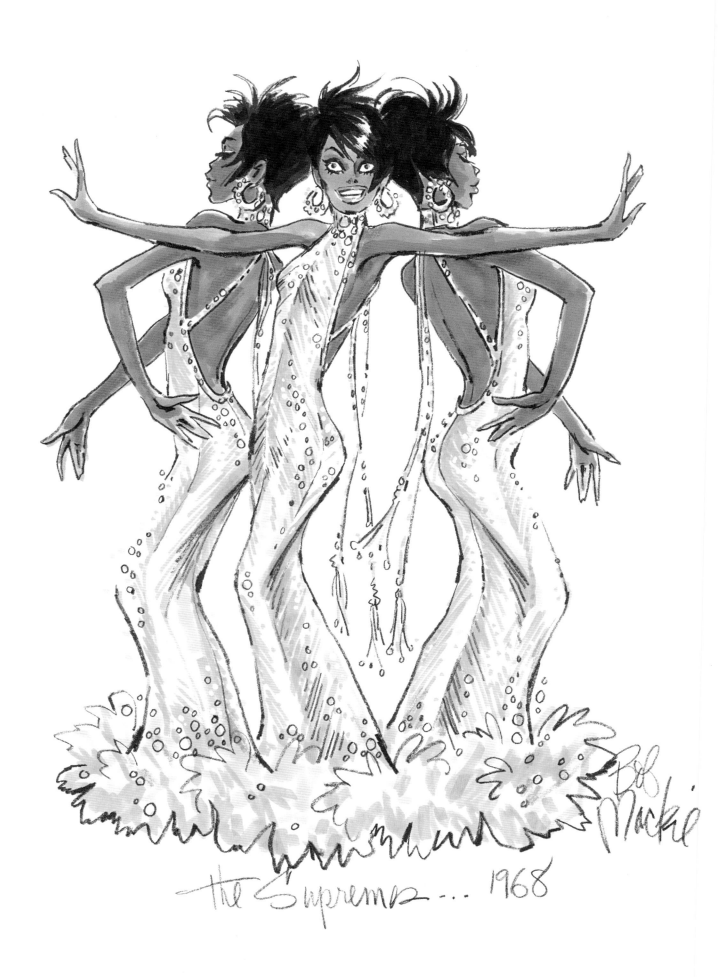

The Supremes 1968

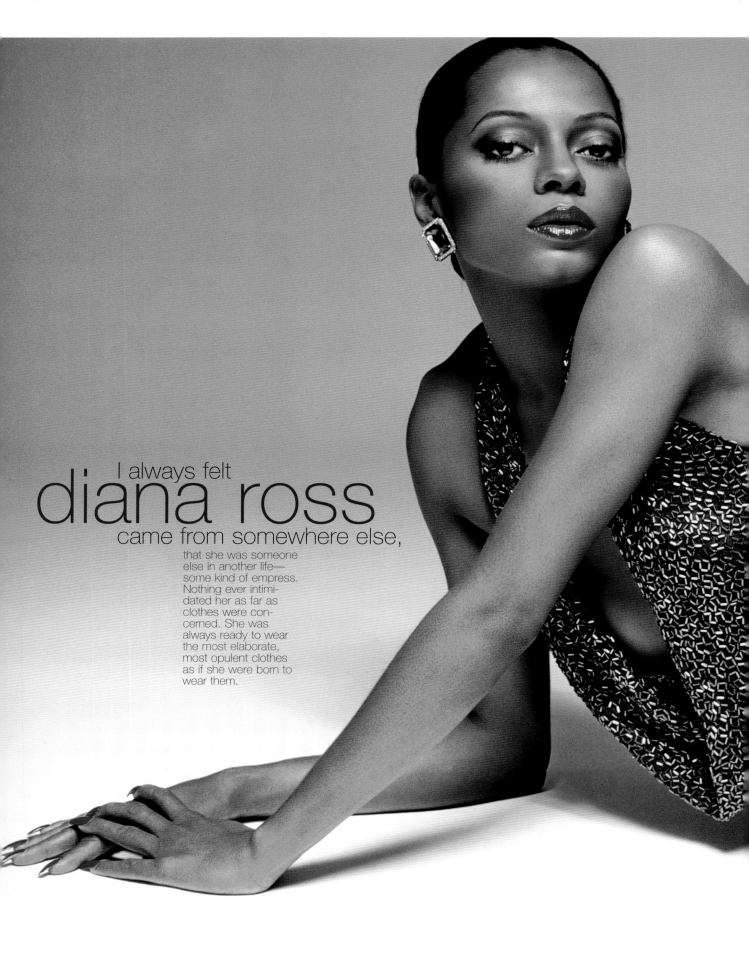

I always felt
diana ross
came from somewhere else,

that she was someone
else in another life—
some kind of empress.
Nothing ever intimi-
dated her as far as
clothes were con-
cerned. She was
always ready to wear
the most elaborate,
most opulent clothes
as if she were born to
wear them.

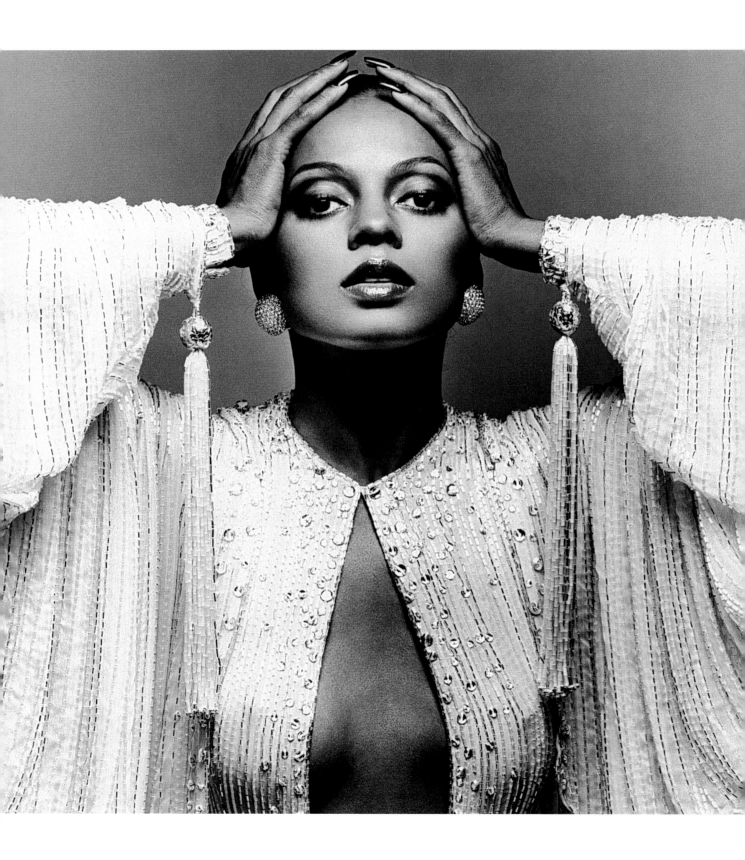

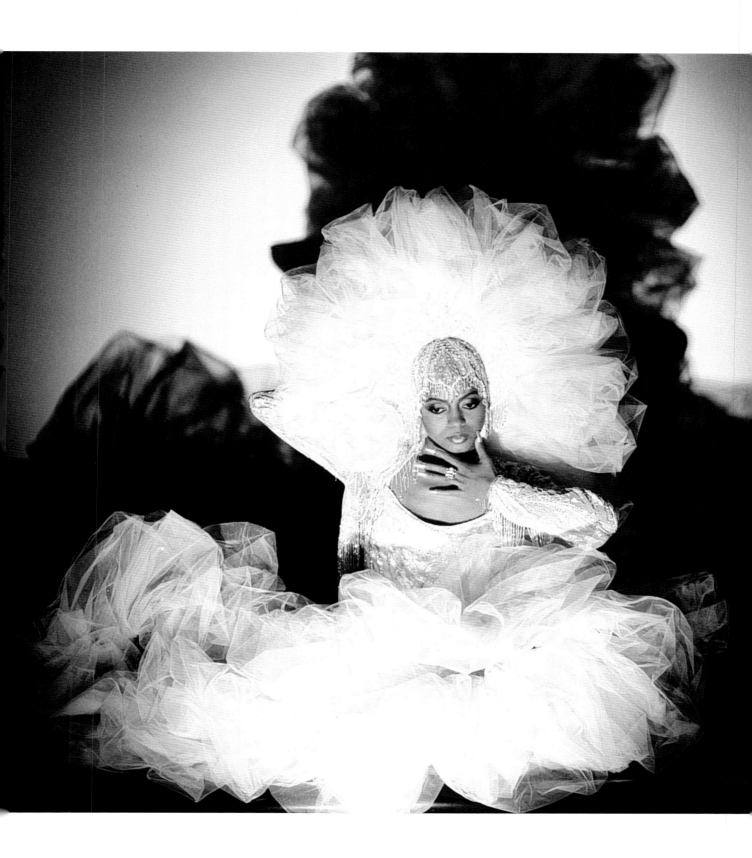

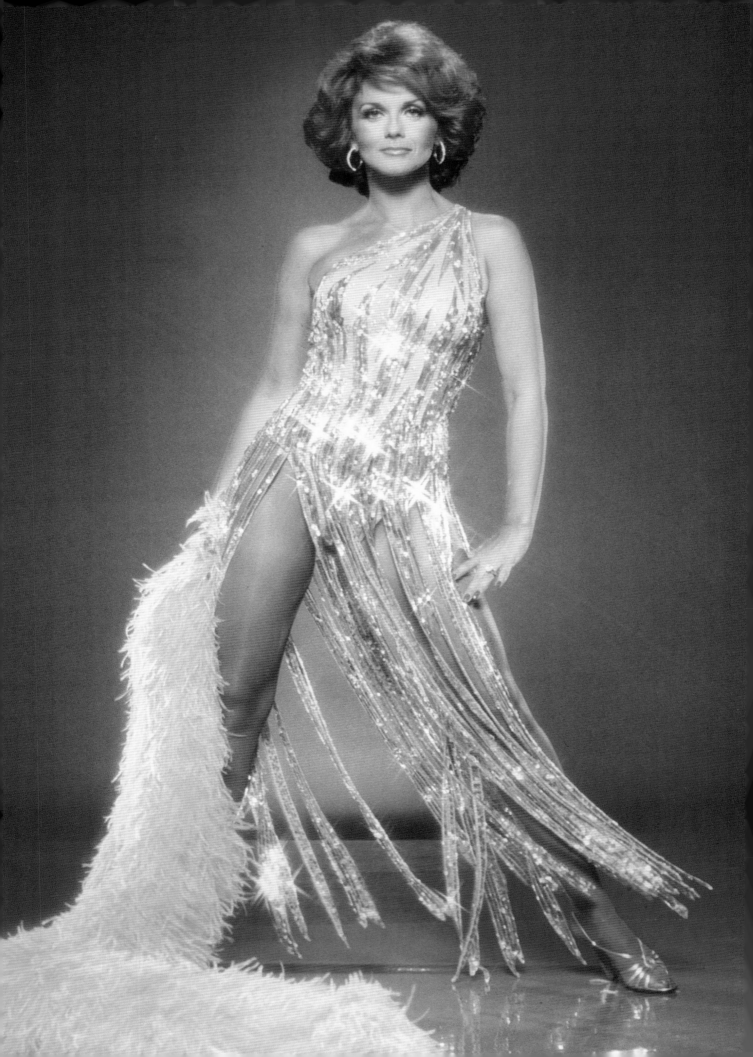

How long have you known Bob?

I met Bob when I was doing my first film, *Pocketful of Miracles,* in 1961. Edith Head, who did the clothes, introduced me to this young man who was in a little cubicle doing her sketches, and that was Bob Mackie.

When did you start working together?

Bob started doing my concert shows in 1974 and did them until 1991 when I retired. Other people have done my stuff, too—Nolan Miller and Jean Louis. But it was mainly Bob who did all my show clothes. I performed for fourteen years at Caesar's Palace in Las Vegas and then in Atlantic City, and he did all those clothes. They were fabulous. What's great about Bob is that he likes women to look like women. And he's got a great sense of humor. I did "Abbadabbadabbadabba" in one show and he had me in this unbelievable Tarzan/Jane kind of thing with a little cap to match; long, long, long bright red hair; and, of course, my high, high heels. I was born in four-inch heels.

ann-margret

He understands exageration.

So many times I screamed when I saw what he had come up with. If it were a comedic thing, he'd make it very funny. But other times it was very subtle. I remember I wore black stretch satin shorts in one number. Bob made them extra short and put a red sparkling heart on the seat.

You often worked together on TV.

He did so many of my specials. One time I did a motorcycle scene to "Give me some men, who are— uh, uh—stout-hearted men" in a really slow, slow tempo. I was wearing very, very tight black hip huggers and a black leather jacket with a tank underneath. The jacket had a standup collar that was bright red. I was wearing gloves and boots too. I always knew the outfit would be perfect for the character I was going to be portraying. And I knew it would move well.

As far as glamour goes, what was Bob's vision for you?

When I came to him all I wanted was long sleeves. He put a stop to that. He put me in halters. He put me in spaghetti straps. I'm modest, and it was very difficult for him to get me to wear something that showed a lot of skin. But I would always think of myself as the character I was playing; then I could wear the clothes. They made a poster of me in this yellow one-shoulder beaded dress with strips coming down from, uh, where my leg meets my torso. They put a fan on it for the picture.

You made a lot of teenage boys very happy. Tell me about the Bob Mackies you've worn to the Academy Awards. Which was your favorite?

It was from 1978 and I was one of the presenters. I had short hair then. The dress was black lace, scalloped, with long black lace sleeves coming down the shoulders. It had an empire waist with satin charmeuse following the line of my body down to the floor. He got a lot of calls about that one. It seemed like a very simple dress, but it really wasn't. It had nude souffle underneath so it looked like you could see through it but you couldn't.

What makes Bob's designs so special?

You can always tell if it's a Bob Mackie because he's very good with proportions. If he's doing a dress for a fifties number, he makes your waist look like it's thirteen inches no matter how big it might be.

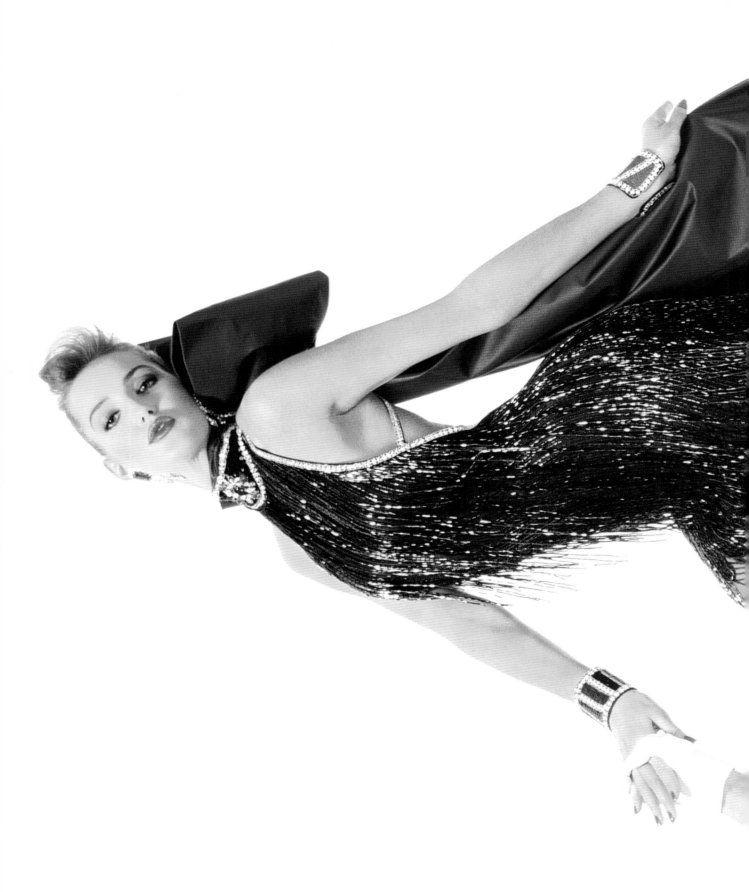

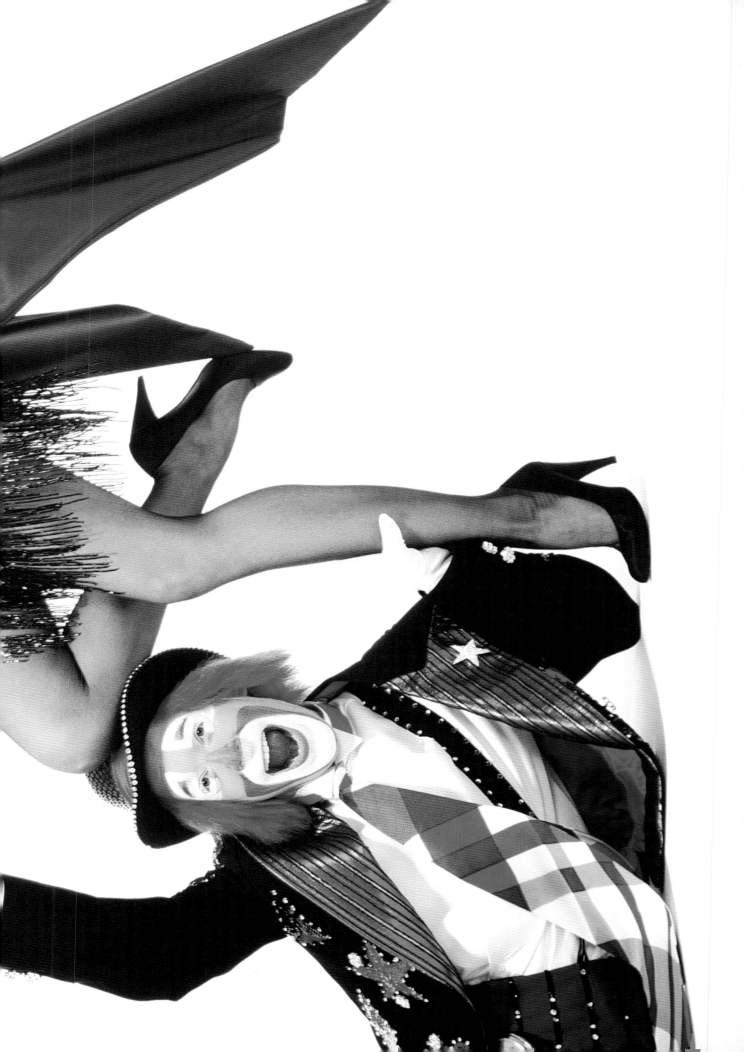

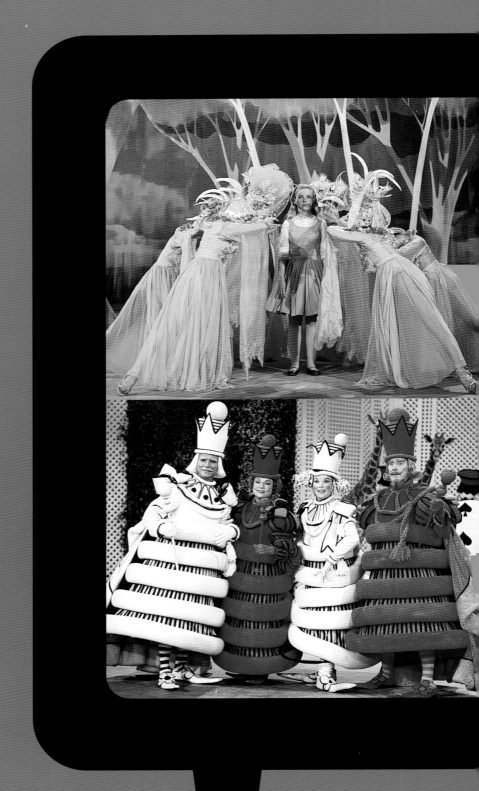

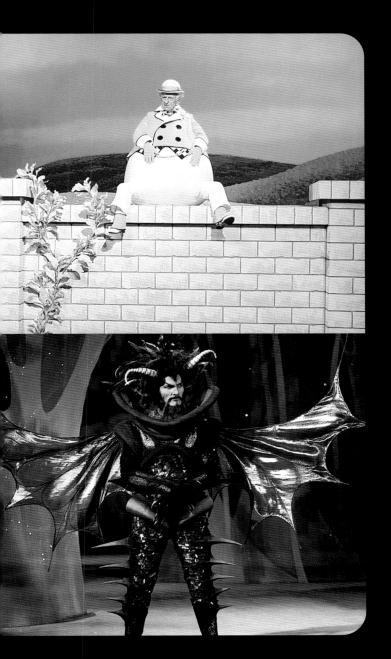

Bob Mackie and Ray Aghayan struck gold four years after their fortuitous meeting with the all-star version of *Alice Through the Looking-Glass,* starring Judi Rolin as Alice. They created costumes as dazzling as anything ever seen on television—fanciful designs that were too sophisticated for children to fully appreciate. They dressed a then-sexy Jack Palance as a glitter-clad Jabberwock, lamé wings outstretched to menacing effect. Jimmy Durante was the oversized, ovoid Humpty Dumpty in a bowler hat and spats. Robert Coote, Ricardo Montalban, Nanette Fabray, and Agnes Moorehead, ringed in foam rubber from neck to ankle, looked like puffed-up chess pieces as the white and red kings and queens. The show won the first Emmy ever given for costumes on television. Perhaps because he was so successful with *Alice*—or because his proclivities for glamour so fitted the form—Mackie made designing specials something of a specialty, particularly TV adaptations of Broadway musicals.

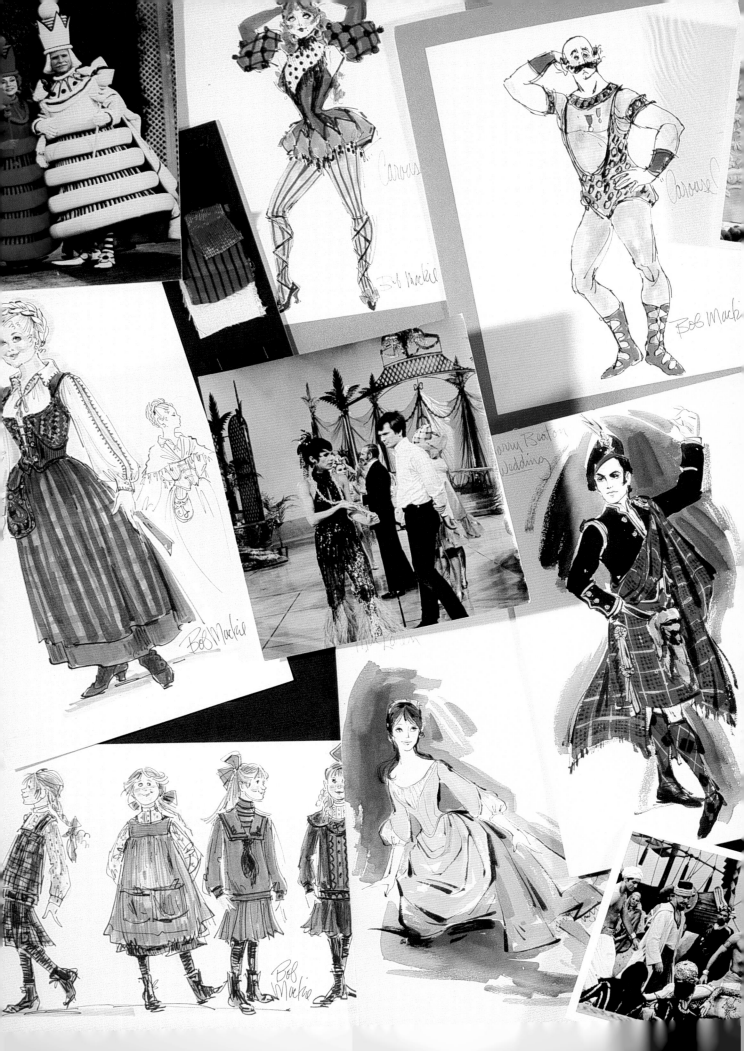

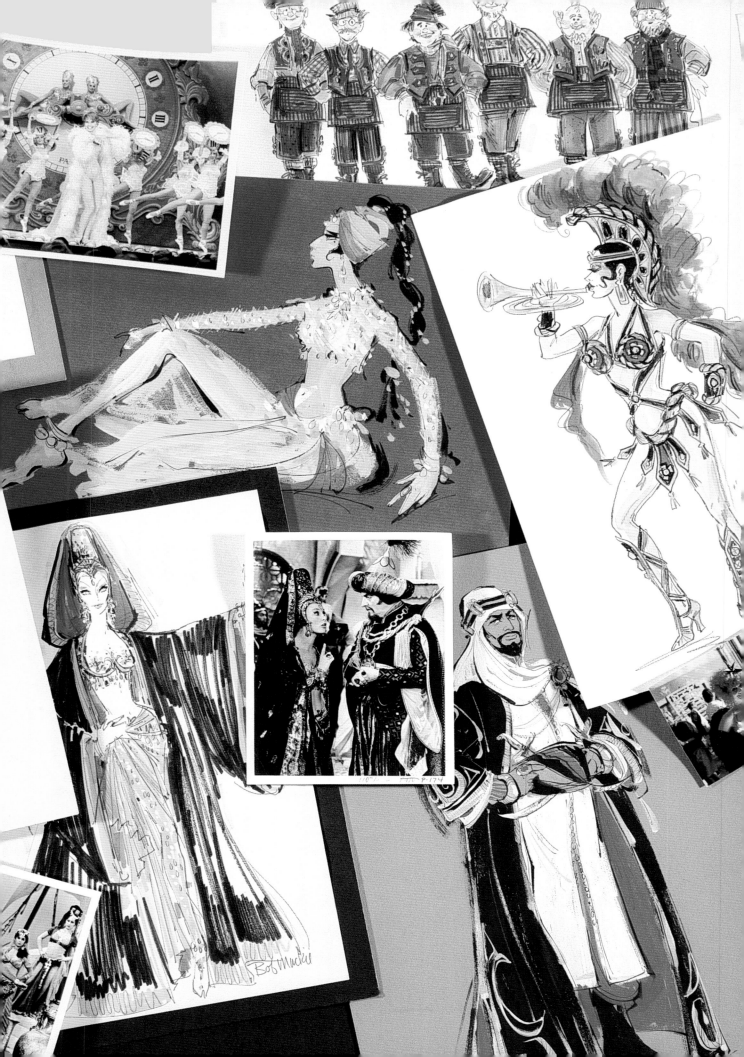

Bob Mackie

110% — P-174

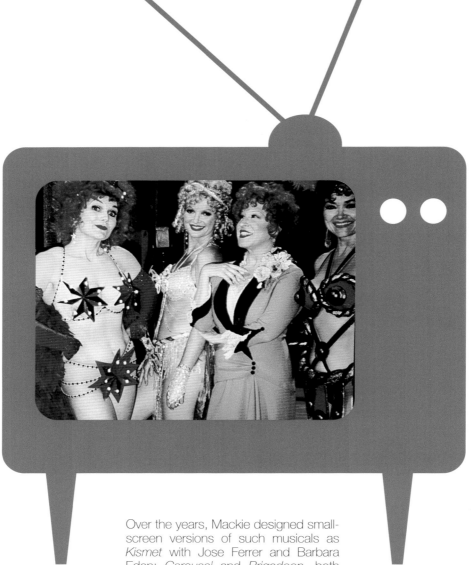

Over the years, Mackie designed small-screen versions of such musicals as *Kismet* with Jose Ferrer and Barbara Eden; *Carousel* and *Brigadoon*, both starring Robert Goulet; *Once Upon a Mattress* with Carol Burnett; and, in 1994, **Gypsy starring Bette Midler** with Ann McNeely, Christine Ebersole, and Linda Hart. A show for which Mackie received great reviews and an Emmy nomination, *Gypsy* was the best looking of the lot, the designer says. "It was very very much in the mood of the original, which is what they wanted. Bette realized that dressing in the twenties style was fun and she looked good in those kinds of clothes and that hair. She looked like the period. It wasn't always altogether glamorous, which was a little hard for her to deal with, but at the same time she understood what she was doing."

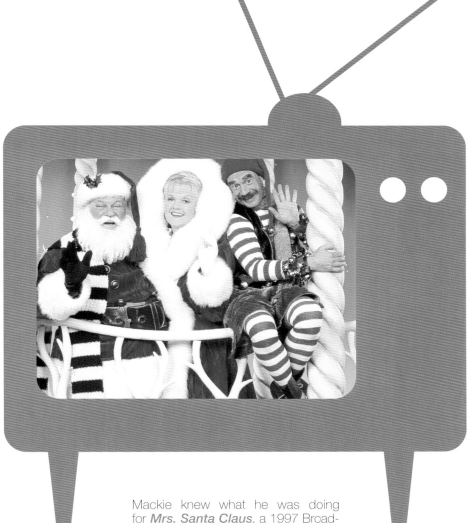

Mackie knew what he was doing for **Mrs. Santa Claus**, a 1997 Broadway-style musical written for television by Jerry Herman and starring Angela Lansbury along with Charles Durning and Michael Jeter. The show garnered him another Emmy nomination. "It was fun to do an original show like that with Angela, who is perfect," Mackie says. "I enjoyed it, but it was hard. We were doing New York in December on a Universal back lot and it was 110 degrees and all these people were about to pass out in their furs and wool coats in all this fake snow. Try keeping mufflers around people's necks and looking cold when it's literally 110 degrees out." But the cast looked great. "Bob's character work was extraordinary," Lansbury remembers. "Everyone was perfectly turned out."

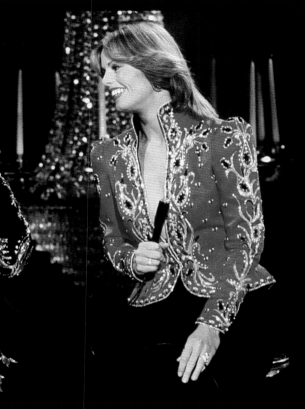

Over the years, Mackie's talents have helped glamorize TV specials, spotlighting talents as diverse as Ann-Margret and Beverly Sills, Dolly Parton and Julie Andrews, Lynda Carter and Peggy Fleming, Ella Fitzgerald and Toni Tennille. The shows he designed were some of the most special specials of the Baby Boom era. Among them were *Bubbles and Burnett at the Met*, starring Sills and Carol Burnett, *Pure Goldie*, starring Goldie Hawn and Liza Minnelli, which featured the duo singing "All That Jazz" from *Chicago*, and Midler's famous 1977 special *Ol' Red Head is Back*, which opened with the buxom singer emerging from a giant clam shell to the overture from *Oklahoma*. "She'd done that on Broadway in her *Clams on the Half Shell Revue* but she was dressed differently," Mackie recalls. "She had a little sarong on. I had her coming out dressed in coral and pearls instead—all underwater glamour. Her body looked great and she was wearing almost nothing." Certainly, it was risqué for the time. These specials, like the weekly variety shows upon which Mackie found his greatest acclaim, are now all but extinct on television—too hokey and earnest for contemporary audiences craving irony. But they brought Mackie four of his seven Emmy awards. Outfitting a woman he calls "a very supreme Supreme," Mackie won for *Diana Ross & The Supremes and The Temptations on Broadway* in 1970. Then, creating costumes for Mitzi Gaynor, he won two Emmys—one for *Mitzi Roarin' in the '20s* in 1976, and another for *Mitzi Zings Into Spring* in 1978. And, sixteen years after the final episode of *The Carol Burnett Show*—a sartorial tour de force for which he was nominated for Emmys but never won—Mackie earned one for *Men, Movies & Carol*, a 1995 special that allowed Burnett to employ her talents for film parody once more. A few years earlier, he'd won for a 1991 episode of *Carol and Company*, Burnett's short-lived comedy anthology series. In 1987, he also nabbed an Emmy for *Mama's Family*, on which Vicki Lawrence reprised her role as confederate battle-ax Thelma Harper, Eunice's blue-haired mother from *The Carol Burnett Show*. That show laid the groundwork for so much he would do.

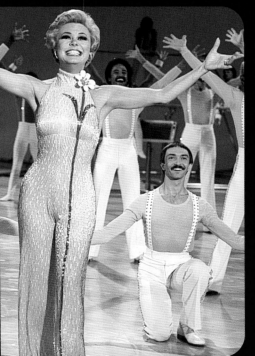

mitzi

You were Bob's first big celebrity client. What was his prescription for you?

When we first started to work together I had a 22 1/2-inch waist and a perfect hour-glass figure. My head size and my waist size were the same. He played that up. He said you always have to show the legs. Then there are Mitzi colors— a certain kind of pink and aquamarine. He likes to use yellow on me. And that's bad luck in show business, so we started calling it gold. Bob has had a great deal to do with my career. Once, I was working in Columbus, Ohio, and the marquee read MITZI GAYNOR WITH HER BOB MACKIE COSTUMES. When you say his name, it's hallowed.

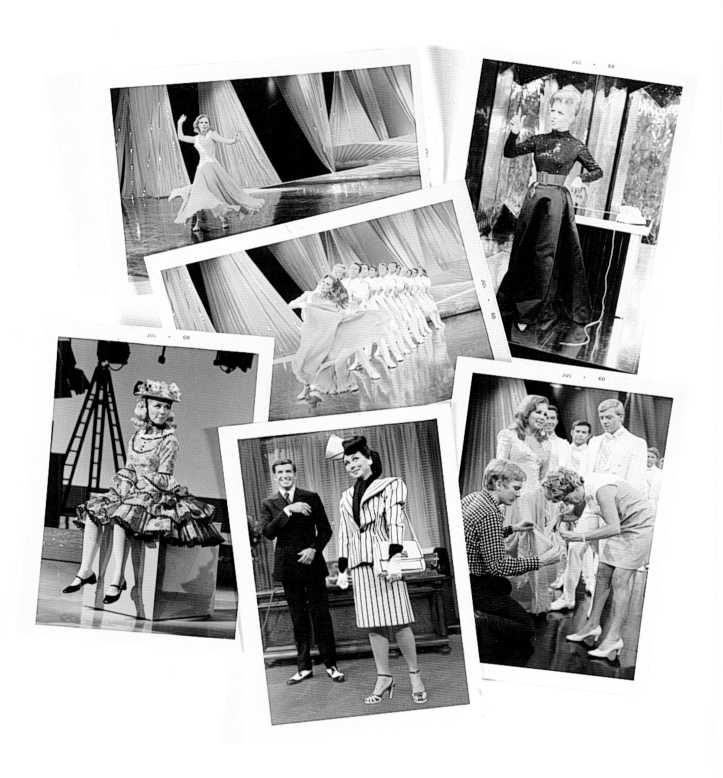

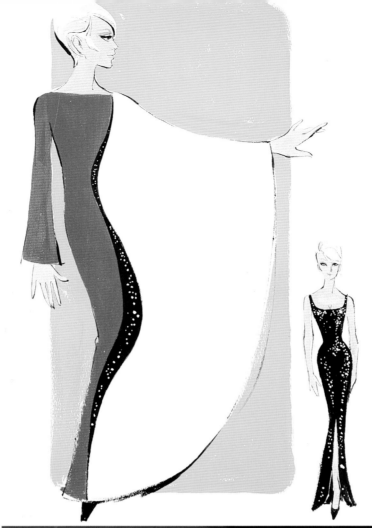

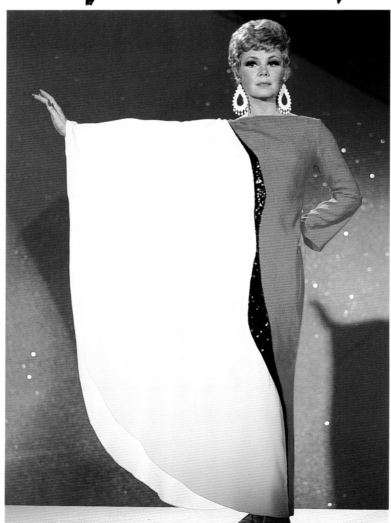

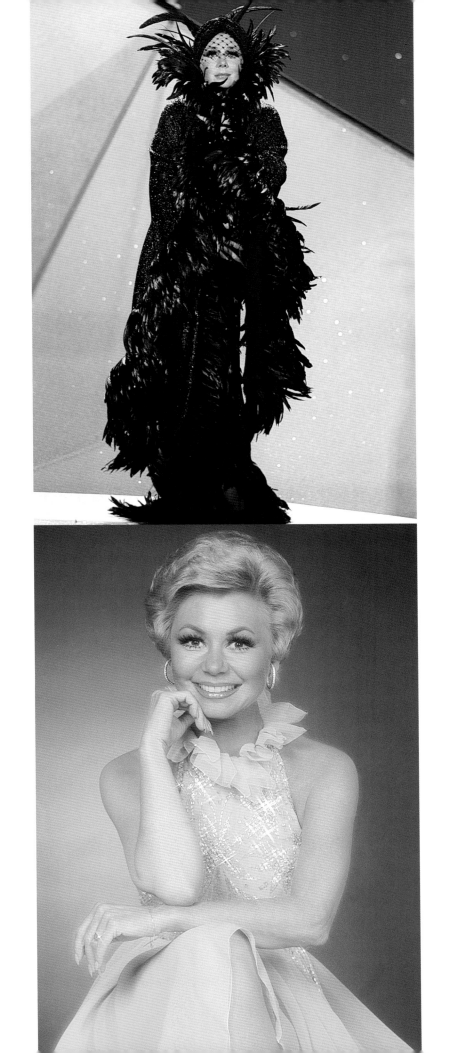

What's your favorite Mackie?
Favorite? Oh God, it could be my seventeenth-century mazurka or a Marie Antoinette costume. He did a little black dress—ha ha—high in the front, low in the back, with short sleeves. It was totally beaded with a red petticoat that I could twirl in. He has this blue he calls Milk of Magnesia–bottle blue. He used it for a skirt that went with a kind of bolero jacket with multicolor beads for a Latin number. He also did a long, swirly kind of dress in the shades of my skin—hello. And after that a sailor suit; guess why.

How did you two meet?
My agent called and said that Danny Thomas was going to be doing a TV special and asked whether I would like to be on it. I had just come back from Brazil, and I thought that it would be fun. The other guests were Sonny and Cher and Jim Nabors. So I was sent to meet the costume designer and it was Ray Aghayan who showed me sketches. I said I'd never seen such costume sketches in my life. Not only were they gorgeous, they were fun and funny.

Were they Bob's sketches?
Exactly. So now I'm in love with Ray Aghayan. I said, "I want you please to do the costumes for my new show." And he said, "I can't, because I'm up to my you-know-what with Judy Garland. But do you remember those sketches I showed you? He's your man." So I had an appointment with this guy, Bob Mackie. He came to see me, and I thought he was just one of those kids wanting my autograph. I said you're only twelve years old, for God's sake. But he was charming, and you know how beautiful he is. He's a tall Brad Pitt. Remember when Van Johnson was young and beautiful? Well, Bob practically did the show in one afternoon, and that's more or less how I met him. I ended up doing nine or ten specials of my own, all of them with Bob.

What's he like to work with?
He is not only a costume designer; he's a director, a producer, a choreographer, a writer, a vocal coach, and a dramatic coach. He's always there for you. If he's hanging from one foot off the Empire State Building pinning someone's hem on a shoot and you call him and say, "I need a ball gown by 4:30 this afternoon," he's there for you. The man has absolutely no attitude. He's just as nice to the lady who cleans the john as he is to the biggest star. I've seen him upset maybe three times, and I met him in 1966. When he gets mad, he casts his eyes up to God, although I'm sure there are holes in walls someplace.

What does it feel like to wear a Mackie?
When you're having a fitting you're usually worried about your big fat ass, but when Bob Mackie designs something for you, he's painting in beads and crystal. He's creating art. It's wearable art. It really is. Your dresser will stagger carrying this thing that weighs fifty pounds—fifty pounds of crystal. But then you put it on. The way it's constructed, it's perfect, and it'll last for forty years. It's no Joe Dinner with him. It's worth every penny.

You wear his clothes in real life, too, right?
Yes. If it's a really good party, I'll wear a Bob Mackie dress. If it isn't, I'll wear somebody else's. **You were the first Mackie glamour girl. How do you like his designs for his latest—Barbie?** Oh, I think they're charming. Hell, I've worn all of those.

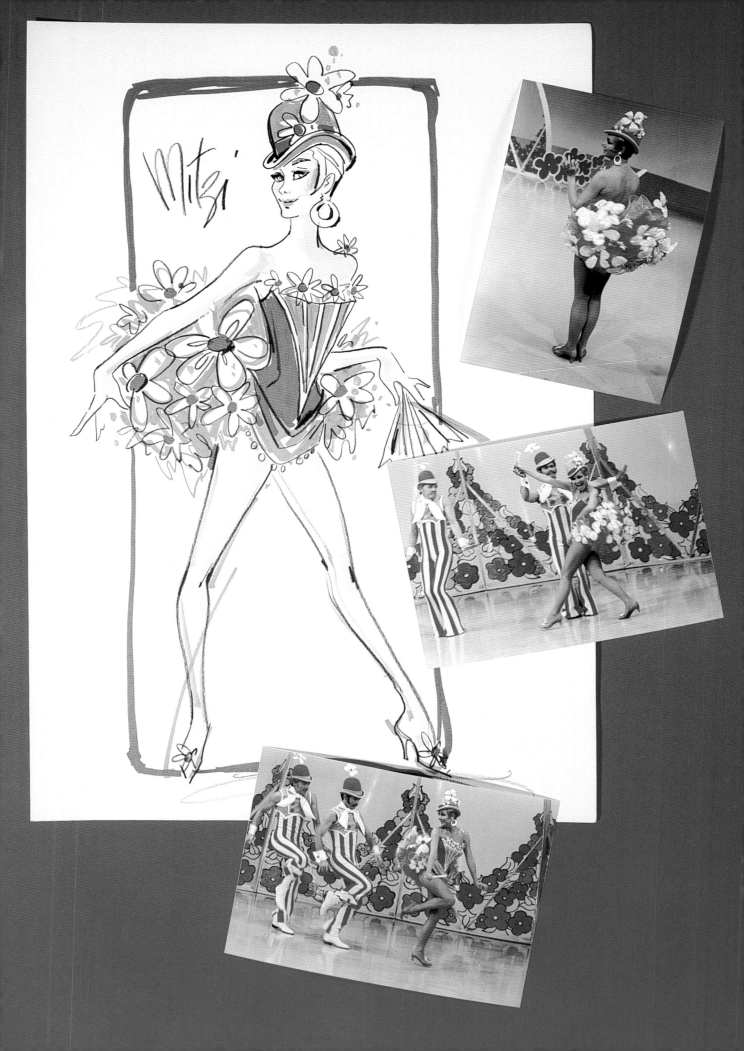

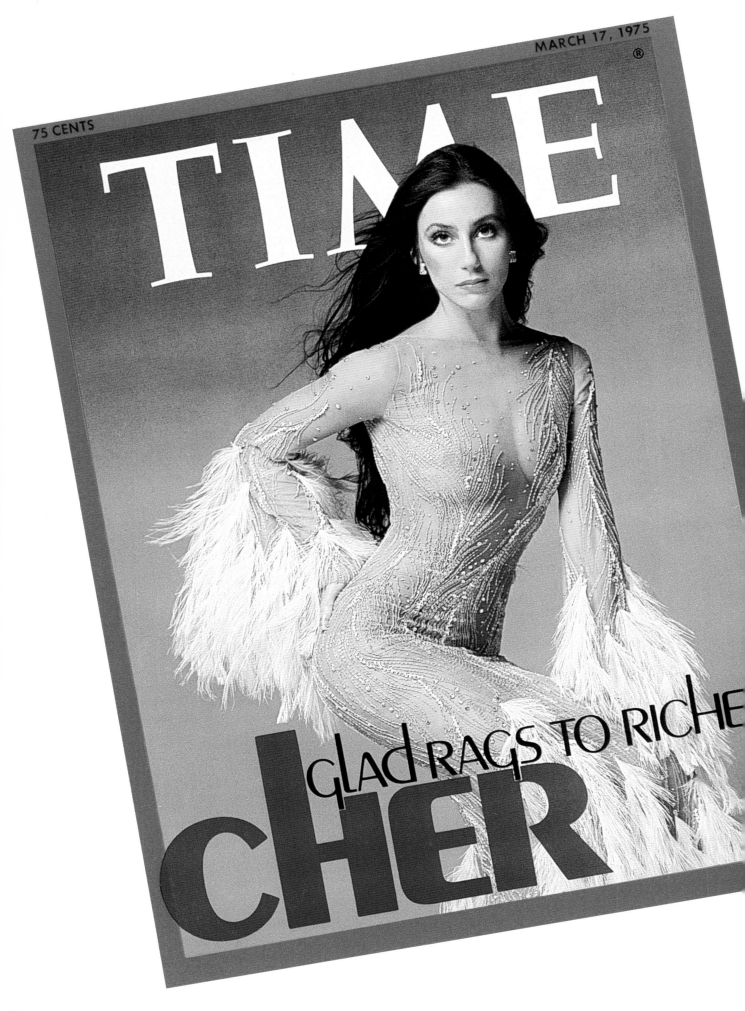

MARCH 17, 1975

75 CENTS

TIME

GLAD RAGS TO RICHE

CHER

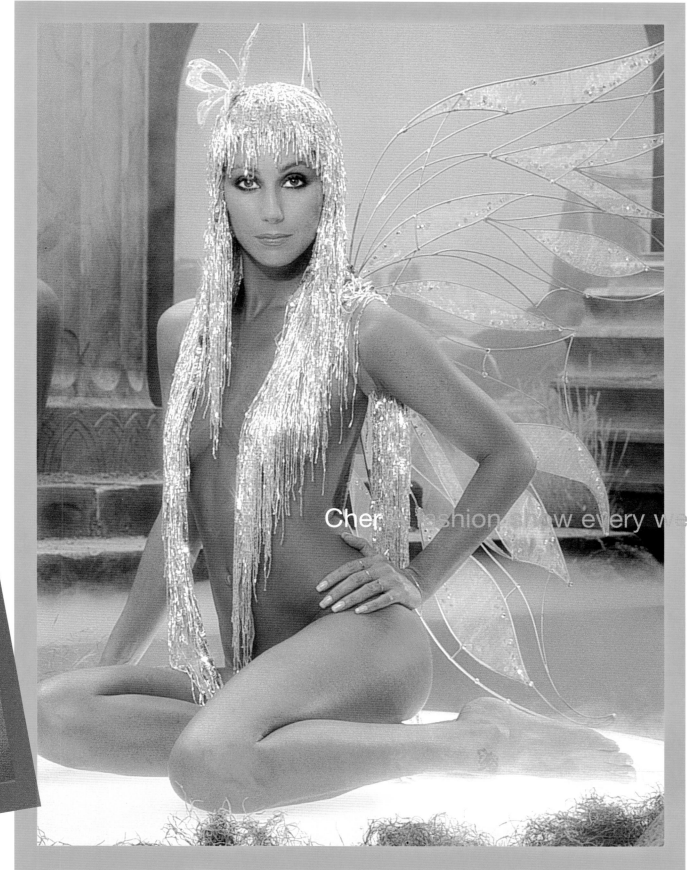

Cher fashion show every week

In Cher, Bob Mackie found the perfect mannequin and his ultimate muse.
A perfect size six with not much cleavage—built much like Carol Burnett, although no one but Mackie has ever noticed the similarity—Cher was a human hanger who wore even the wildest ensembles with drop-dead nonchalance. "She used to just stand there with her hands on her hips like she had jeans and a T-shirt on, no matter what it was," Mackie recalls. It was just what the clothes needed to look their sexiest. For *The Sonny and Cher Comedy Hour*, beginning in 1971, Mackie played peek-a-boo with the censors. Outfitting Cher in clothes that revealed more than they hid, he capitalized on her exotic good looks. One critic said Mackie had "transmogrified Cher Bono Allman from bellbottom funky to TV's answer to Dietrich." She could become a "Dark Lady," the most glamorous gypsy, tramp, or thief, or even an Indian princess in a beaded loincloth lamenting (and ultimately embracing) her heritage in "Half Breed." In sketches, Cher would dress as Olive Oyl, all gangly limbs and clunky shoes; Lady Godiva, with major hair to keep her modest; sizzle-hipped Sadie Thompson, a vamp just out of the "Rain"; or Laverne, her most enduring character, whom Cher took with her to her eponymous solo show after divorcing Sonny Bono in 1975. With its star alone in the spotlight, the *Cher* show became an all-out fashion extravaganza that ran for almost eleven months on CBS. For Mackie, it was a forum for his most undiluted creativity. Even the show's set looked like a fashion runway. The clothes became a national obsession, furthering Mackie's hold on our imaginations. Perhaps the most extremely glamorous number he ever created for Cher found the singer reclining on a divan in a sheer costume with leopard embroidery; her long, long wig wrapped in the trees behind her. A live panther was to cross in front of her as she started to sing. "We started pinning the gown to the settee and pulling it tighter and tighter. Then we thought, 'What if the panther attacks her, she can't move.' She had that entire piece of furniture attached to her. Thank heaven, the panther just walked by, they put it in a cage, and she started her song." Such risky moves paid off for both performer and designer. Harry F. Waters, writing in *Newsweek* in February 1975, suggested that Cher's costumes were in fact the real draw of the series. The critic said the singer played "second banana to the show's real star—a cool, hip, certifiably freaky costume designer named Bob Mackie. Television hasn't shown so much glitter and flash since NBC did a special on Liberace's closet." Concluding his review of the Cher show's first episode—a landmark special that guest-starred Bette Midler, Elton John, and Flip Wilson—Waters wrote, "If she does indeed make it, Cher should reserve most of her thanks for the miraculous Mr. Mackie."

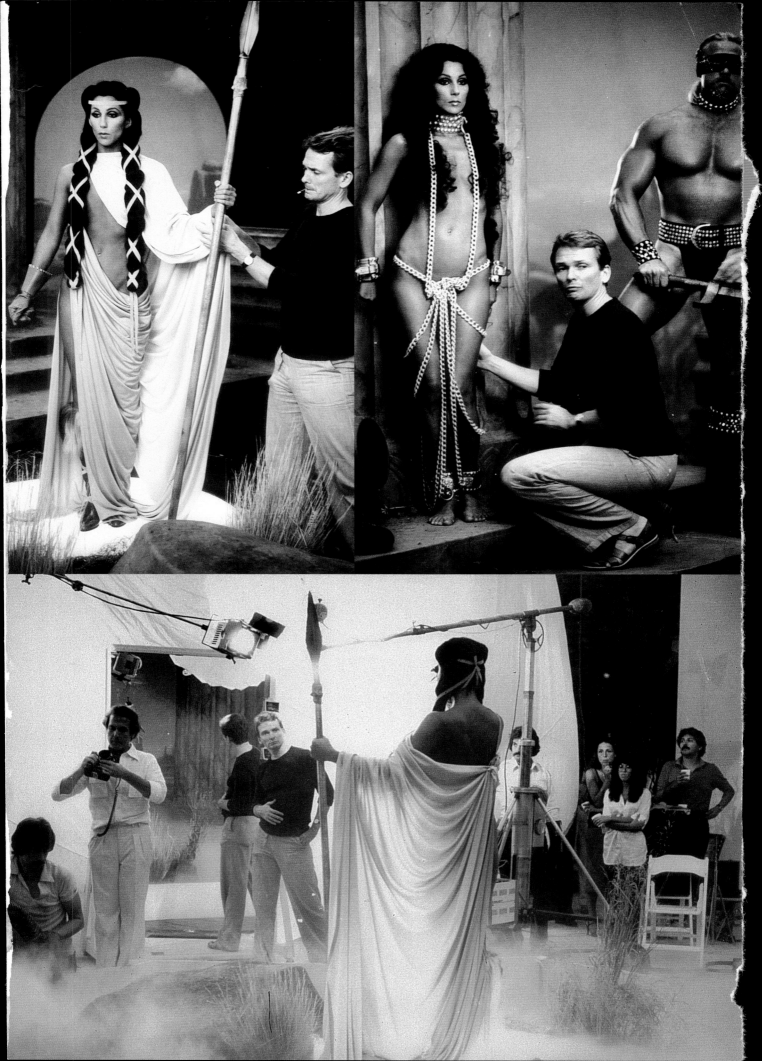

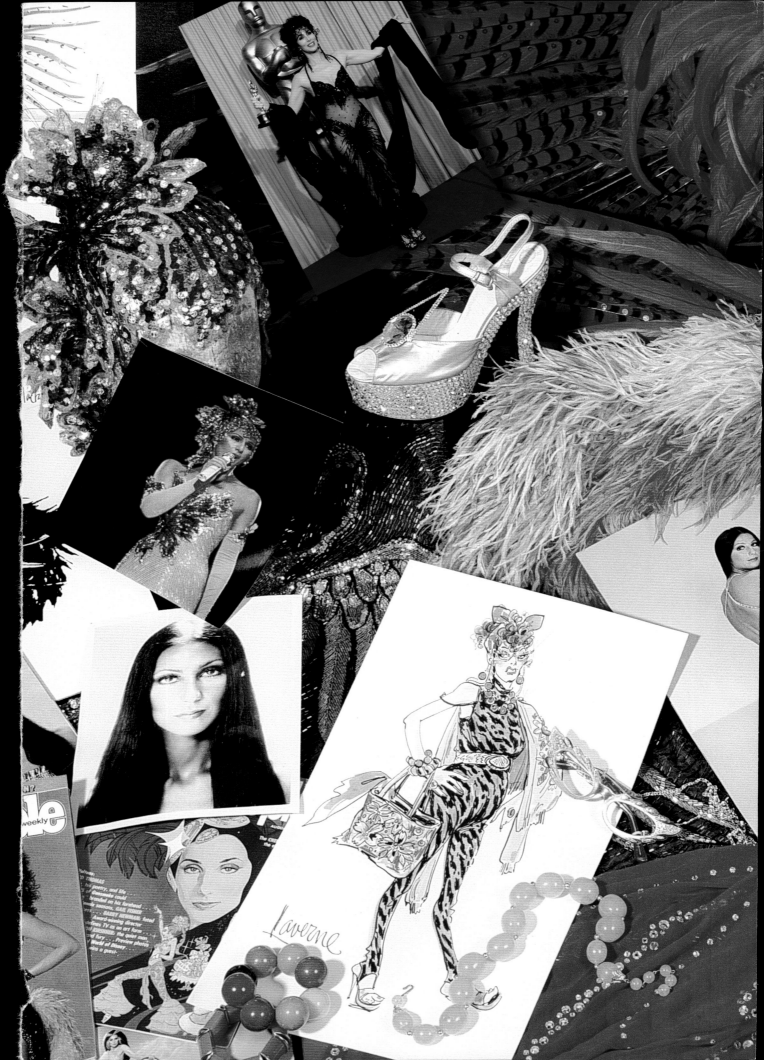

Laverne

Not everyone, however, was sold on Cher's racy clothes. The censors drove Cher crazy. "Most shows have only one censor in the studio and we've had as many as five," she told *TV Guide* at the time. "People can watch a show and see kids stealing hubcaps and then they can go out and steal hubcaps, but I don't think my show will ever provoke anybody into stealing a bellybutton." The biggest uproar came from the CBS affiliate in Cincinnati, which dropped Cher's show from its schedule. The station's general manager, Bob Gordon, harrumphed, "I object to the total emphasis the lady seems to have on her way of dressing." Likewise, the August 1975 issue of *Rona Barrett's Hollywood*—a Tinseltown tabloid built around that decade's leading gossip maven—claimed that a shocked public wanted to know, "Have Cher's dreams of glamour overstepped the bounds of reason?" They hadn't, of course, but the magazine got one thing right. "It's interesting to note that Cher creates 'nervous anticipation' from those who approve her outfits and those who do not. Those who approve wait in breathless ecstasy to see what eye-popping, mind-boggling, and sexy costume Cher will appear in each Sunday night. Those who don't approve wonder and worry whether her gowns will accidentally show more than Cher—or Mackie—intended to show." The designer made sure Cher didn't bare it all, of course, sometimes using toupee tape and eyelash glue to keep her outfits in place. Often covering the singer in flesh-colored fabric, Mackie gave audiences the illusion they were seeing everything, but they really weren't. As Cher said at the time, "What you see is a lot more than what you get." Mackie admits today, however, that the clothes were risqué. "Her skirts were cut so low, people thought, Where'd she put it—she was so long-waisted. After a few years," he adds, "there was nothing left to show."

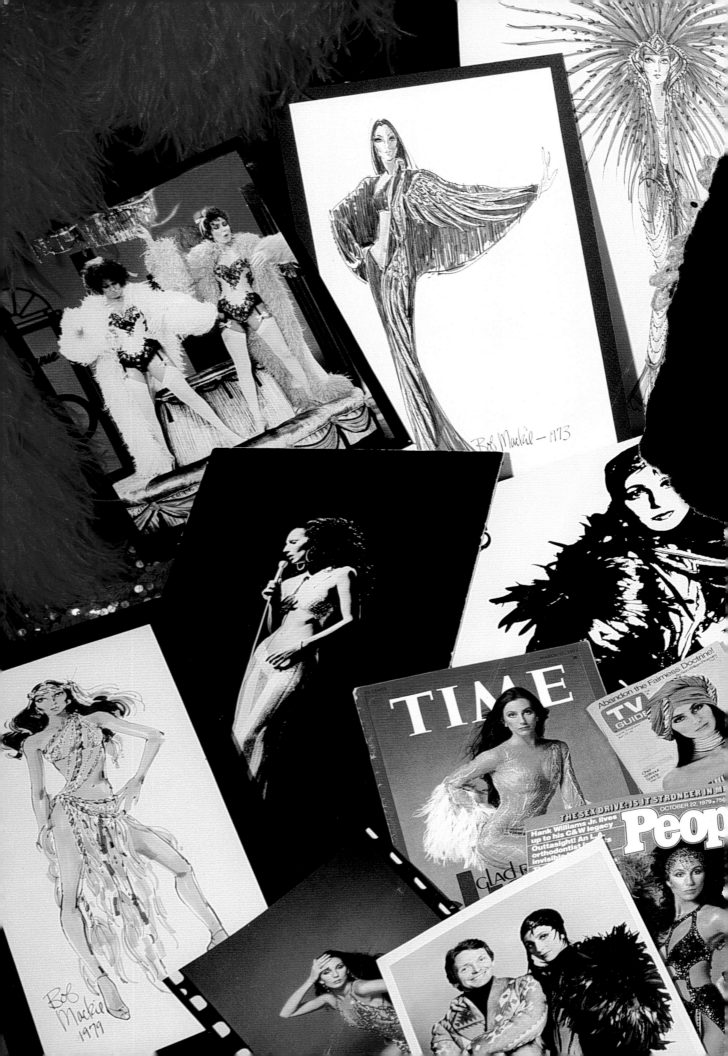

The Cher/Mackie partnership has been one of
the only constants in the singer's ever-changing
career. It has resulted in some of Mackie's
most famous outfits. The see-through
gown she wore in *Vogue* and on
the cover of *Time*—a
$5,000 confection said
to have taken seven
seamstresses ten days
to sew up—caused
a sensation when
Cher wore it to
the opening of
the Diana Vreeland–
curated costume show,
*Romantic and Glamorous
Hollywood Design*, in 1974. Eight
of Cher's outfits were on display, but
the one she wore that night took the cake.
People magazine, in its December 9, 1974,
issue, put it best when it quoted veteran direc-
tor Joshua Logan (*South Pacific* and *Camelot*) as
saying, "I saw the whole show through her legs
and it was terrific." **E**leven years later, a more
demure Cher returned to the Met in another
Mackie creation for the museum's fourteenth
annual Party of the Year, celebrating Vreeland's
Costumes of Royal India exhibition. *Newsweek*
reported in its December 23, 1985, issue,
"Cher chose to dazzle the crowd of nine hun-
dred with a textile display of her own: pearl-
studded see-though silk threads by
Hollywood designer Bob Mackie." **T**hen
there was the seat belt and a yard of
mesh Cher wore in her 1989 video
for "If I Could Turn Back Time," in
which she reveals the tattoos on
her derriere for an entire fleet
of sailors to see. Thanks to
Mackie, Cher dressed
as Cleopatra to
launch her fragrance,
"Uninhibited," in
November 1988.
"She wanted
s o m e t h i n g
Egyptian and
she wanted
s o m e t h i n g
wild," Mackie
recalls. **T**hen, of
course, there
were her dresses
for the Oscars.
Whether she was
working a Mohawk
headdress, as in 1986, a
Grecian-style gown like the
one she wore to collect a Best
Actress statuette for *Moonstruck* in
1988, or the peach-colored number
with the giant hat she wore ten years
later, no one has ever dressed more mem-
orably for the occasion. That last night, *USA
Today* decided "Cher proved she can still wear
Bob Mackie like nobody else." As the singer's
career has risen yet again—thanks to the success of
"Believe"—she has remained true to the couturier she first
worked with so long ago. Cher hasn't changed and neither
has Mackie. Together, they still live by the dictum, "Never be in
one dress longer than eight minutes."

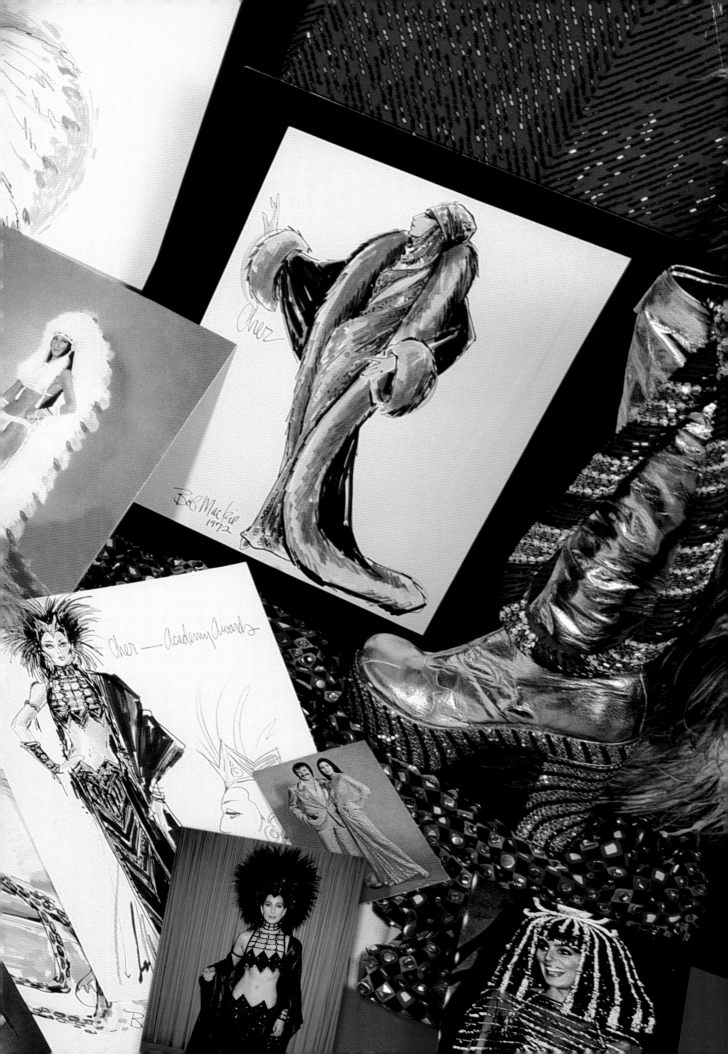

Cher

Bob Mackie
1972

Cher — Academy Awards

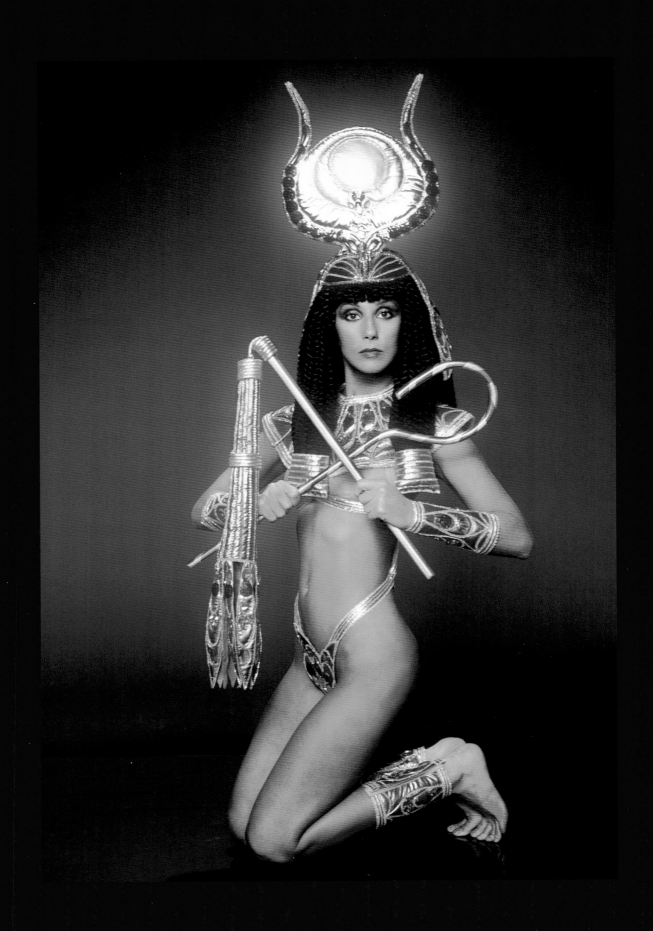

Some of the finest work Bob ever created was for *The Sonny and Cher Comedy Hour* and the *Cher* show in the seventies. What were those years like?
We got together every Wednesday night. I'd just stand there and he'd hang clothes on me. Every week, dress after dress would come in and I would "ooh" and "ah," and he would always laugh. It never occurred to me that we were stockpiling this essay on costume. I didn't realize we were making an impact on fashion, but I know half the women in the audience watched to see what I was going to wear.

rsation with Cher

You were a perfect mannequin for Bob's designs.
Raymond [Aghayan] called me Bob's Barbie doll. Whatever Bob did, I was right for it. We always had a meeting of minds. I was never nervous about the clothing, so he didn't have to limit himself. There was nothing he designed that I wouldn't wear, and he never ran out of ideas. After we started working together, he just knew what I'd like. He walked the line between fashion and costume, and that's my favorite place to go. In the whole time we worked together, I probably didn't like only about two things he had made.

No matter how outlandish the design, you always looked comfortable in it.
I would put his clothes on, and I would still feel like I was in my own skin. I never had to worry that if I walked one way the dress was going to walk the other way. He knew the importance of fit. And the clothes were so beautifully made; you could turn them inside out and wear them. It's hard to be impressed by other designers' work when you've had Bob make something for you.

Your *Sonny and Cher* show costumes were very risqué for the time.
I was the first person to show my belly button on TV.

And what a belly button! Your navel became a national obsession. But I remember Bob saying that you also had the most beautiful . . .
Armpits. That was very important. I know that's very important for the way clothes hang.

We've all seen the pictures, but tell us about the Oscar dress the year you presented Don Ameche with his award. It's one of the most famous ensembles in the world.
Bob kept saying, "Are you sure you want to do this? Are you sure you want to do this?" I was a little nervous, but then thought, "Fuck it. This is what I want to wear." The costume was like something for a beautiful Mohawk warrior. He made me a breastplate out of these beautiful jet beads and a head dress that was made all out of feathers. I came waltzing out of the bathroom in it, and I think my date just about shit. If John Galliano or Dolce & Gabbana presented that dress as a bridal gown in one of their fashion shows, people would stand up and cheer.

You've taken a lot of hits for what you've worn to the Oscars.
The bigger the target, the more trouble you're going to get. But people who are big targets make other people braver. It's not about the clothes; it's about personal freedom and not being afraid to try something. Most of the people who are laughing at my style I wouldn't let buy me a pair of socks. Besides, you don't remember what anyone else was wearing, do you?

You've criticized Bob's most recent fashion shows as being too conservative.
He went into fashion and he should have gone into costume fashion. He tried to fit into something that he's really not. He can't be tied down to earth, he's too talented.

What would you suggest instead?
I think he should do one show that doesn't try to figure out who his audience is and make a bunch of clothes as though he were just making clothes for me. He should do exactly what he wants and make it insane and take it to the wall, because that's where he shines. That's what all these other guys are doing, and they don't do it as well as he does.

The Council of Fashion Designers of America decided to honor you in 1999 for your contribution to fashion. Do you feel vindicated?
I think it's brilliant. It's great, but the truth is, I don't really need to be vindicated. I don't need people's permission to be me. I was doing really cool stuff when people didn't think it was cool, and if they didn't get it, they didn't get it. When you go out on a big limb, you can't expect everyone to like what you're doing.

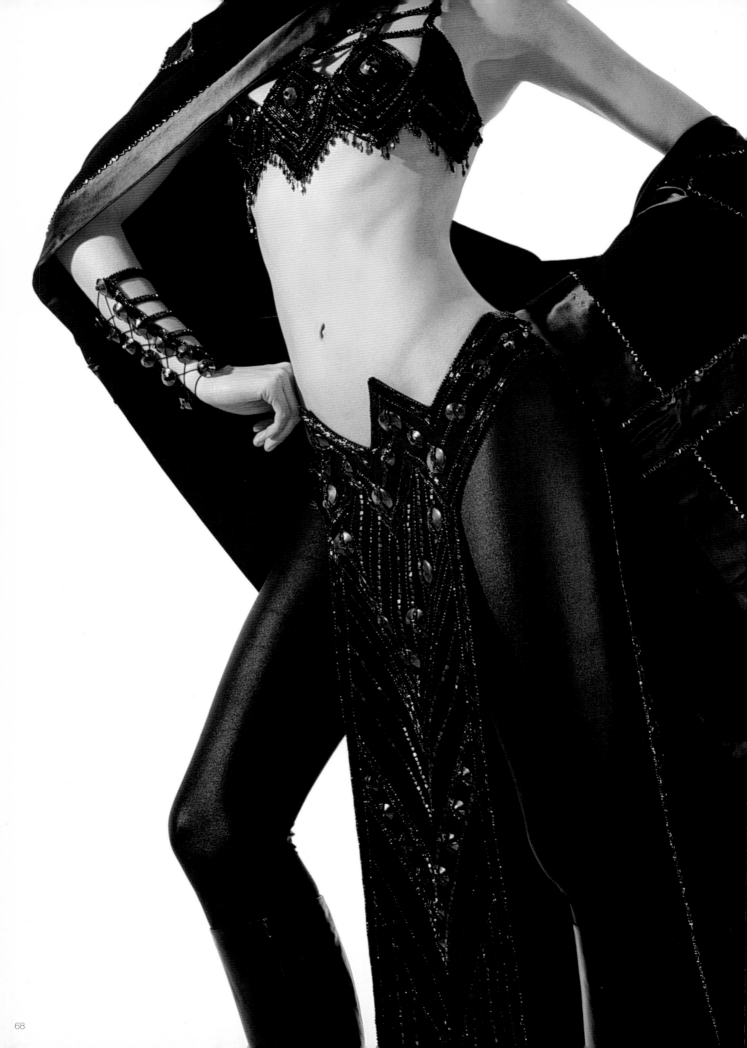

The 1975 *Cher* special with Bette Midler and Elton John, which was a preview of her solo series, was an amazing hour—so much fashion and music. What do you remember about it?

Cher was terrified. It was her first big outing by herself and having those people on was just amazing. Although they were famous then, Bette was almost underground. She had her records out and everything but the average American didn't see a lot of her. And Elton was just a perfect guest. It was a wonderful coming-together. The three of them really made it work.

Cher didn't do as many characters as Carol, but Laverne Lashinsky, the wisecracking "At the Launderette" lady in the tiger stripes, is certainly memorable.

Cher just fell right into that character. She had it down the first time she did it. We basically just tried to make her as tacky as we could. It was the whole laundromat thing she did with Teri Garr. That's how the whole character started. She had on those sort of gold clogs without a back on them and the padded body and the bra strap hanging out from the jumpsuit. Then she had a lime green sweater that had flowers embroidered all over it and a big straw bag with stuff all over the side of it. Her hair was all wrapped up. It was all the bad-taste things we could think of in the seventies. She was such a good contrast to the real Cher, who in her own way was very pristine and so clean with that long hair and slim body and sleek kind of clothes.

Did you ever think those clothes would be considered fashionable?

The Laverne clothes? Well, no. But shortly after that, leopard came in all of a sudden in a big way and everybody started getting very cheesy. People were beginning to embrace the real trashy end of fashion. I used to laugh, thinking, "Poor Laverne doesn't stand a chance now. She looks too much in fashion." The flowered rag around the head and the whole thing—that was before Madonna.

In 1974, you and Cher attended the opening of the *Romantic and Glamorous Hollywood Design* exhibition, which featured your clothes. How did it happen that you two caused such a stir?

Cher was like, "What should I wear to this party?" Well, we had tons of clothes, but she wanted to wear her new dress. Her new dress was done just for a shoot with Richard Avedon for the 1974 Christmas issue of *Vogue*. I said, "You can't wear that in public; you can't walk around like that with all those people there." She said, "Why not? It's my new dress." So I said, "Alright, go ahead." And she did. It was one of those dresses where you thought you could see everything but you couldn't see a thing. Well, nobody really wore see-through dresses in those days and she looked so amazing in it. The next day, she was on the cover of every newspaper—I mean all over the country. I've never seen such coverage. Marisa Berenson, who was the hot star at the time, Bianca Jagger—all the designers were there and they all got no coverage. Nobody got anything but Cher.

If that dress was memorable, the one that Cher wore to the Oscars in 1986 is legendary. It's probably your most famous costume. Tell the story of that one.

Cher didn't get nominated for *Mask* and she didn't get nominated because she was Cher, not because she didn't do a good job. She was pissed off. But they wanted her to be a presenter. She knew what it was going to be for and she said, "They haven't seen me in a long time and I still look pretty good, so let's really do something." She was presenting an award to Don Ameche and I said, "Don't you think this is a little bit much? Don't you think you'll be pulling focus from poor Don Ameche?" And she said, "Oh, he won't care." She has that instinct. She knows how to get her picture. And they're still printing pictures of that thing.

At the time it caused quite a scandal.

The next day, people were giving me grief, saying things like, "How could you design such a thing?" Like it was just up to me to put that on her. You don't put that on someone without them wanting it awfully bad. But it was not a dress—fashion people treat it like it was a dress—it was a get-up. She was thumbing her nose at the Academy. That year there were a lot of rules about what you were supposed to wear and what you were not supposed to wear and what colors and Don't do this and Don't do that. And all you have to do is tell that to Cher. She's the eternal adolescent who would just do the opposite of what her mother tells her to do. And she's still like that.

What about the dress Cher wore in 1988 when she won the Oscar for *Moonstruck*?

It was kind of like a 'teens dress—like 1915 or something. It was a hybrid. It was not an authentic re-do of that period, but it certainly had that feel. It wasn't Erte really. It was more neo-classical. It had a big stole with big tassels on the end. The embroidery, the gunmetal, the crystal, and her hair were all kind of Grecian. Even though it was a gimmick, she looked quite beautiful in it. I told her not to wear a big hat, so she still had something in her hair but it looked like part of the hairdo.

What about the outfit she wore in 1998, the one *with* the big hat?

Well, that was just Cher wanting to wear something different, like she always does. She didn't want to be in black. So it was sort of nude and crystal. It had a sort of a First World War quality. It was quite peachy but you couldn't really tell. She'd been watching *Out Of Africa*, and there's some hat Meryl Streep wears at a New Year's Eve party in the movie. She wanted a hat that was shaped like it. All anyone ever saw was the hat; that's all they remember. It's like, "Why did she wear that hat?"

What gives Cher the courage to wear these clothes?

Halloween is her favorite holiday. So she likes to dress up and get people to go, "Oh, it's terrible how she looks." I think it's been that way ever since she went to the costume thing at the Met and got so much attention. She never quite got over that night.

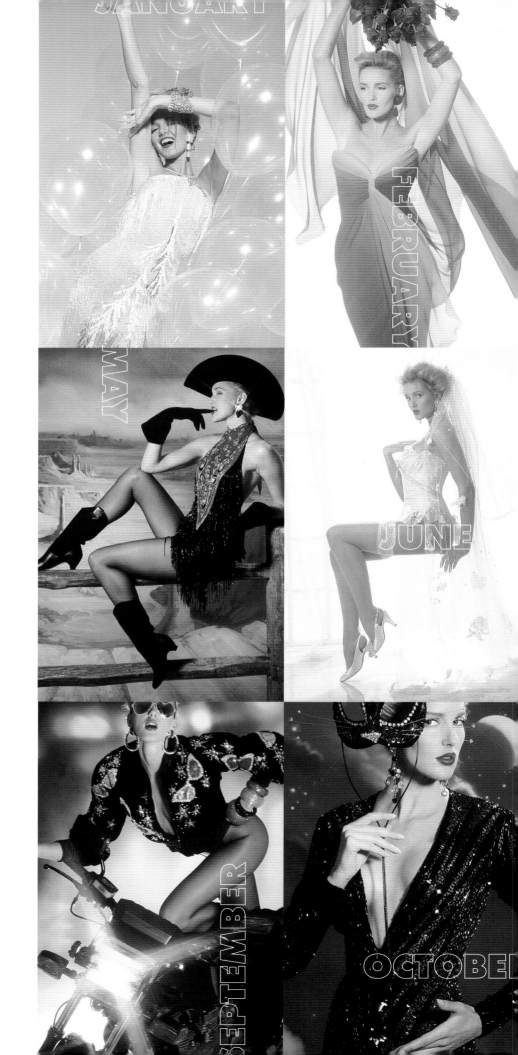

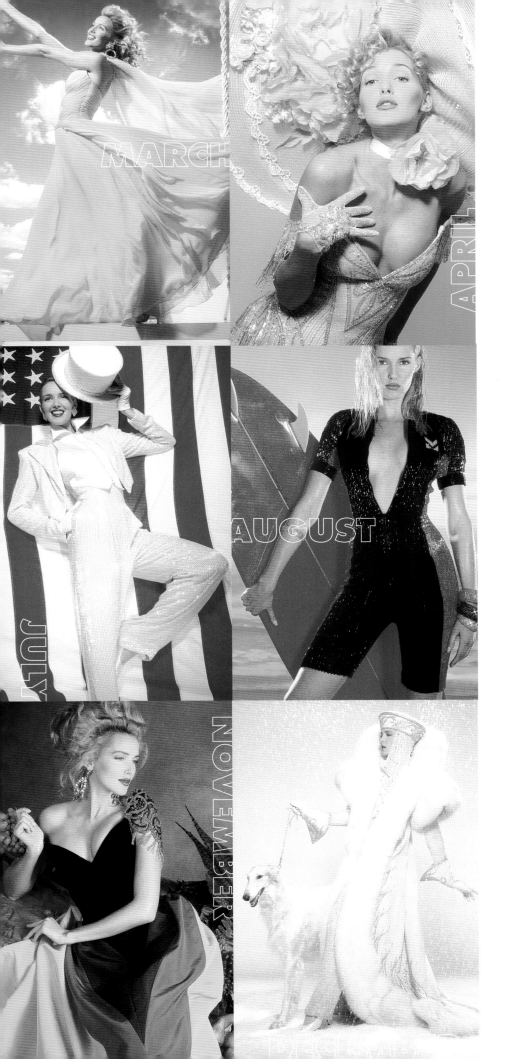

MARCH

APRIL

JULY

AUGUST

NOVEMBER

I saw it in the Win

and I just couldn't resist it

Carol Burnett

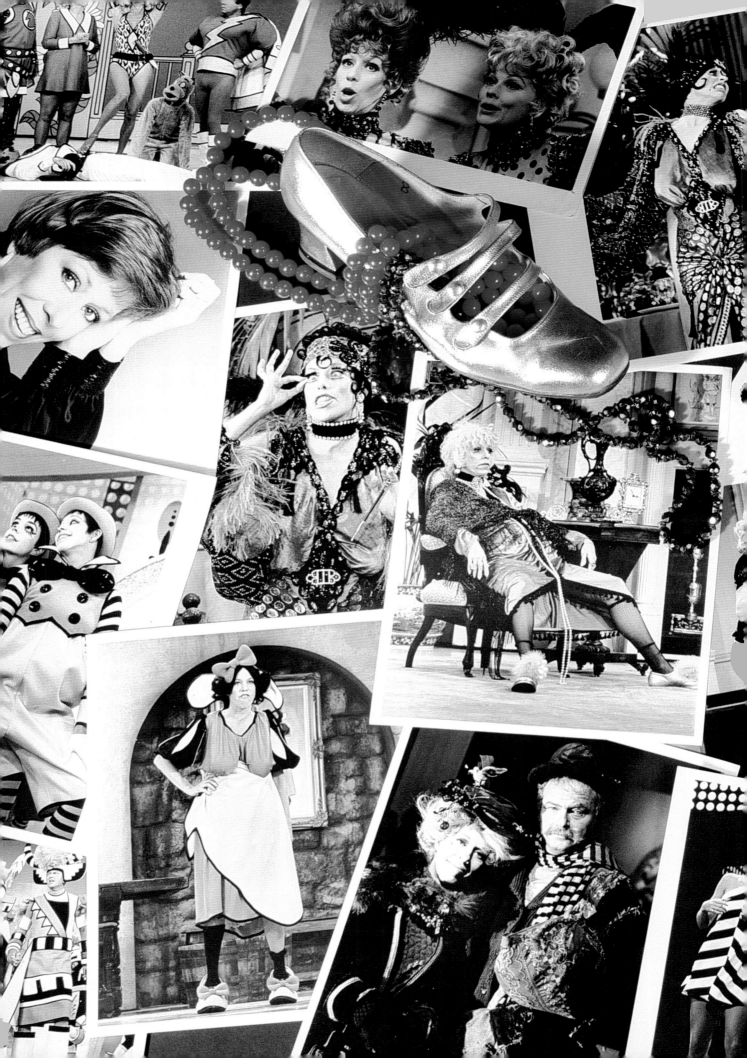

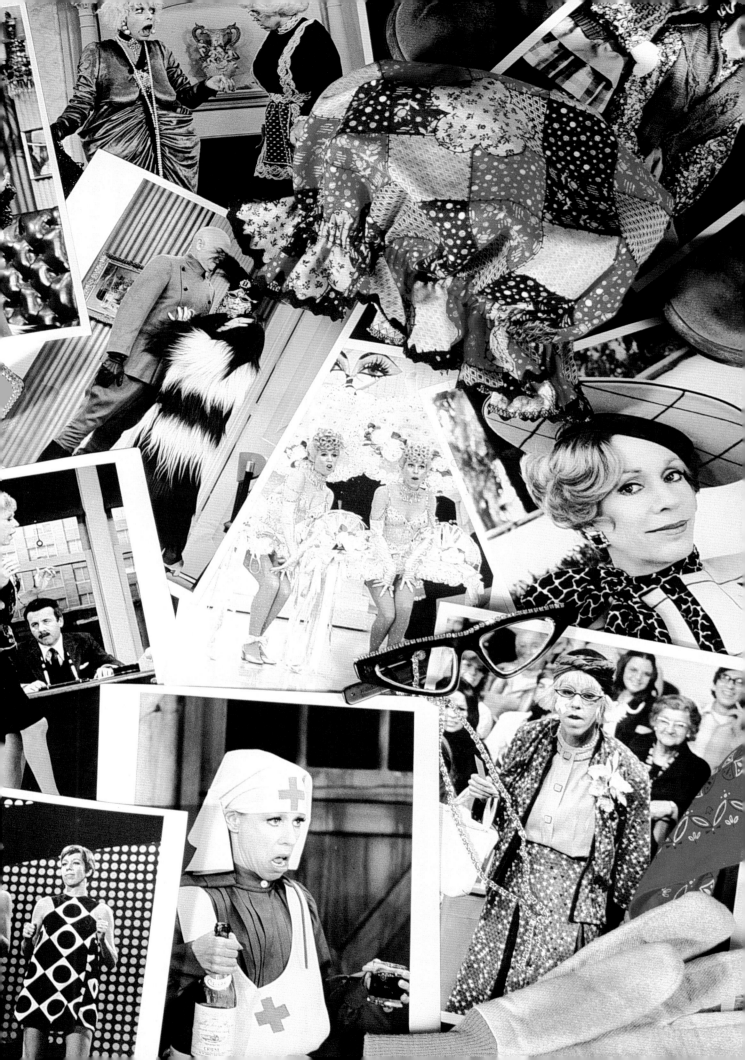

When Mackie began costuming *The Carol Burnett Show* in 1967, he embarked on one of two collaborations that would distinguish his career. Cher gave him an outlet for his most glamorous impulses. **In Burnett, he found the perfect venue for his wicked sense of humor.** The comedienne let him run wild to create memorable looks for characters as disparate as Burnett's dim-bulb secretary in a too-tight skirt (Mrs. Wiggins) and her shrill Tennessee Williams–esque dreamer in vintage ruffles (Eunice Harper Higgins). Using his encyclopedic knowledge of movies, he also helped fashion the show's movie parodies, one of Burnett's signatures. Together, the comedienne and the designer sent up such screen legends as Shirley Temple, Gloria Swanson, Joan Crawford, Sonja Henie, and, of course, Vivien Leigh. Each week, Mackie turned out as many as fifty costumes, outfitting Burnett and her costars, Vicki Lawrence, Harvey Korman, Tim Conway, Lyle Waggoner, and later, Dick Van Dyke, as well as their guests. "It was a bit exhausting," Mackie remembers. "But at the same time it was exhilarating to have a whole new script every week and to have to solve those problems and get it up on its feet within a few days." The cast rehearsed all week and then taped the show twice every Friday. "Carol did it as if it were a live show and the audience rarely ever had to sit through a retake," Mackie recalls. "The only thing they would stop for were set and costume changes, which we did very quickly. So it took about an hour and a half to shoot an hour-long show. It was great because I could always go out to dinner with a nine o'clock reservation on Friday night." That was no small accomplishment. Today, half-hour sitcoms take the entire night to shoot. As the designer says, "We did it. I don't know how we did it. But we did it."

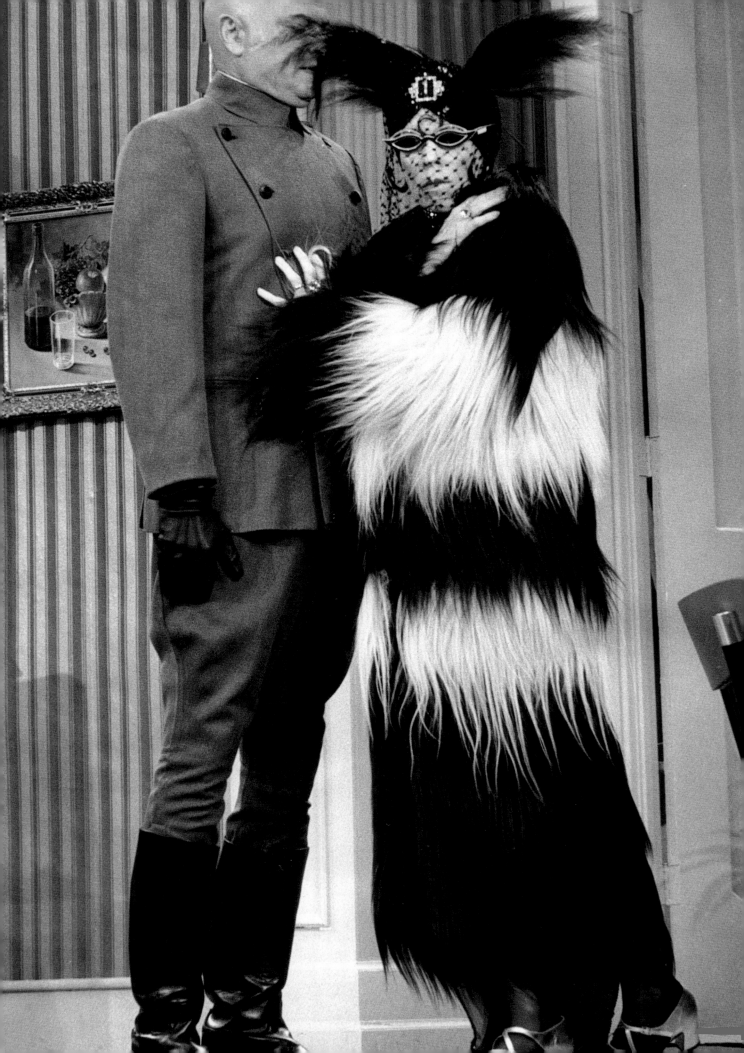

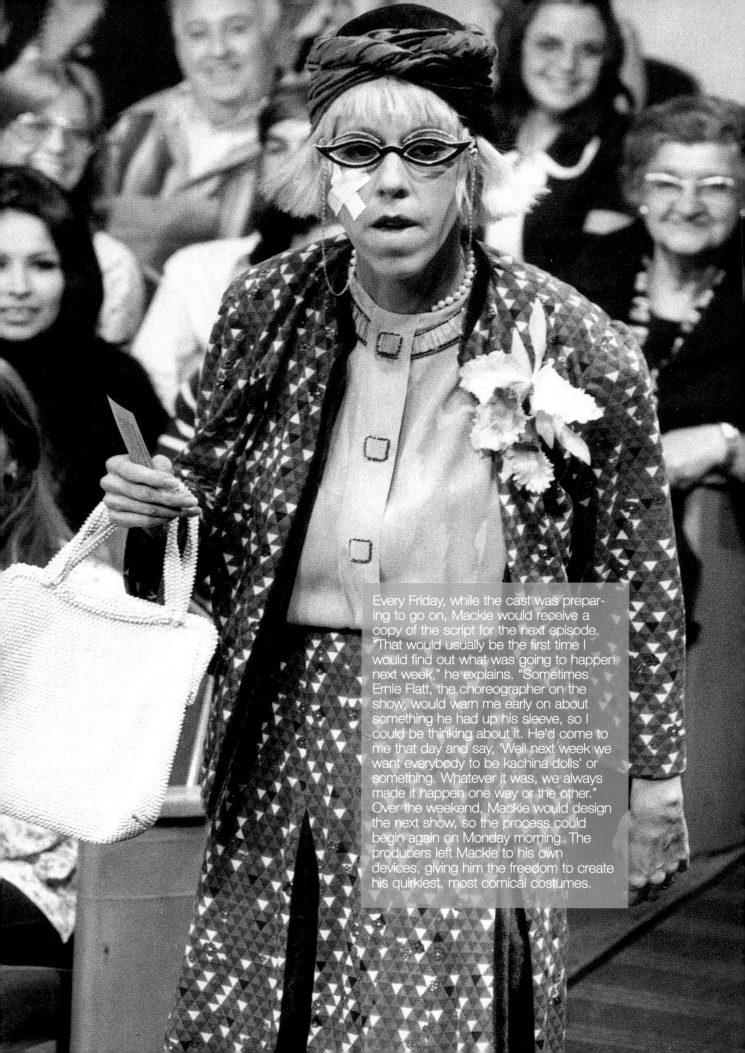

Every Friday, while the cast was preparing to go on, Mackie would receive a copy of the script for the next episode. "That would usually be the first time I would find out what was going to happen next week," he explains. "Sometimes Ernie Flatt, the choreographer on the show, would warn me early on about something he had up his sleeve, so I could be thinking about it. He'd come to me that day and say, 'Well next week we want everybody to be kachina dolls' or something. Whatever it was, we always made it happen one way or the other." Over the weekend, Mackie would design the next show, so the process could begin again on Monday morning. The producers left Mackie to his own devices, giving him the freedom to create his quirkiest, most comical costumes.

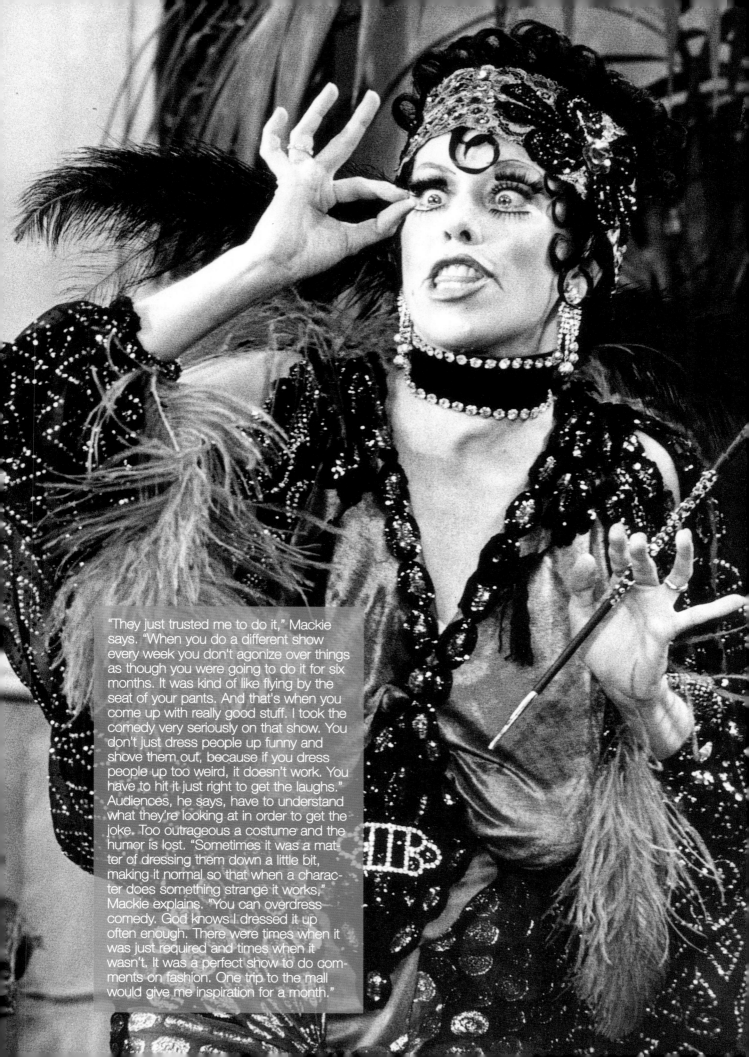

"They just trusted me to do it," Mackie says. "When you do a different show every week you don't agonize over things as though you were going to do it for six months. It was kind of like flying by the seat of your pants. And that's when you come up with really good stuff. I took the comedy very seriously on that show. You don't just dress people up funny and shove them out, because if you dress people up too weird, it doesn't work. You have to hit it just right to get the laughs." Audiences, he says, have to understand what they're looking at in order to get the joke. Too outrageous a costume and the humor is lost. "Sometimes it was a matter of dressing them down a little bit, making it normal so that when a character does something strange it works," Mackie explains. "You can overdress comedy. God knows I dressed it up often enough. There were times when it was just required and times when it wasn't. It was a perfect show to do comments on fashion. One trip to the mall would give me inspiration for a month."

"Carol has great legs

and she knows how to use them

for her physical comedy," Mackie explains. "On the
show, I'd have people say, 'Well, she's got to climb
out of a window here, she better be in pants.' But
I'd say to Carol, 'If I put you in pants you're not vul-
nerable at all. When you're doing all this stuff, it's
much funnier in a skirt' and it clicked in her head and
she never forgot it. So we never went for the pants
thing because she can get more comedy out of
those two legs than most people get out of their
entire bodies."

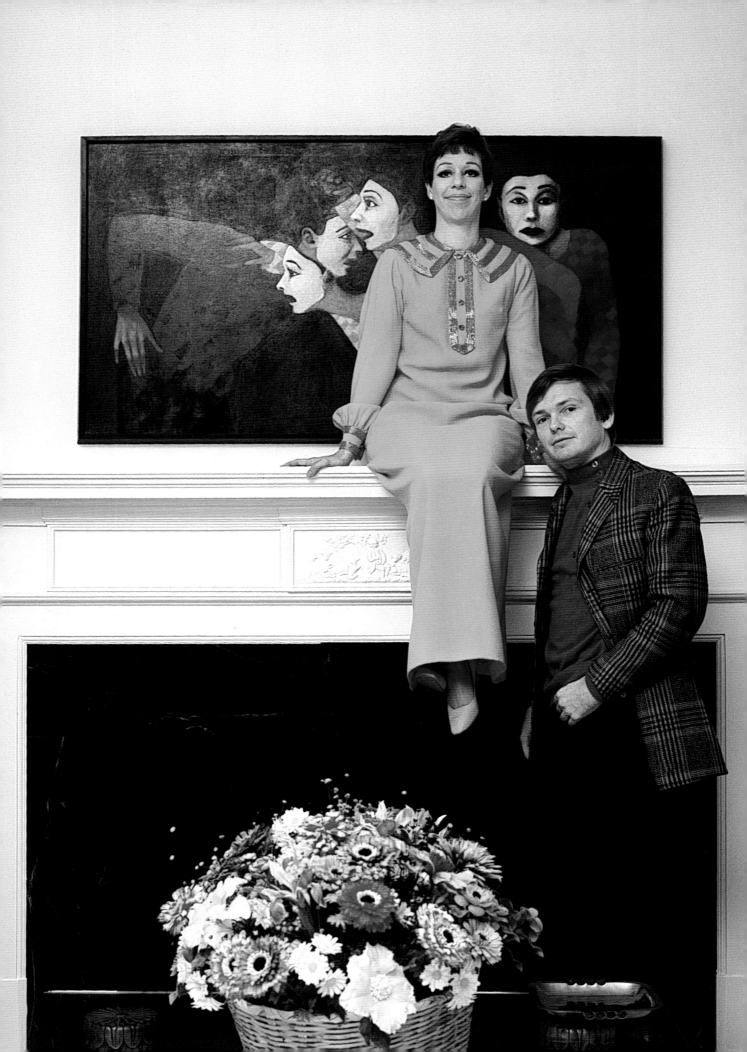

Carol Burnett

You worked with Bob every week for eleven years. What was it like working together?
Working with Bob is like working with a fantastic director and writer. He does half the character for you. There were many times when a sketch wasn't working until we came out in the drag costumes that Bob had designed. Be it Harvey or Tim or Vicki—all of us—he made those characters come to life. Those costumes gave us the courage to do things that we couldn't do in our rehearsal clothes.

Like what?
One time we had Vincent Price on and we were doing a horror movie takeoff. I was playing this cockney tart in late-1800s London. I just wasn't getting her and Bob said, "You know, in those days, nobody went to the dentist, so they all had bad teeth. Why don't you get some tooth black and 'chip off' your front tooth." It gave me this great look. Then I figured that when you have a chipped tooth, you lisp. So I had this cockney lisp and it just worked.

The "Went With The Wind" sketch, when you came down the stairs with a curtain rod in your dress, is a scream. *TV Guide* has designated it as one of TV's Fifty All-Time Funniest Moments. How did you come up with that?
That was all Bob. It wasn't written in the sketch. What the writers had written was that I would have the draperies just hanging on me rather sloppily. But Bob has this fabulous comedic mind, and that dress was one of the best sight gags on television, ever.

What did you do when Bob first showed the dress to you?
He went into the next room and opened the sliding doors and walked in with the costume on the curtain rod. I fell down on the floor, literally. I had to sit down on the floor because I was laughing so hard. If you see the clip, I'm having a hard time keeping a straight face. All the way down the stairs I kept thinking, "Don't you dare go, don't you dare go." That was one of the finest parodies ever written, and God knows I've done a bunch of them.

You got to wear glamorous clothes, too, on the show.
I always had a pretty dress up front so they could see I wasn't this gnome. It was pretty much tailored, never frou-frou. I'd wear sequins but in a tailored design. What he does with all of his ladies is accentuate their positives and de-accentuate their negatives. He always played up my back and, more recently, my legs. Those are my two best features to flash.

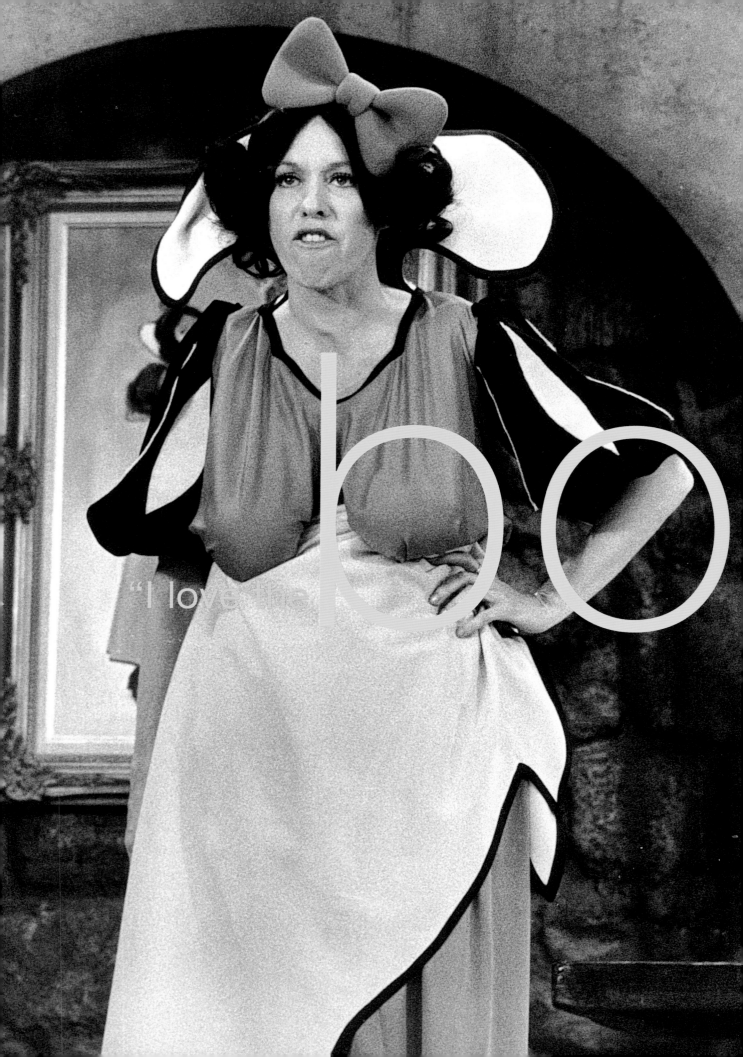

obs "he does"

Tell us about Nora Desmond from your *Sunset Boulevard* spoofs.
Nora was Bob at his zaniest. She speaks volumes about what he's capable of creating. I love the boobs he does. I've had other costumers put me in fake bazooms, but Bob was the first one to put rice in them. They move and they're more real. Uncooked rice, I should say.

Moving on to another part of the anatomy, tell us about Mrs. Wiggins.

When I went in to get fitted for her costume, Bob had this old, off-the-rack, black wool skirt. The skirt was so old that it bagged in the behind. It was saggy. I said, "We're going to have take that in." He said, "**Stick your behind out** into where it's sagging." That's what gave me the Wiggins walk. That's what I mean about him being a comedy writer.

"Dressing Carol Burnett and
making things funny
is always really fun."

The Carol Burnett Show
was the beginning of a
partnership that would last
longer than the show's
initial eleven-year run. The
comedienne has worn
Mackie in many of the pro-
ductions in which she has
starred, including her sub-
sequent series *Carol and
Company*. From *The Grass
is Always Greener Over the
Septic Tank*, a 1978 adap-
tation of Erma Bombeck's
book, to *Fresno*, an under-
appreciated 1986 minis-
eries spoofing *Dynasty* and
Dallas, she has engaged
Mackie to design her cos-
tumes. Even on stage, in
such productions as *Moon
Over Buffalo* on Broadway
and *Putting It Together*, a
Broadway-bound celebra-
tion of Stephen Sondheim's
music, Burnett has
remained loyal. "I love him.
It's a known fact," she says.

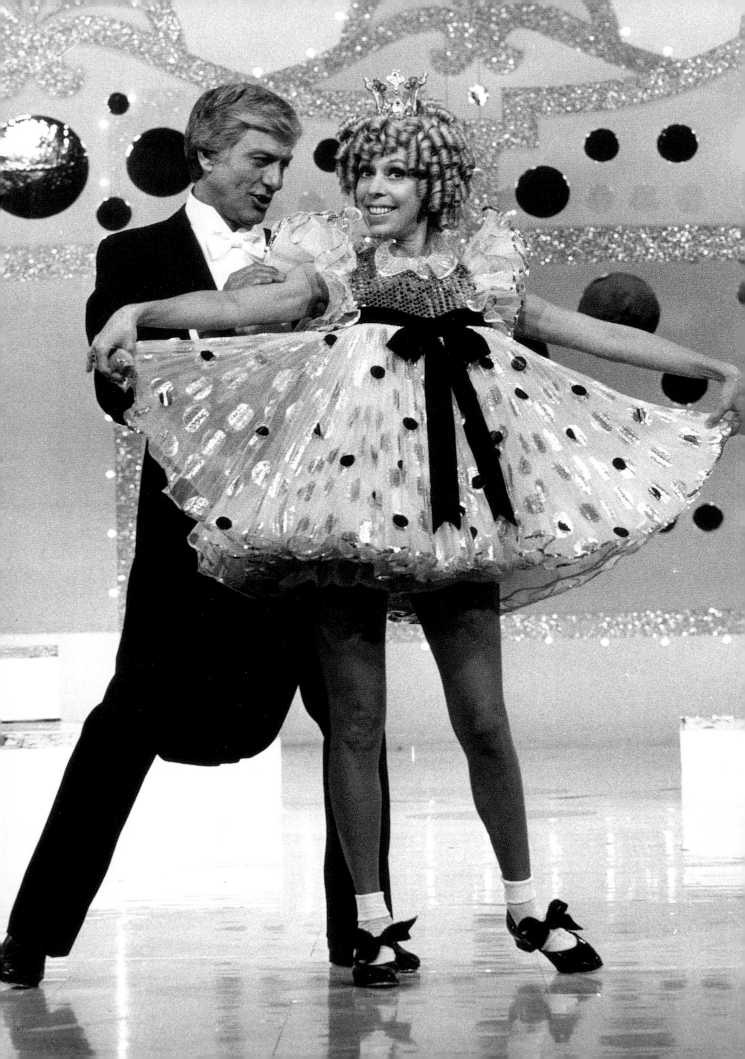

Bob Mackie on Carol Burnett

Your costume design for *The Carol Burnett Show* was some of your finest work. She always looked glamorous at the beginning of the show, but, oh, the outfits you put her characters in. Did Carol mind looking terrible?

She was totally cooperative about it because she wanted that laugh. She knew she could get it and she knew how to get it. When she looked good she wanted to look really good. But not when she was doing a character. Sometimes I would be fitting a skirt for a sketch and I would say, "Oh, let's lengthen it just a little because then it'll really make your leg look awful." She has beautiful legs, but they're slender, and if you hit them just below the calf, they look more like sticks than legs, and she knows that. It's the same with her arms. If you do a kind of sleeve that's the wrong length and too big, then her arms will look really scrawny.

Let's talk about some of her characters. Tell me about Zelda.

She was the Nudge. It was kind of a Walter Mitty takeoff. Harvey Korman would have a daydream that he was a pirate or a Mississippi gambler and the women would always be just gorgeous and buxom and beautiful. Then Zelda would come into the picture and she would always be dressed for whatever the period happened to be, but still very much Zelda. They had one in the Old West, and another one where he was a matador and she came in a Spanish thing. She always had these ugly, ugly shoes—sandals with big rubber soles worn with socks. Zelda was really unattractive.

What about Stella Toddler?

Stella Toddler was originally based on Stella Adler, the acting coach. But then the acting coach thing kind of got pushed aside, and later on she was just Stella who constantly got beat up and knocked over. And Carol was brilliant doing it, just very funny. There's a picture of Stella standing out in the studio audience, and there's an old lady sitting there who looks exactly the same.

What about the really dumb secretary, Mrs. Wiggins?

Mrs. Wiggins was originally written as an old, old, old lady. When I read the script I thought, "What am I going to do?" Carol had done Stella Toddler and a lot of old ladies. I thought, how can I make her look really different and how is Carol going to play it differently?

You had an idea.

Mrs. Wiggins was the worst possible secretary. Well, at CBS in those days there were a lot of receptionists and secretaries who had Farrah Fawcett hair and skirts that were too short and too tight and they were always sitting there doing their nails. That was the most important thing they did all day. That, and making sure they got all their breaks and all their lunch hours. So I called Carol and told her if she was playing her like an old lady it wasn't going to work. I usually never did that, but I just felt that it wasn't quite right. She listened to what I had to say.

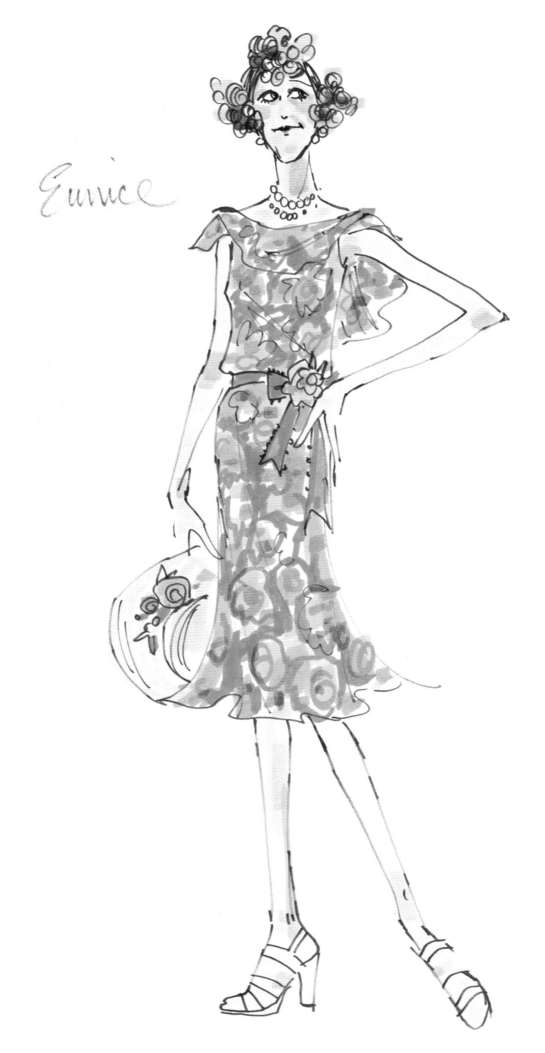

Eunice

Carol credits the tight black skirt you made with inventing that character.
Well, I think it sent her in a direction, gave her a look. She always says, "I don't know how I'm going to do it until I see the costume," but that's not really true. She's smart enough to take it and go with it and use it. I just took the skirt in really tight and cinched her in at the waist. It's nothing special, just a straight black skirt that you make as tight as you possibly can. We also gave her a little padded bra, which they all wore anyway, and a cheesy crepe blouse, which was very popular at that time. By the time she got into the black high heels she had the character down. In rehearsal, they were laughing it up.

Tell me about Nora Desmond, Carol's spoof of *Sunset Boulevard*.
I had never really seen the movie when I did the takeoff on that, which is interesting. But I had seen all the photographs, and we just took it a few steps further. She wore a wig in the first sketch to look like Gloria Swanson and it was a closer Swanson parody than the actual movie. And it was received with such enthusiasm that we started doing more of them. She didn't always change costumes, but very often I would vary her costumes slightly, like when she went to the Brown Derby she was in a monkey fur coat, turban, and dark glasses—a very funny look. Carol and I were laughing because we always thought Nora was way over the top until we saw Glenn Close as Norma Desmond in the musical version of *Sunset Boulevard*, and then, you know, it wasn't so far over compared to that.

What about poor attention-starved Eunice?
She wore an old 1930s flower chiffon dress that I found in a second-hand store. It's floor-length and I cut off the bottom and took the extra fabric and made ruffles around the top. It was a one-time thing as far as we knew. Vicki [Lawrence] wore a dress that I pulled from my stock, one I had done once for somebody else, and it ended up being her dress for Mama. It was all done as a sort of Tennessee Williams–type family. We did that many, many times.

It was heartbreaking in its own way, particularly the night when Eunice went on *The Gong Show* and got gonged.
It was always kind of sad. It made you stop and think, "Oh, it's not really that funny." That's when the show started having a little more depth to it. Carol went from being a female Jerry Lewis to being a really brilliant comic actress.

Carol became very attached to that dress, didn't she?
The dress was falling apart, but we kept patching it from the inside. Fortunately, it was a print so you couldn't really tell. But it was getting really dangerous. So I found another print that was very close and we reproduced the dress exactly. But it still wasn't the dress. Carol got very superstitious about characters like that, and always wore the same dress.

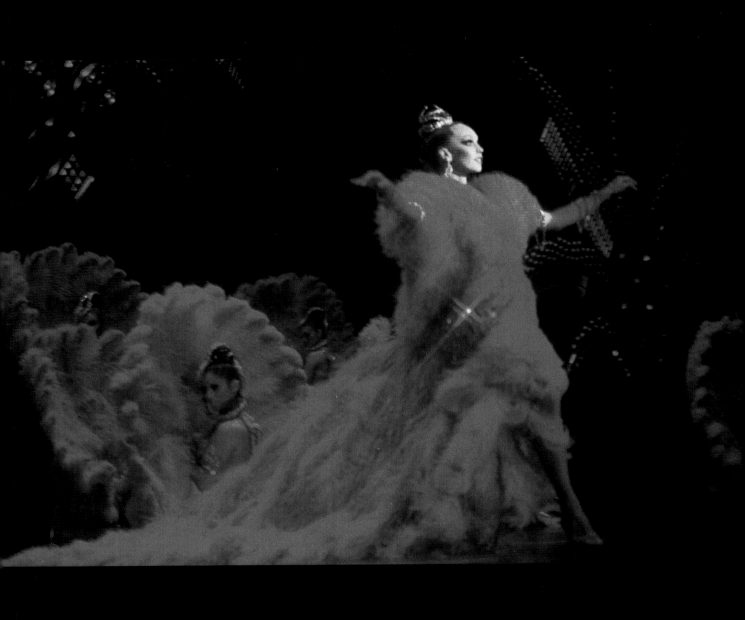

Bob Mackie tells the story of his first trip to Sin City: "I'd never been to Las Vegas, but I went there in 1964 to see the opening of a Juliet Prowse act that Ray had designed. I went up with Ret Turner, a colleague who later did Sonny's clothes. While we were there, we went to see the Lido de Paris, or was it the Casino de Paris—the Whatever de Paris. There were all these 'ooh la la' shows playing in Vegas at that time, with all the feathers and tits and jewels. It was amazing. I'd never seen anything like it in my life. I really thought I'd died and gone to heaven. And I thought, 'You know, I could design those. That's easy.'" Vegas was his kind of town. In the years that followed, Mackie not only designed costumes for numerous nightclub acts—covering everyone from Mitzi Gaynor to Ann-Margret to Tina Turner (and later RuPaul) in sequins—but he also got to design the kind of mega-production that had defined the golden age of Las Vegas entertainment. In 1974, Mackie was asked to design the costumes for *Hallelujah Hollywood*, an over-the-top extravaganza staged by the legendary producer Donn Arden at the MGM Grand Hotel. Arden had a long career directing, producing, and choreographing such spectacles in Paris and Las Vegas. It gave Mackie a chance to excel at the kind of designing he longed to do in art school. "I never thought I'd get to do one because they usually use French designers," he remembers. But thanks to his notoriety from *The Sonny and Cher Show*, Mackie was given the monumental task of creating about one thousand costumes at a cost of several million dollars. "All the feathers and the jewels were done out of Paris and everything was put together in Los Angeles," Mackie remembers.

Defining Las Vegas

"It was the hugest job you could ever imagine. You just keep designing and designing and designing. Then, you never finish fitting it. There was so much, I didn't think it would ever be done. I hated fitting it and I hated getting it together." But he loved designing it. For better or worse, Mackie has always been at home with the Las Vegas aesthetic. "It scares me sometimes," he says. "Everybody else has such trouble with it." But with agility and speed, he is able to turn out a dizzying array of elaborately scanty costumes, creating variations on a theme—the glamour of gambling, for instance—to dazzle the eye. A familiar belle epoque silhouette, in Mackie's hands, is re-imagined as a fantasy of hyper-femininity. Each girl becomes a different flower in a gorgeously overwrought garden. "It's a kind of designing that's just so easy for me. It's harder than you might think, but at the same time it just comes out of me. It just flows. I hate to admit that, but it's true. I really understand it." Why is he so good with showgirls? "Basically I like making women look attractive and appealing," he says. But designing costumes for a leggy Las Vegas chorus is a unique challenge far removed from designing for other types of theater and ever farther removed from the clothes he creates for women to wear in real-life situations. A showgirl costume, he says, "is like making a sculpture or embellishing a statue. It just happens to be breathing and walking." Although the costumes are bare, the titillation factor is undercut by the silliness of it all. "Their boobies are bare but they've got all this other stuff on. There's nothing sexy about it at all. Most people, half the time, don't even realize they're looking at their tits. It's just part of the overall thing." Such costumes may excite, but Mackie says they actually work like chastity belts. "You couldn't get to any of the girls if you wanted to. You'd kill yourself. You'd be stabbed with all these diamonds, surrounded by huge stones from Paris." In 1981, Mackie's services were needed again. He was asked to design the costumes for the finale of *Jubilee!* starring Tricia Lee, Arden's last production at the MGM Grand. While the show was in pre-production, there was a fire at the MGM and many of the costumes were destroyed and had to be remade. Tragically, the costumes weren't the only thing lost in the fire—Mackie's assistant was killed. But the show went on. And on and on. It's still running today at Bally's, as the hotel is now called, where, in 1997, the costumes were refurbished and brought back to their original brilliance. Although he did not design the rest of the show, Mackie says, "The finale is as big as most shows you'd see anywhere else." Its array of costumes—elaborate headpieces and huge feather sprays—still dazzle, even as this old-style entertainment is swept away by such new-age entertainment as Cirque du Soleil's *Mystere!* and *O* in the new, more tasteful Las Vegas. Seen today, *Jubilee!* is a time capsule of Vegas-style glamour, a reminder of the off-kilter notions of beauty that Mackie was born to define. While the show's production numbers may seem outdated, the finale costumes Mackie designed so long ago still manage to impress. As he says, "I look at them sometimes and think, 'How did I think of that?'"

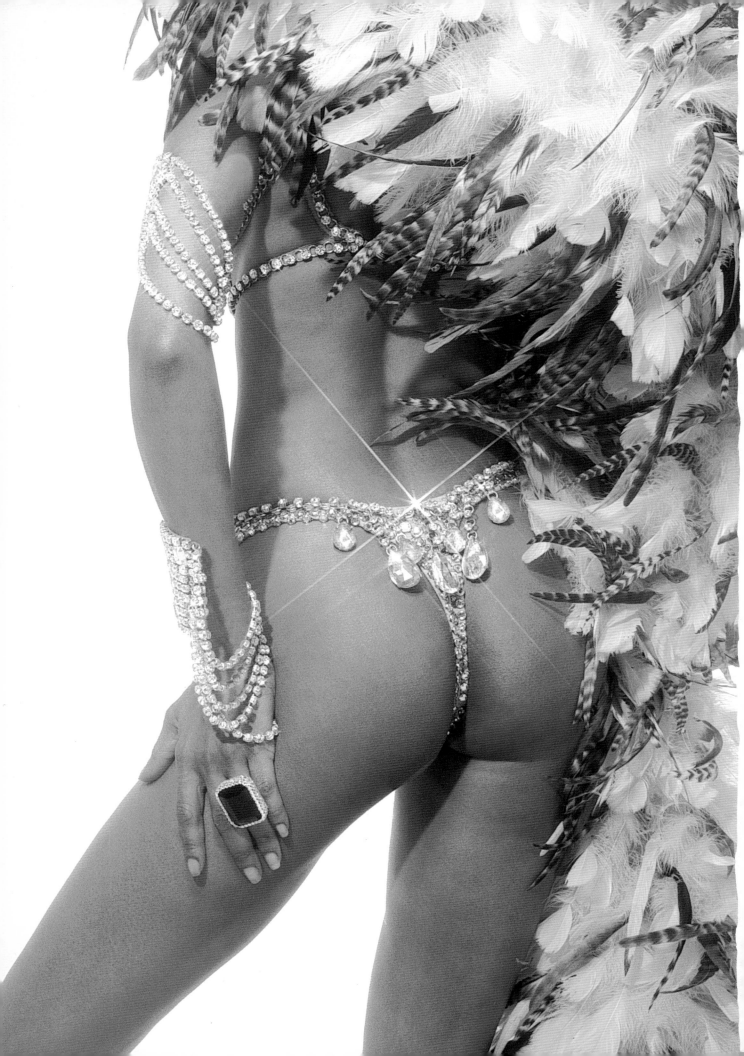

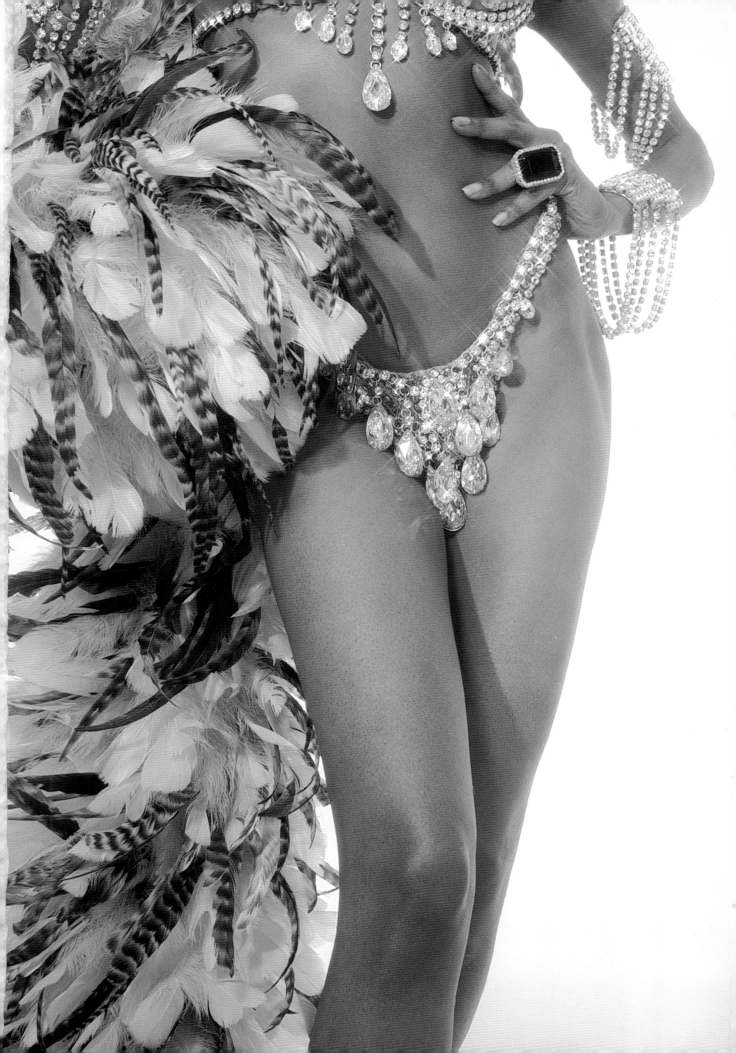

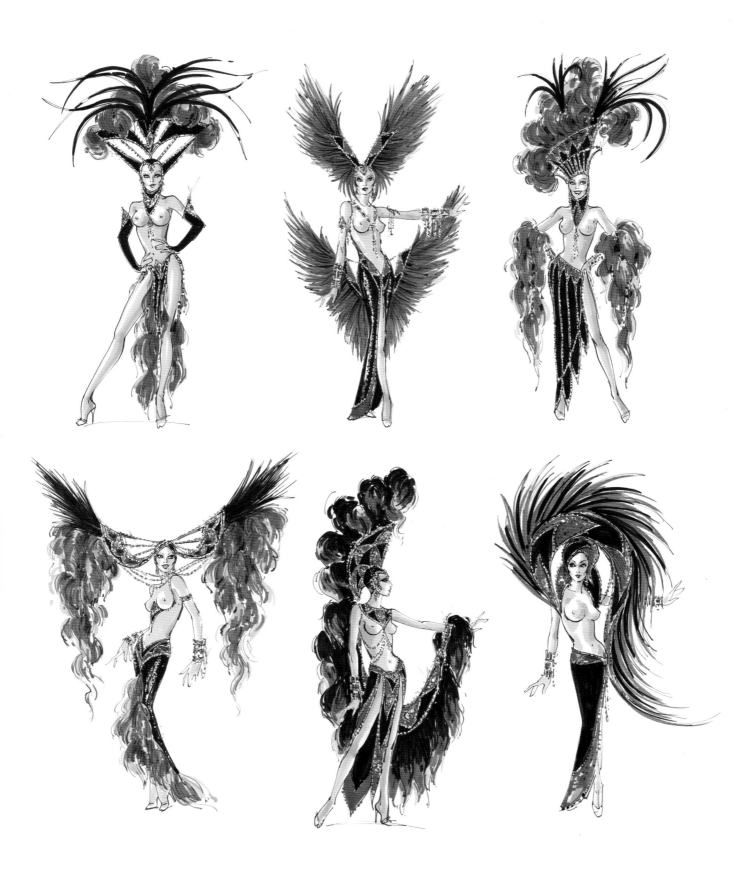

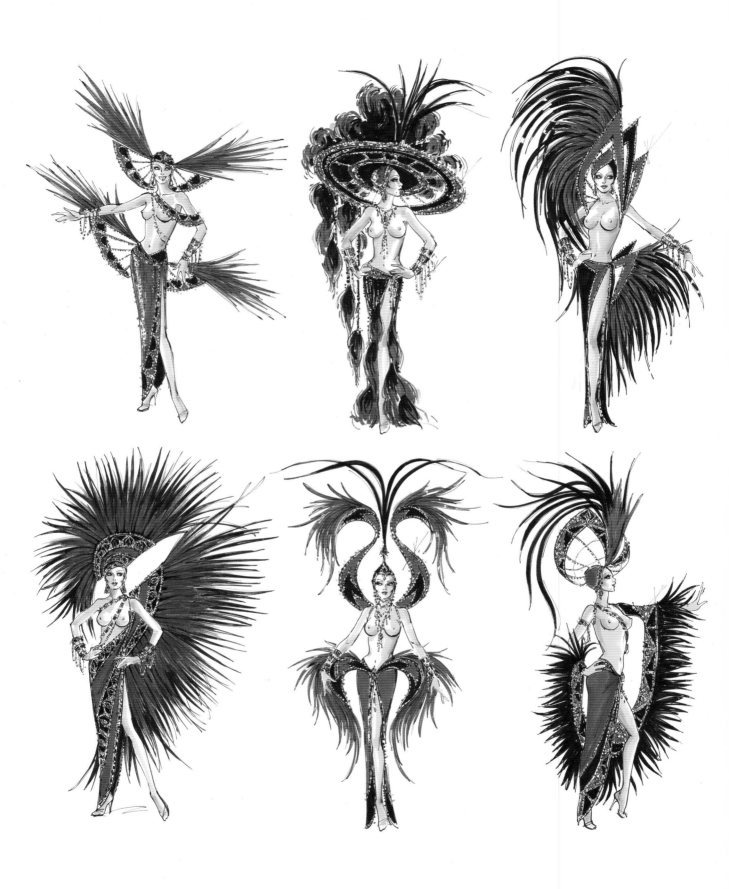

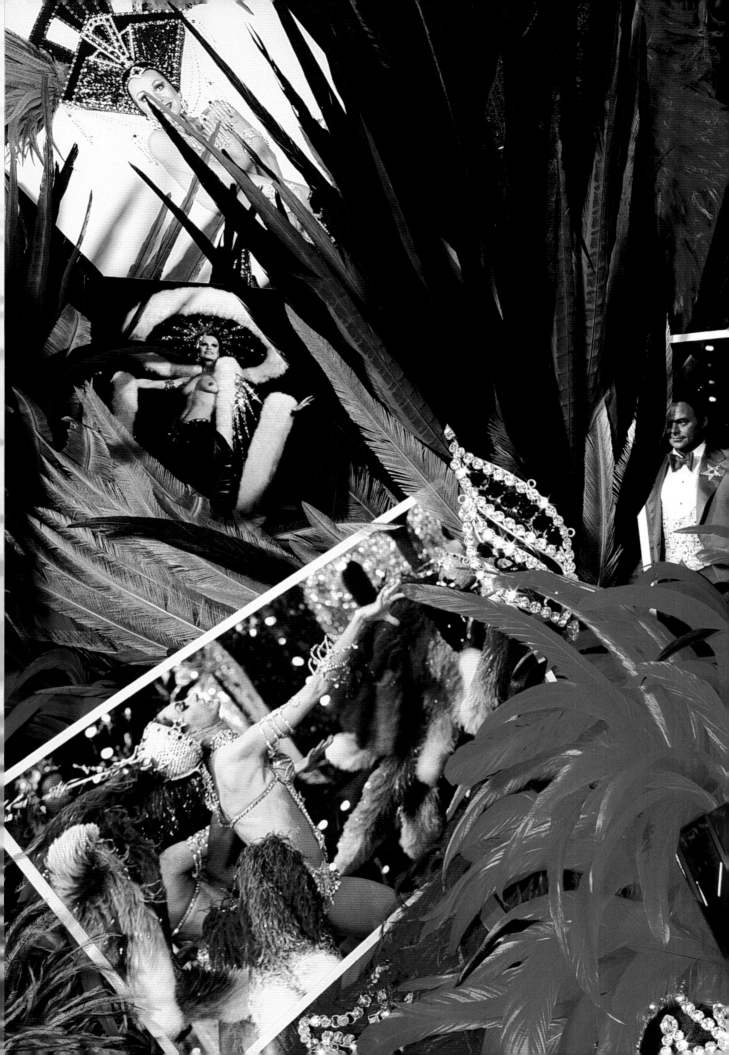

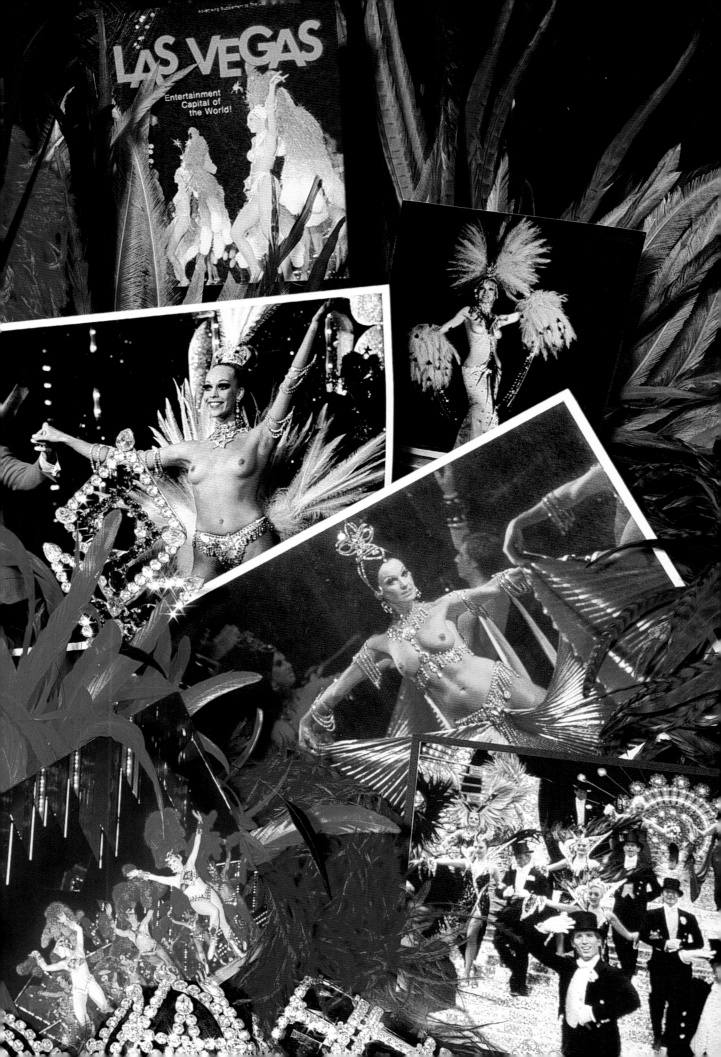

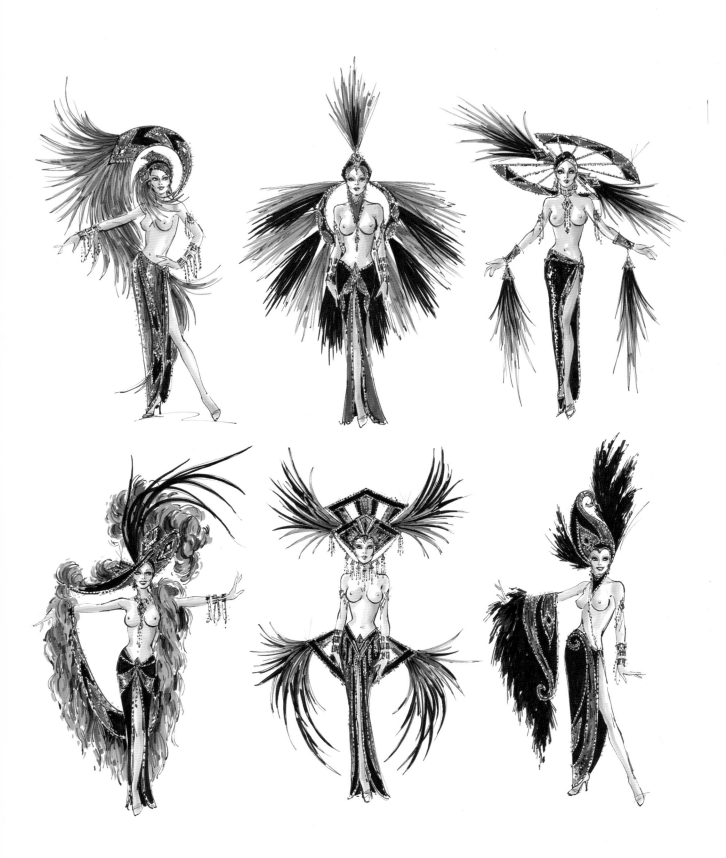

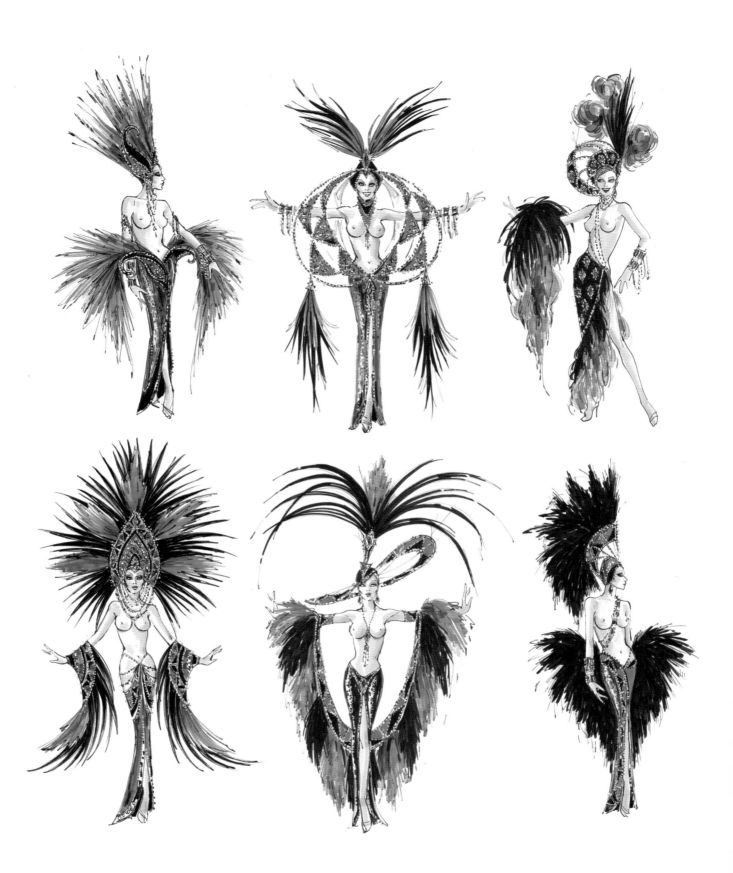

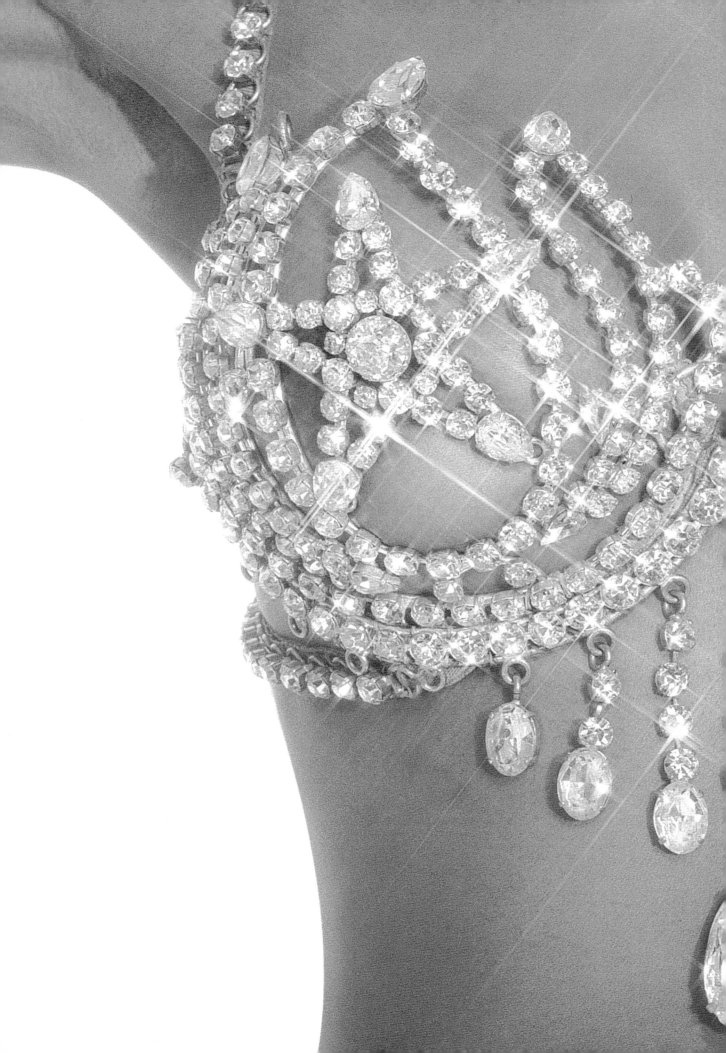

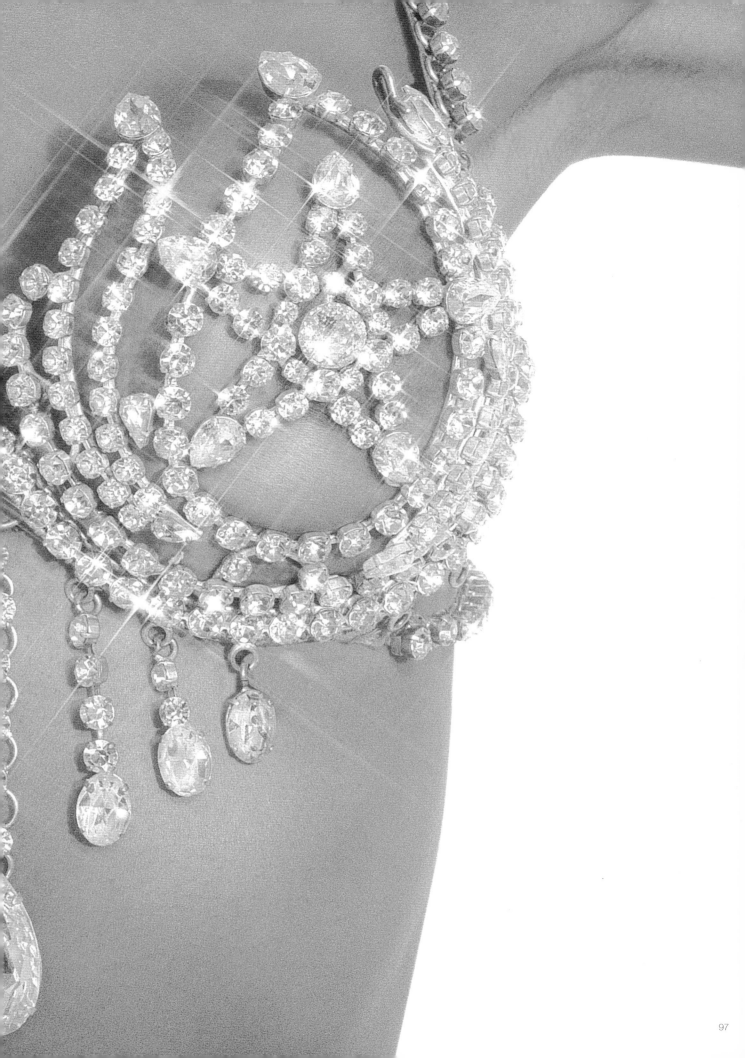

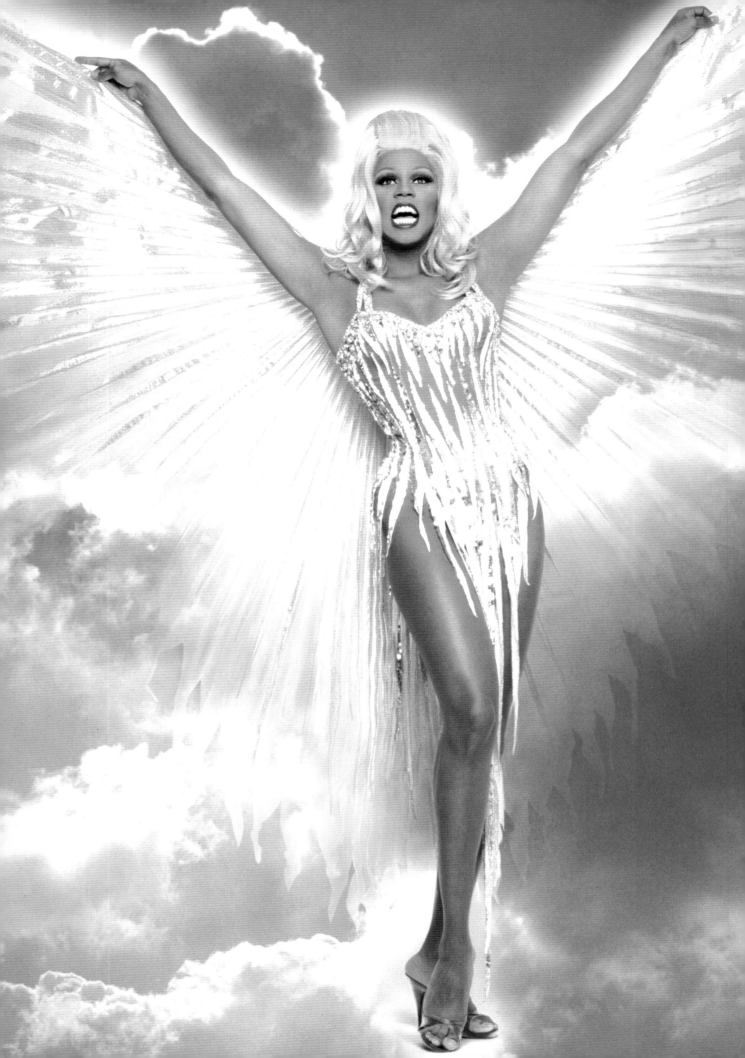

As a kid, you were a big fan of the *Sonny and Cher* and *Carol Burnett* shows. Every boy, girl, creative person, queer, and dyke tuned in to those programs to get their first dose of fashion knowledge. It's where I got my sense of show-business style. I would do impersonations for my parents in our living room. I could always do Cher doing Laverne. That was an easy one. I could do Tina and I could do the Tarzan yell. That was the pulse of America. It was so easy to emulate the shows as a kid. Take some towels and sheets and put some twigs in your hair or cut the feet out of some socks and you've got gauntlets. *Why did you relate to Bob Mackie's designs so well?* Bob always seemed to say, "You might as well use all the colors in the crayon box and not take yourself so seriously." How could you when you're wearing a Cherokee-feather, bare-midriff outfit? *For a lot of us, those costumes were our first exposure to glamour.* Bob was the first designer I ever recognized as a kid. Bob Mackie, Edith Head, and Robert Hall—those were the first designers I'd ever heard of. I don't have to tell you how important he's been to what I do. That's what set the standard of glamour for me. That's why I was so excited about getting my own Mackies. I got to go to the dream factory and get fitted by the master. *He did the costumes for your first Vegas show, in 1996. What was that like?* It was amazing. I came out wearing this Ann-Margret motorcycle-chick outfit with a patent-leather skirt and a motorcycle jacket. It was pink, silver, and white. I looked like Barbie. I took off the jacket and skirt on stage, revealing this glitterized, nude bodysuit, and then I put on this boa coat. It had feathers and was sheer. That nude bodysuit was the constant, and I could put things over it. Then I went into my Aunt Hattie Ruth routine, in which I wore this Carol Burnett fatsuit—one that she'd actually worn on a TV special in the eighties. Then I got into this Bob Mackie–Tina Turner winged thing that I also wore on the VH1 Fashion Awards. You can't beat those damn wings. They quadruple your size on stage. When I open my wings, the audience bursts into applause, and then I spin around like Diana Ross, and it's all over. *What did you learn from that experience?* It taught me the importance of a good costume change. You can never do too many. Do as many as you can get away with. That's the whole Bob Mackie experience for me. Nothing beats a great pair of legs and nothing beats a great pair of legs in Bob Mackie. *You and Bob seem like a perfect match.* I know, I was built for Bob Mackie. You want pure glamour? This is it. He's done it all. What else can you do to a gown that he hasn't already done? *Your devotion hasn't wavered.* He is my favorite fashion designer of all time. Anyone who has ever done glamour has had to pay homage to Bob Mackie. Dolce and Gabbana, Versace, Jean-Paul Gaultier, Vivienne Westwood—they've all done him. *Hello! What's your favorite Mackie creation?* My favorite would have to be Cher on the cover of *Take Me Home*. It's my favorite album cover of all time. That antler, handle bar, Viking, crazed-woman-on-a-horse look—it just doesn't get any better than that.

RuPaul

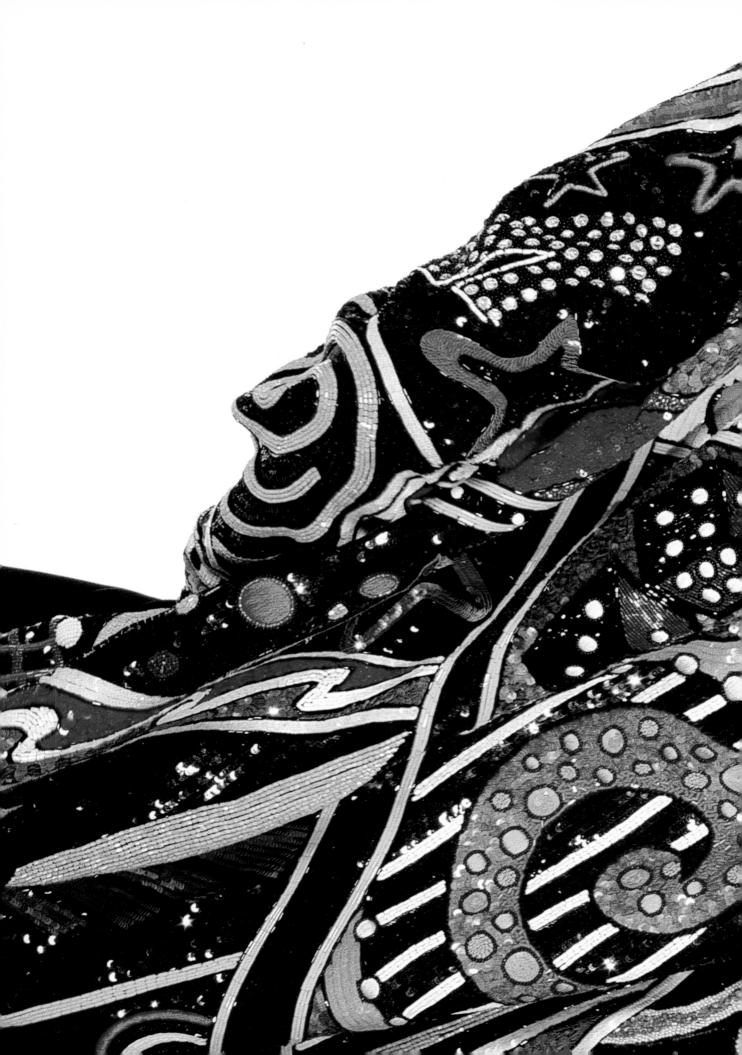

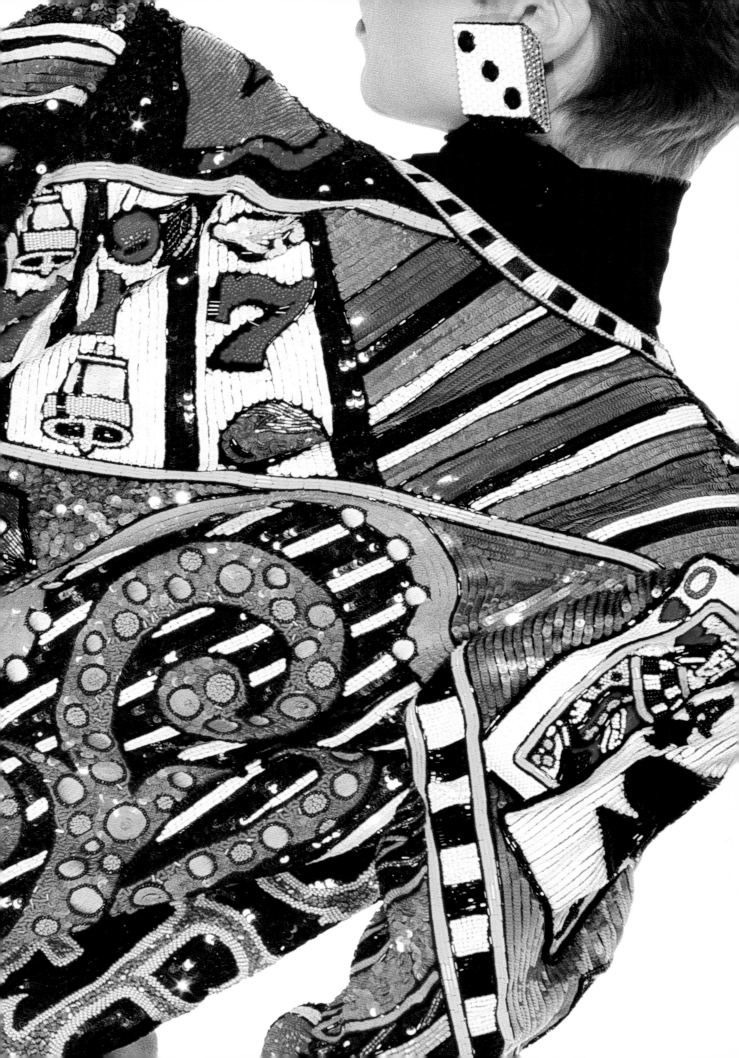

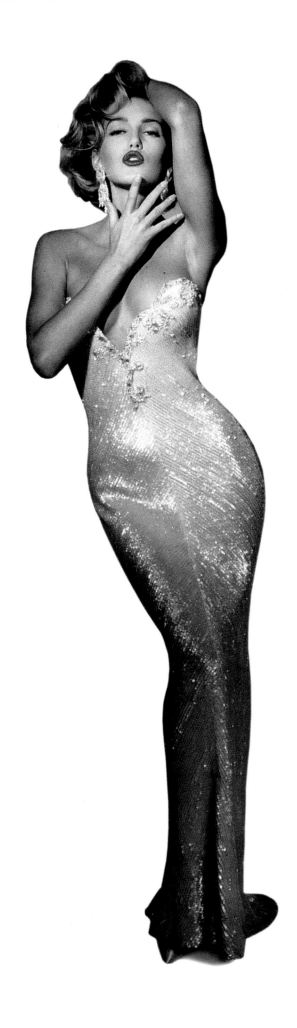

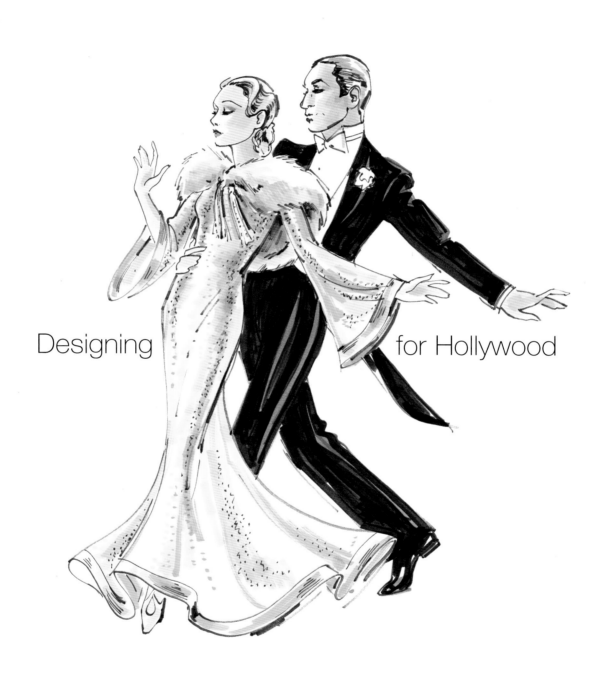

Designing for Hollywood

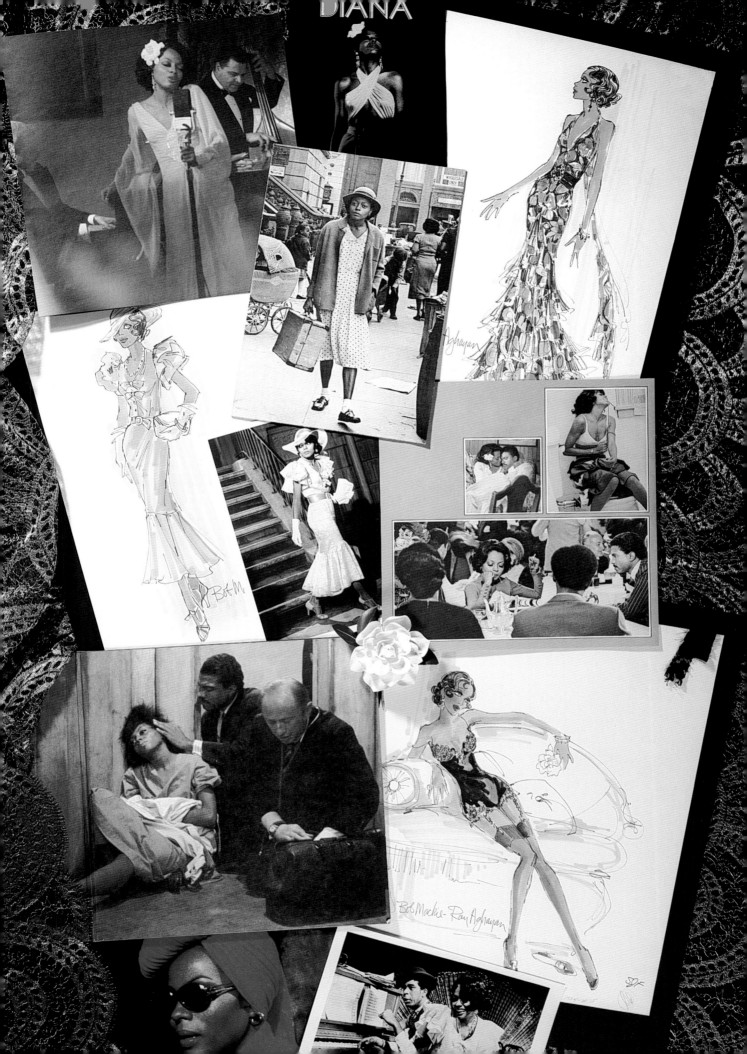

Lady Sings the Blues, Sidney J. Furie's 1972 biopic about Billie Holiday, marked Diana Ross's film debut and Mackie's first Oscar nomination. Mackie was not the original choice to design her costumes. A designer at Paramount had been chosen for the job, but Ross wasn't satisfied. "She was one of those designers who really just pulls stuff out of stock," Mackie remembers. "And Miss Ross was not about to go for that. She wanted her own designer." Because Mackie had designed her costumes two years earlier for the TV special *Diana Ross & The Supremes and The Temptations on Broadway*, he was summoned. "About two weeks before it was starting, we got this emergency call to do it. I couldn't do the whole thing so Ray and I did it together," Mackie recalls.

Mackie and Aghayan transformed the former Supreme into the legendary blues singer. "Diana Ross doesn't look anything like Billie Holiday," Mackie says. "Billie Holiday was kind of a big woman. But we just dressed her in thirties clothes and started her off as a child. Diana could pull that off beautifully. She looked like a skinny kid of about thirteen or fourteen. She braided her hair and took off all her makeup and she was adorable. Then we made her a couple of dresses to wear in the performing parts." Their work, and that of Norma Koch who designed the other characters' clothes, was enough to earn the Oscar nomination. Although they lost to Anthony Powell, costume designer of *Travels with my Aunt*, Mackie says, "It was fun to get nominated right off the bat."

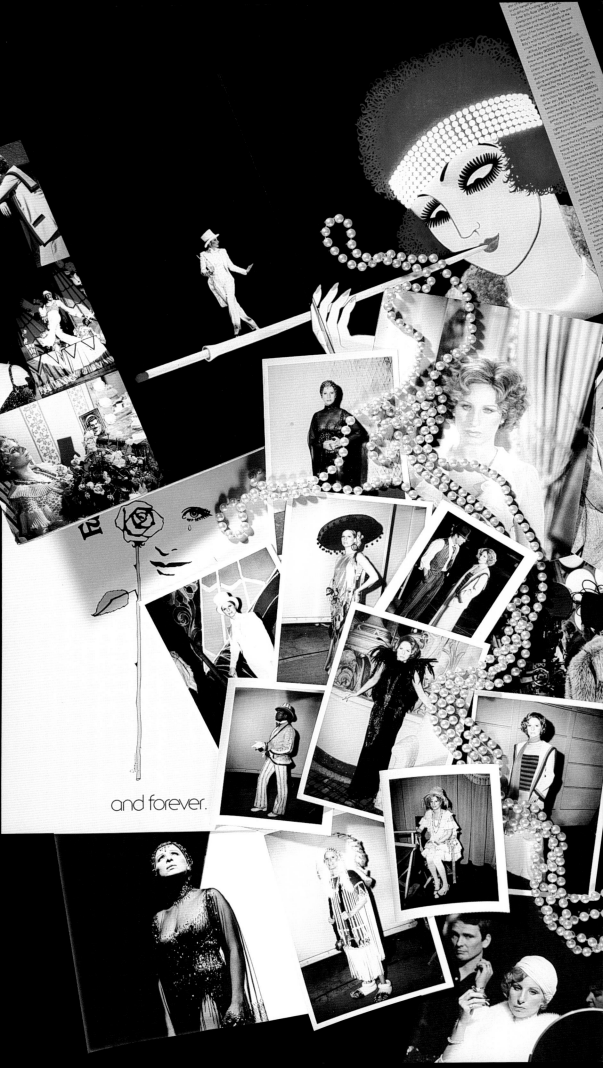

and forever.

"When you watch **Funny Lady** now, it's kind of an amusing film because there's so much stuff in it," Mackie says of the 1976 sequel to *Funny Girl*, on which he collaborated with Ray Aghayan. "There are musical numbers and lots of costume changes. It's really a good old-fashioned movie." Barbra Streisand, however, was a new-fashioned woman, always willing to take charge. "After you'd shot a scene she'd say, 'Maybe I should have worn red, let's do that again,'" he recalls. "But I must say, she has an amazing sense of color and she really knows what's right for her." The greatest pleasure for Mackie came from recreating the kinds of musical comedy numbers Fanny Brice performed in her heyday, but Streisand preferred looking good to looking funny. "It was always the glamour because Barbra's so glamorous. I don't think she really enjoyed doing the comedy parts that much. But we did a few things like that, so I had a good time."

Streisand's day clothes were fun to do, too, he says. "She wore a lot of wonderful 1930s suits and coats and hats. I loved seeing her all dressed up like that in furs and beautiful hats. She has a great hat face. One of the fun moments in the film is when she's dressed as Little Eva—sort of a version of *Uncle Tom's Cabin*, with Ben Vereen playing Uncle Tom. She dies and flies up into the heavens wearing this nightgown. It's all very silly but really fun to do."

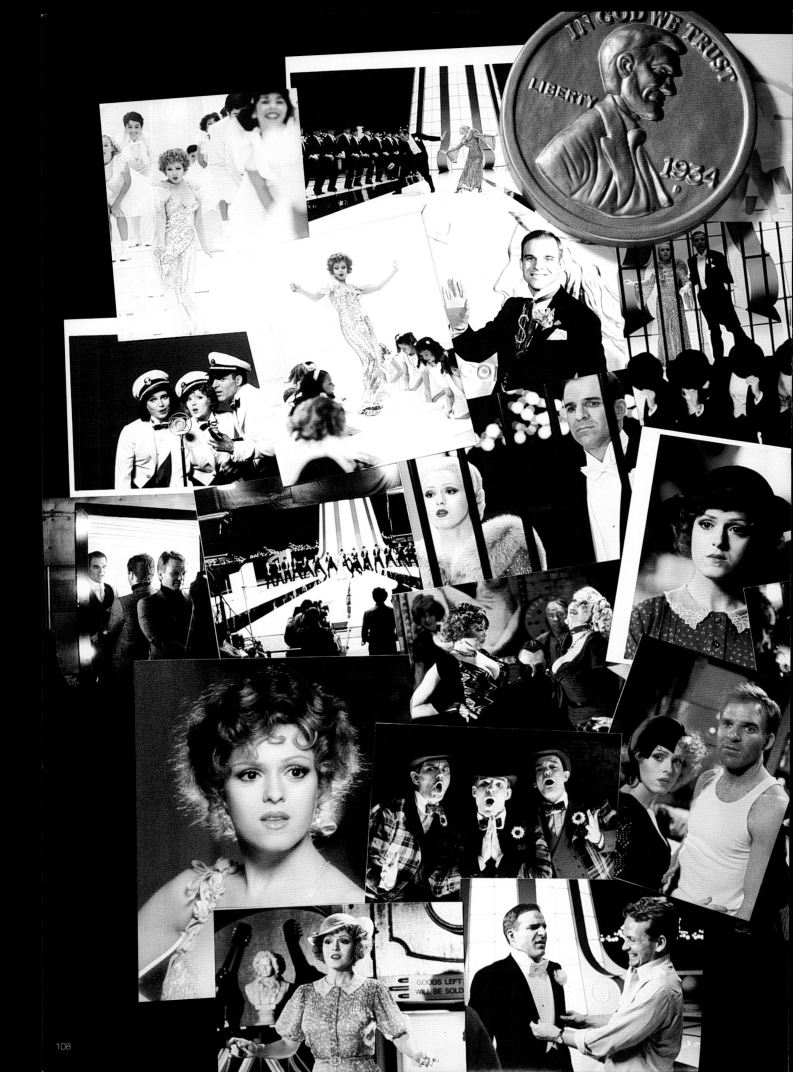

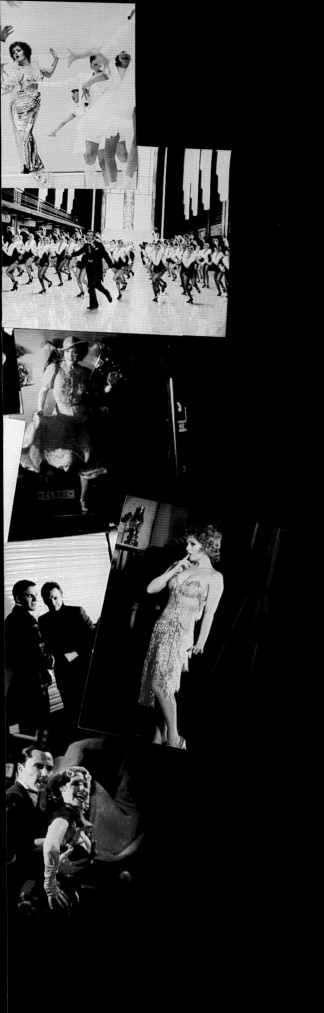

In 1981, Mackie designed the costumes for **Pennies from Heaven**. Written by Dennis Potter and directed by Herbert Ross, it was an abridged version of the earlier British miniseries starring Bob Hoskins. Quirky and challenging, the American film starred Bernadette Peters and, in one of his first dramatic roles, Steve Martin. "It was a weird movie, a very chancy film, and unfortunately it was promoted as the return of the MGM musical," Mackie recalls. "Mommy took her little children to see it and there was Jessica Harper with her nipples painted red. There were just so many bizarre things going on in that film. People thought they were going to see a wacky Steve Martin thing and it wasn't that at all. Even though it did have some musical numbers, it was very dark and almost mean-spirited in a way. A lot of people really like that film today. It's kind of an underground film now. But you rarely see it anywhere because it is so disturbing."

The film was a departure for Mackie, allowing him to create the glamorous fantasy clothes for which he is known, as well as depression-era street wear. He had to clothe Peters, for instance, as both "a sad little country school teacher whose life is just miserable" and, in dream sequences, a sort of Ginger Rogers type. "It was really like doing two separate films for me," he says. (It was, however, nominated for only one Oscar.)

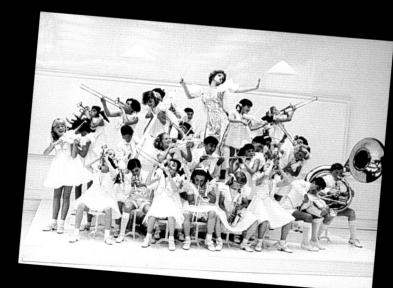

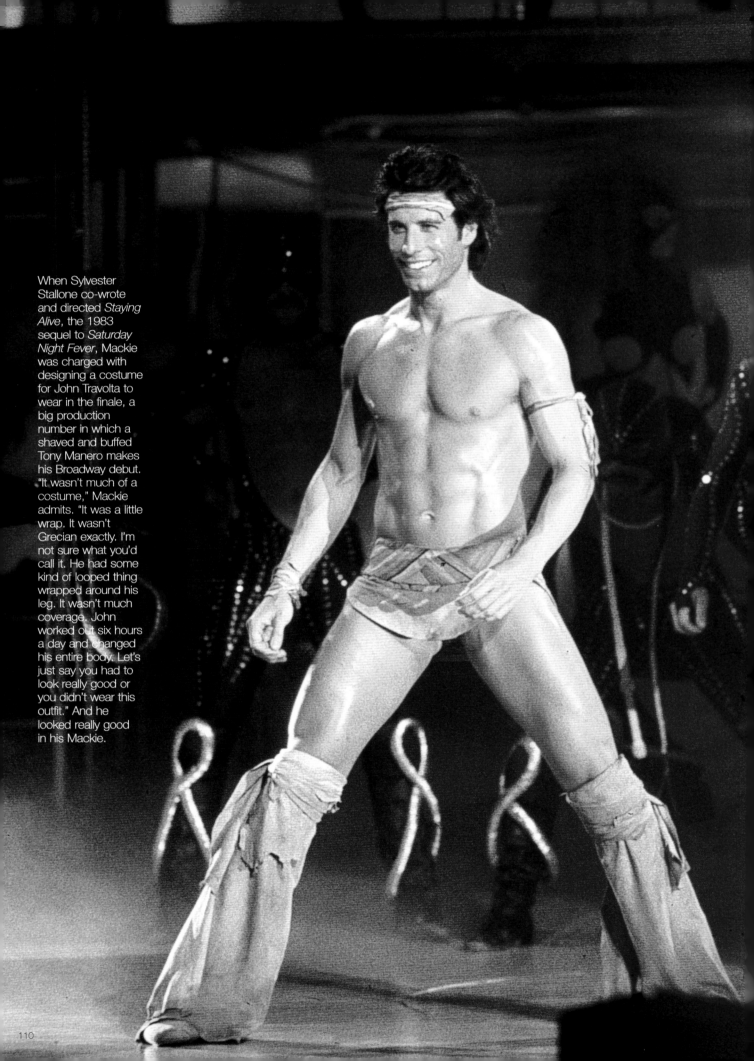

When Sylvester Stallone co-wrote and directed *Staying Alive*, the 1983 sequel to *Saturday Night Fever*, Mackie was charged with designing a costume for John Travolta to wear in the finale, a big production number in which a shaved and buffed Tony Manero makes his Broadway debut. "It wasn't much of a costume," Mackie admits. "It was a little wrap. It wasn't Grecian exactly. I'm not sure what you'd call it. He had some kind of looped thing wrapped around his leg. It wasn't much coverage. John worked out six hours a day and changed his entire body. Let's just say you had to look really good or you didn't wear this outfit." And he looked really good in his Mackie.

You met Bob when you guest-starred on *The Carol Burnett Show*, and you've been wearing him ever since.
He made me a beautiful dress right away, so I loved him.

Today, he does all your clothes for your concerts.
I did a concert in London at Royal Festival Hall that was taped for PBS, and since then I've worn his gowns. The cover of my Carnegie Hall CD has his dress on it. It looks like I'm nude with beads thrown on me.

What does it feel like to wear a dress like that?
You don't feel nude in it. You feel powerful. You feel very secure because you know it's not going to fall off. He knows how to make them stay up and look beautiful and look great. That's the difference between a Bob Mackie gown and just any gown. They feel secure and yet they create illusions. You always know you'll look great. Unless you're doing a comedic thing, and then you'll look funny, of course.

When did he make you look funny?
At a run-through for one of my concerts where I sang the Tammy Wynette song "D-I-V-O-R-C-E," he came up with the idea to put on huge hair. So he made this flat piece—a cutout of hair like a hood that I held up with handles. The audience was hysterical with laughter. Here I am singing this country western song really tongue-in-cheek and I had this huge head of hair that just sat on my head. I started to elaborate on that and began to add lines to the song about my hair.

You've done concerts where you've changed clothes without ever leaving the stage.
For one show he dressed me in a color that I just loved—a mauvey violet. I came out first in pants and a jacket, I took off the jacket so it looked like I had on a bustier, and then I took off the pants to reveal this little short, fringed dress. At the end I put on a skirt that matched the bustier and it looked like I had a gown on. The skirt had been hooked on the piano, so I just turned around in a transitional moment and wrapped it around me, and suddenly, I had on this gown and I'd never left the stage.

In 1981, he dressed you for the film *Pennies From Heaven*, the film you starred in with Steve Martin. What was that like?
It was great. He got to design real clothes. A lot of people don't realize he can do that. A lot of costume designers buy things. But Bob had his workers knitting me sweaters. He made sure everything was something that my character would wear. And then for the fantasy numbers, he'd do the shiny stuff.

Bob did a very important dress for you in 1996.
He made my wedding dress as a gift. It was an off-white—cream almost—satin-backed crepe dress. It was strapless. It looked like a dress had dropped out of the heavens and just wrapped itself around me. I had a traditional veil—just tulle with some little flowers in my hair.

Is that your favorite Mackie?
My favorite dress, the one I'm most comfortable in, is a black, strapless, hammered satin dress. It's years old but I still wear it.

If you're still wearing it, it must look great.
The thing that Bob does that's so great is that he designs for you. He really knows your colors and what will look good on you. They flatter the figure and they flatter the body. He knows how to make a woman look beautiful.

You're a front-row fixture at Bob's fashion shows. How would you describe them?
They're luscious. They're different each time, but they're luscious. It's funny, my husband, Michael Wittenberg, didn't know the history I have with Bob Mackie. I took him to one of the fashion shows and he said, "This is the way you should dress." He wanted to buy me everything in the show.

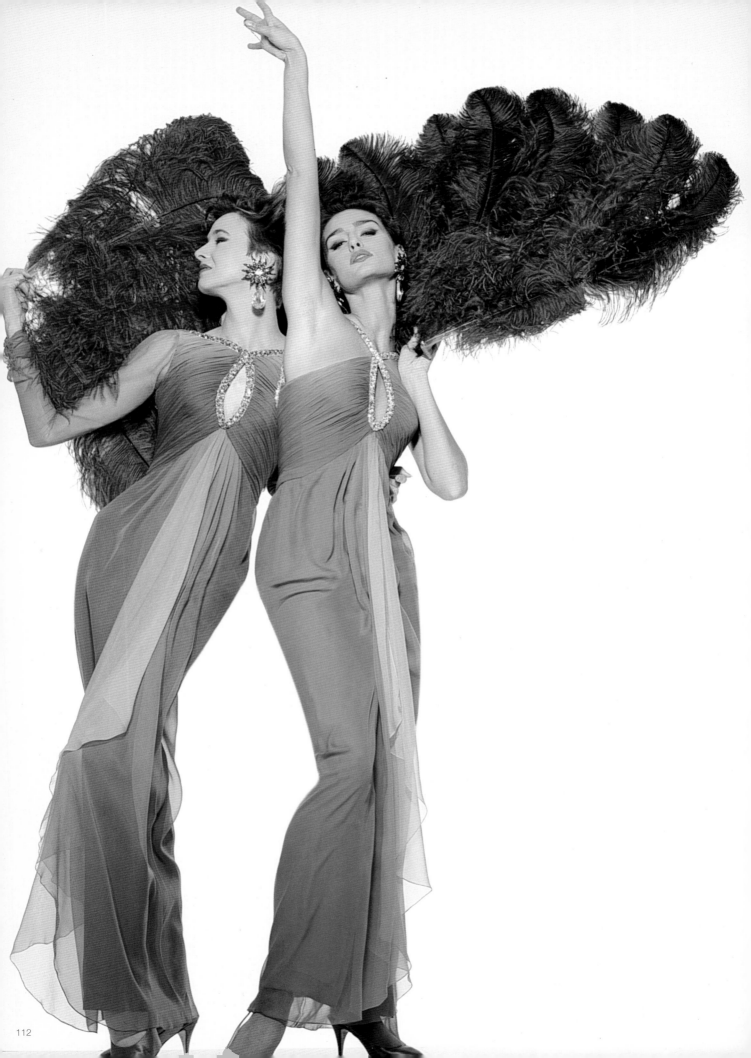

going public

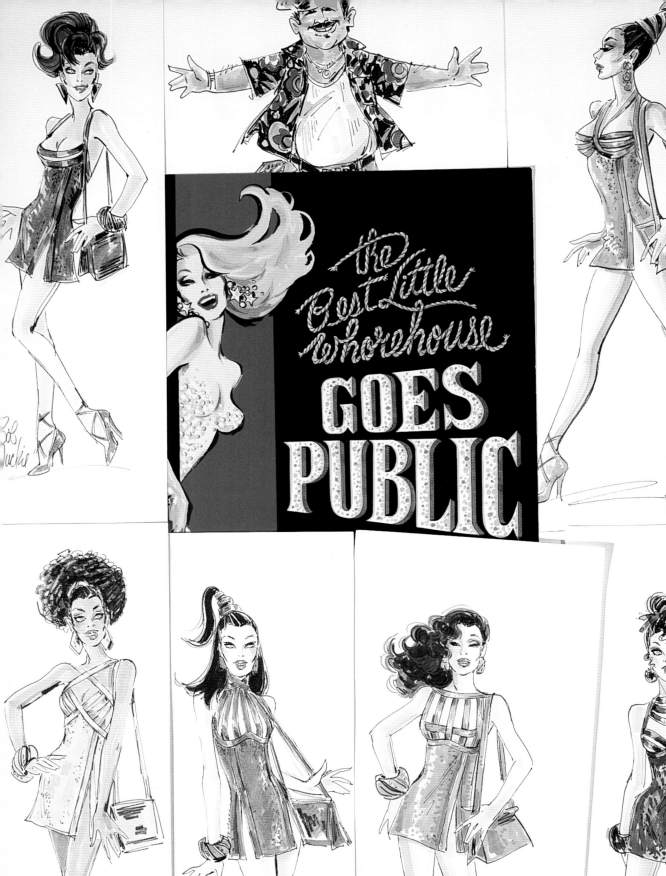

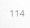

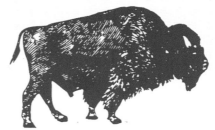

MOON OVER BUFFALO

The New Comedy by
KEN LUDWIG

also starring
Randy Graff

Dennis Ryan Andy Taylor Kate Miller
James Valentine
and
Jane Connell

Scenic Design by · Costume Design by · Lighting Design by
Heidi Landesman · **Bob Mackie** · **Ken Billington**

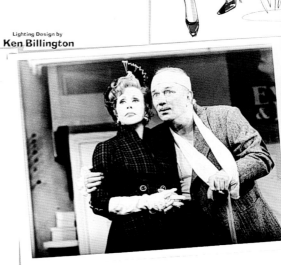

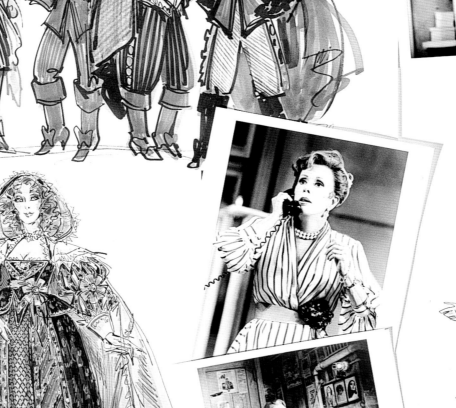

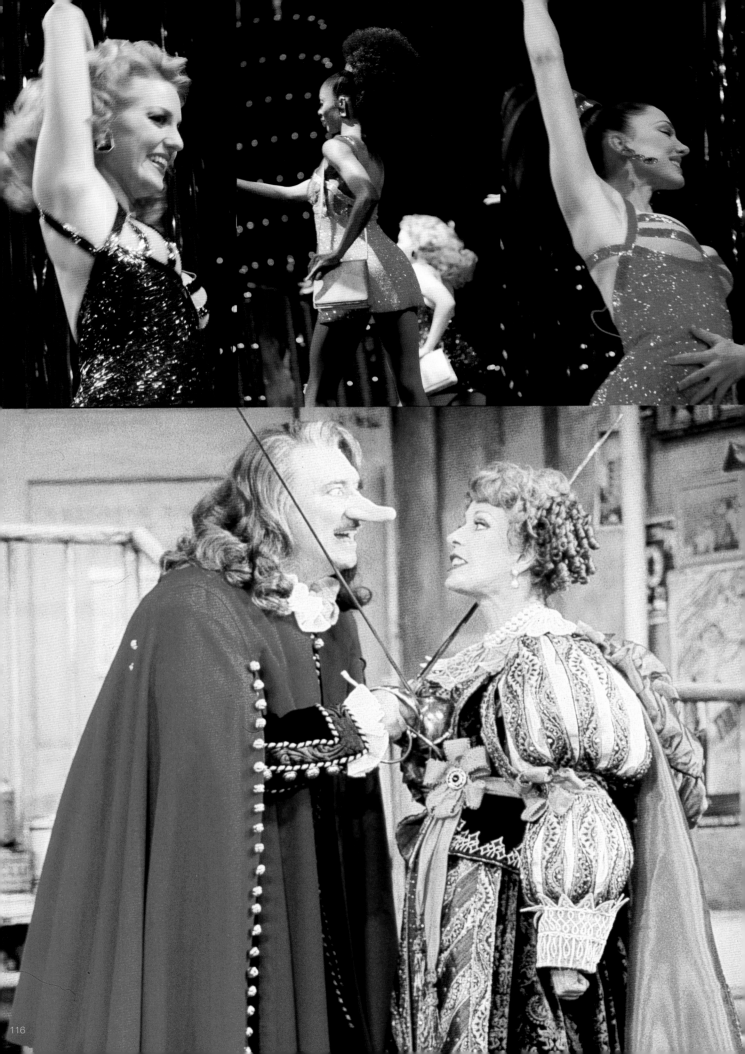

Mackie, sad to say, has never been associated with a huge theatrical success. "Nothing I've done has ever been a killer hit," the designer admits. But even in a gobbler the size of *The Best Little Whorehouse Goes Public*, starring Christina Youngman, Amy N. Heggins, and Pamela Everett, his ingenious costumes have been reason enough to pay the ticket price. In that 1994 sequel to *The Best Little Whorehouse in Texas*, Mackie had two brilliant moments—a courthouse scene in which the hookers wore "respectable" clothes and a Las Vegas production number, complete with one character dressed simultaneously as both Siegfried and Roy. Subtle, it wasn't.

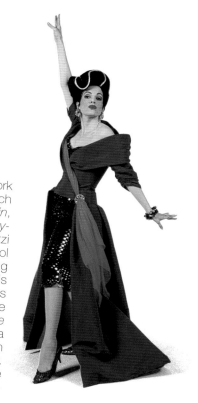

Over the years, Mackie's work for the theater has included such productions as *Ain't Misbehavin*, starring the Pointer Sisters; *Anything Goes*, starring Mitzi Gaynor; *Lorelie*, starring Carol Channing; *On the Town*, starring Bernadette Peters and Phyllis Newman; and the Los Angeles production of *Ruthless*, the campy musical based on *The Bad Seed*, featuring Rita McKenzie, Joan Ryan, Loren Freeman, and Lindsay Ridgeway. He has costumed many stage productions starring Carol Burnett, including *Plaza Suite*, in which she costarred with George Kennedy, *Same Time, Next Year* with Dick Van Dyke, and *I Do, I Do* opposite Rock Hudson. More recently, he designed the costumes for *Moon Over Buffalo*, which costarred Burnett and Philip Bosco and was the subject of the documentary *Moon Over Broadway*. His most recent project is *Putting It Together*, a Stephen Sondheim revue starring Burnett, which is expected to open on Broadway in late 1999.

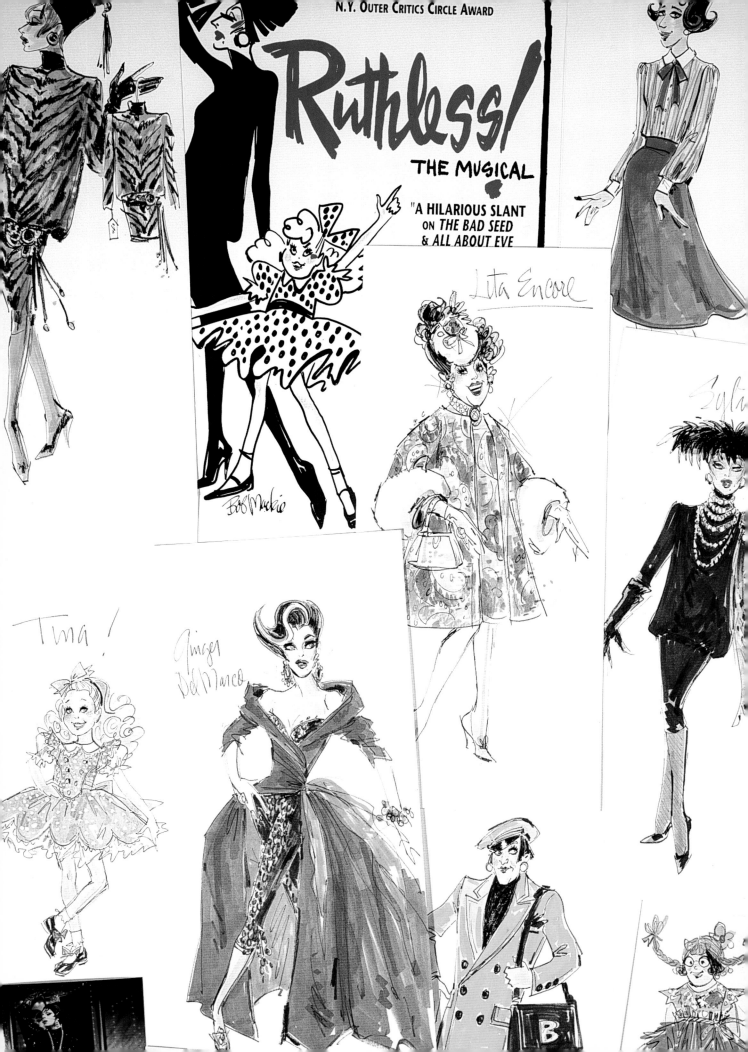

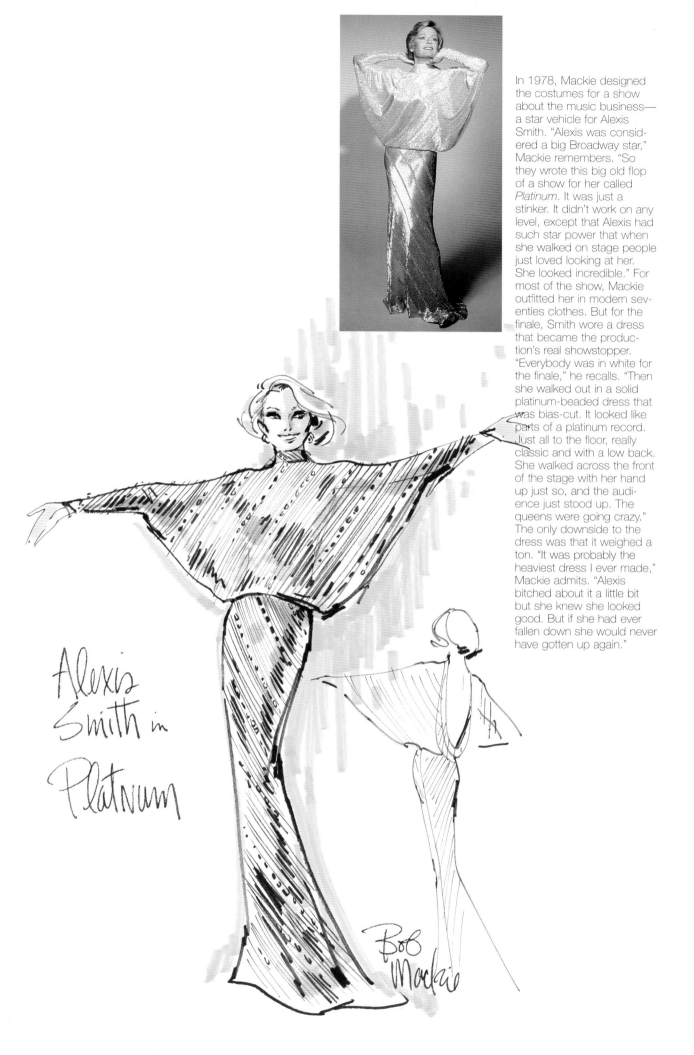

In 1978, Mackie designed the costumes for a show about the music business— a star vehicle for Alexis Smith. "Alexis was considered a big Broadway star," Mackie remembers. "So they wrote this big old flop of a show for her called *Platinum*. It was just a stinker. It didn't work on any level, except that Alexis had such star power that when she walked on stage people just loved looking at her. She looked incredible." For most of the show, Mackie outfitted her in modern seventies clothes. But for the finale, Smith wore a dress that became the production's real showstopper. "Everybody was in white for the finale," he recalls. "Then she walked out in a solid platinum-beaded dress that was bias-cut. It looked like parts of a platinum record. Just all to the floor, really classic and with a low back. She walked across the front of the stage with her hand up just so, and the audience just stood up. The queens were going crazy." The only downside to the dress was that it weighed a ton. "It was probably the heaviest dress I ever made," Mackie admits. "Alexis bitched about it a little bit but she knew she looked good. But if she had ever fallen down she would never have gotten up again."

Alexis Smith in Platinum

Bob Mackie

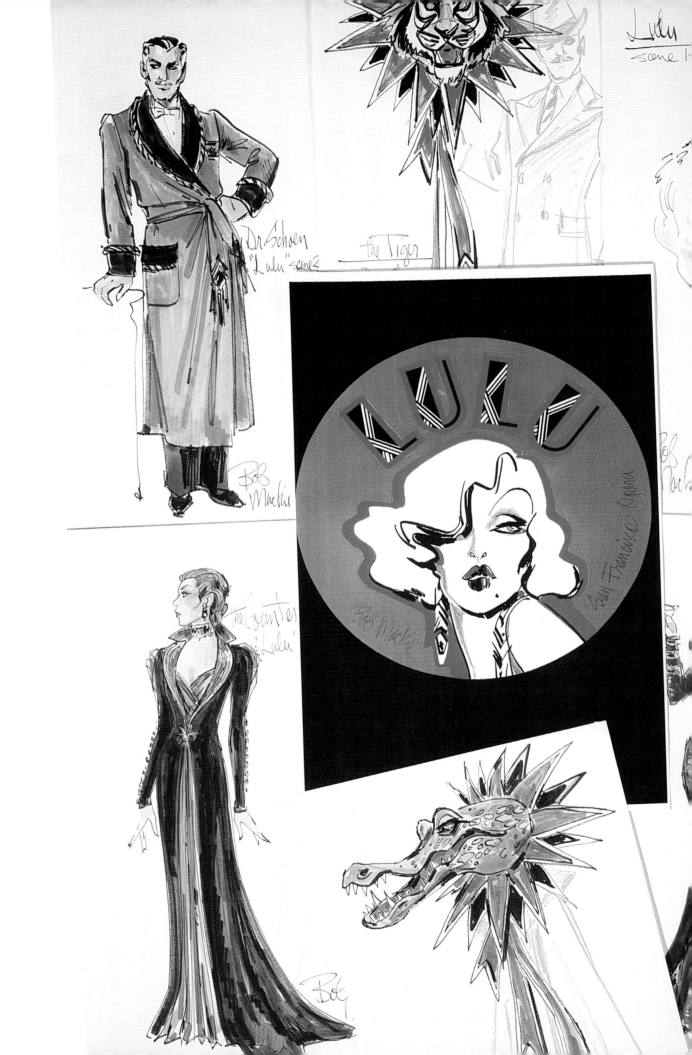

Dr. Schoen
"Lulu" scene 2

The Tiger

Lulu
scene 1

Bob
Mackie

LULU

Bob Mackie

San Francisco Opera

The Countess
"Lulu"

Bob

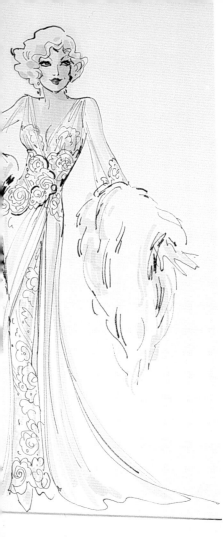

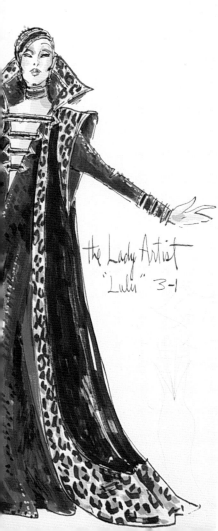

the Lady Artist
"Lulu" 3-1

In 1989, Mackie designed his first opera, Alban Berg's *Lulu*, for the San Francisco Opera. It was not his favorite opera, but it was a chance to create costumes on a grand scale. "Even for my line, it's a little over the top," he told the *San Francisco Chronicle*. For *Lulu*, he dressed the title character in the style of Louise Brooks, who played Lulu in the 1929 G. W. Pabst silent movie *Pandora's Box*. "We made Lulu gorgeous," he says, having outfitted the amoral heroine in such costumes as a hand-beaded, black hooded fox-trimmed velvet gown that would have cost $14,000 at retail that year. "Bob Mackie's costumes were eye-catching, distinctive, and hand-somely executed, especially Lulu's," one review stated. Nine years later, Mackie was asked to redesign the opera for a new version at the San Francisco Opera. "We changed it and did her as Jean Harlow, which worked almost better for the new production. She just seduces the world: men, women, dogs—anything that will walk on that stage. She'll just have her way with them and then they're destroyed forever. It's not a happy saga. And in the end Jack the Ripper kills her. It's just unbelievable. How did he ever think of this?" Mackie says he is itching to do another. "I'd love to do more opera but I'd like to do something that's not set in the 1930s. I'd just love to get my teeth into another period. The thing that's so odd about an opera is that it costs a fortune and maybe they'll only play it six times and then they put it away. It's as elaborate as a Broadway show and sometimes they don't do it again for another ten years. I suppose if you do a production of *Carmen* or something they'll yank it out every couple of years because the audience loves it. But this one is so esoteric, I don't think there are too many people who adore it, but maybe there are."

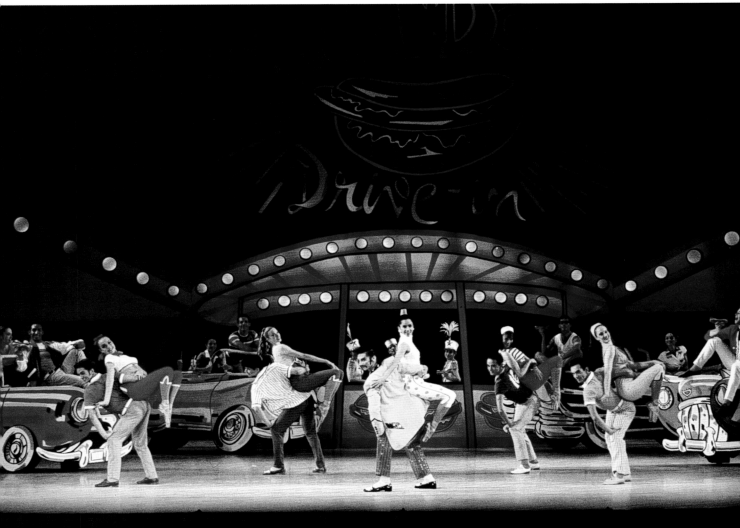

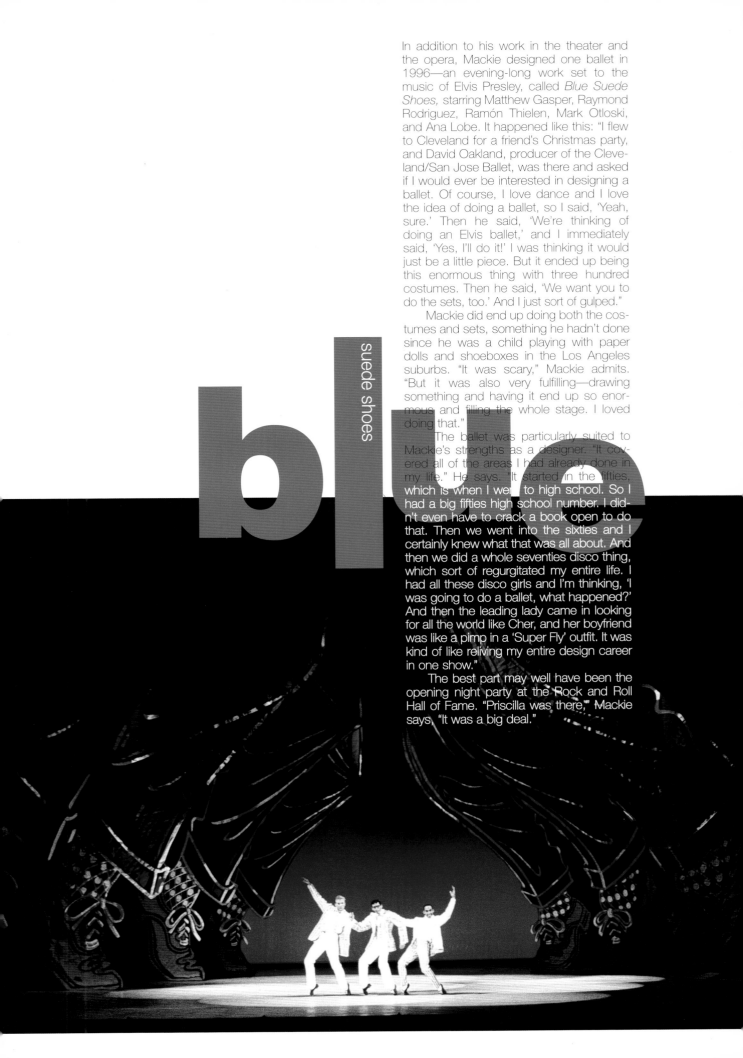

In addition to his work in the theater and the opera, Mackie designed one ballet in 1996—an evening-long work set to the music of Elvis Presley, called *Blue Suede Shoes,* starring Matthew Gasper, Raymond Rodriguez, Ramón Thielen, Mark Otloski, and Ana Lobe. It happened like this: "I flew to Cleveland for a friend's Christmas party, and David Oakland, producer of the Cleveland/San Jose Ballet, was there and asked if I would ever be interested in designing a ballet. Of course, I love dance and I love the idea of doing a ballet, so I said, 'Yeah, sure.' Then he said, 'We're thinking of doing an Elvis ballet,' and I immediately said, 'Yes, I'll do it!' I was thinking it would just be a little piece. But it ended up being this enormous thing with three hundred costumes. Then he said, 'We want you to do the sets, too.' And I just sort of gulped."

Mackie did end up doing both the costumes and sets, something he hadn't done since he was a child playing with paper dolls and shoeboxes in the Los Angeles suburbs. "It was scary," Mackie admits. "But it was also very fulfilling—drawing something and having it end up so enormous and filling the whole stage. I loved doing that."

The ballet was particularly suited to Mackie's strengths as a designer. "It covered all of the areas I had already done in my life." He says. "It started in the fifties, which is when I went to high school. So I had a big fifties high school number. I didn't even have to crack a book open to do that. Then we went into the sixties and I certainly knew what that was all about. And then we did a whole seventies disco thing, which sort of regurgitated my entire life. I had all these disco girls and I'm thinking, 'I was going to do a ballet, what happened?' And then the leading lady came in looking for all the world like Cher, and her boyfriend was like a pimp in a 'Super Fly' outfit. It was kind of like reliving my entire design career in one show."

The best part may well have been the opening night party at the Rock and Roll Hall of Fame. "Priscilla was there," Mackie says, "It was a big deal."

suede shoes

blue

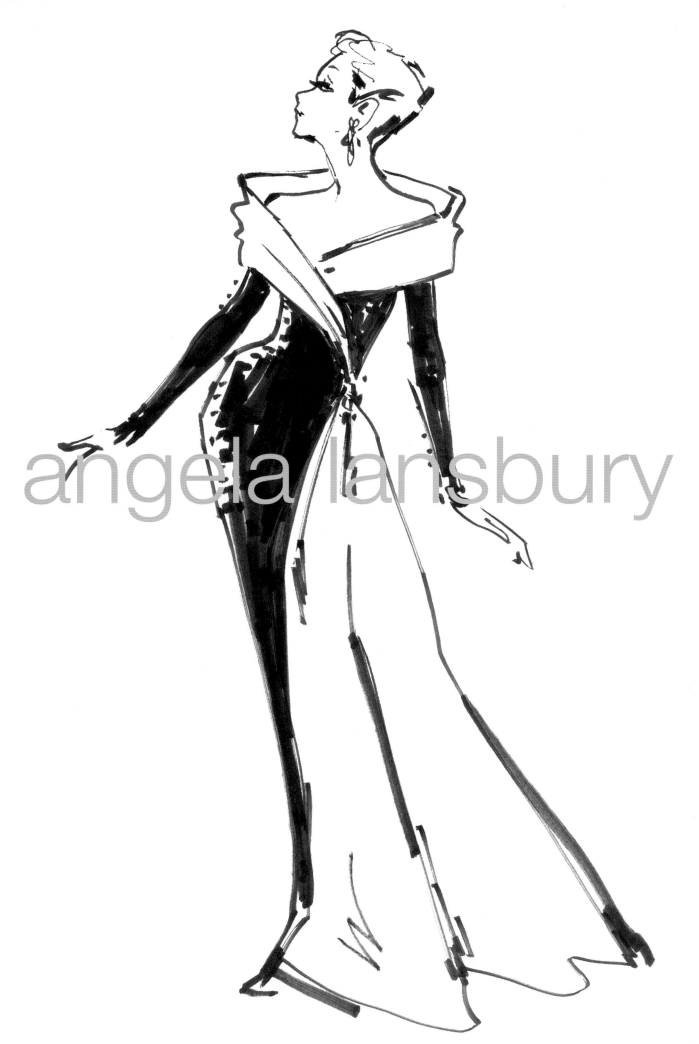

You first wore Bob's clothes at the Academy Awards in 1972, but the Mackie dress everyone remembers is the one you wore at the Tony Awards in 1987.

The memorable dress, the one everyone wanted, the one everyone adored, was the black dress with the white, stand-up collar in which I sang "Bosom Buddies" with Beatrice Arthur.

That was an amazing night. How did it feel to look that good?

Just prior to 1987, I'd lost about sixteen pounds, and I came out on stage looking even thinner thanks to the gown's wonderful inner construction. Up until that time I'd been considered a church mouse as far as fashion was concerned, but that night I blossomed forth like a moth from a chrysalis. It was this wonderful new look which knocked people for a loop. For the first time in my life, I had a sense of myself as someone who could be fashionable. I'm extraordinarily grateful to Bob for that. But it required that I live up to it from then on.

And you have. How does it feel to wear such clothes on stage?

It hurts, usually. You're not your most comfortable self, but you know you look like a million dollars, so you don't give a darn. You're prepared to feel constricted to create this marvelous effect.

Bob designed the black sequined dress you wore when you sang the theme to *Beauty and the Beast* at the Universal Amphitheater in 1991, as well as the red sequined dress you wore when you performed at the opening of EuroDisney in France the same year. What was it like to wear those outfits?

I knew as I stood in a sheath of brilliance that I was halfway home. That's what a performer needs, particularly someone who isn't normally associated with glamour. There are times when you need that support, and then you can go ahead and do your thing. As actors, we're really rather earthy souls, but we're capable of revealing extraordinary glamour. That's why we're actors. Glamour is one of the things we act. You have to be very serious and involved with your own glamour to carry it off.

Bob did your costumes for the 1997 TV special *Mrs. Santa Claus*.

Jerry Herman, who wrote the music and lyrics, first came to me with the project. I was a little worried because it sounded like milk and honey and donuts with raisins for eyes. But finally we got the script right. I told the producers that my one provision in doing it is that they consider having Bob Mackie do the costumes. Thank God I did. Bob created a wonderful look for me. I went from being Mrs. Santa Claus to being a very glamorous woman singing a torch song. And then he created a gown for the end with a lovely red cape with a fox-fur trim. He just went to town. There was no question that he should have won an Emmy for it.

What was he like on the set?

He's an absolute perfectionist. He never stops fiddling, tweaking, adjusting. He comes on the set and he's completely focused on his costumes—his babies. Nothing gets past him. He's ever watching. His enthusiasm and his excitement about what he is creating are great. He makes you feel like a million dollars when he's working with you. Bob's a one-off, a very rare bird. He's really quite marvelous. Much, much too self-effacing, though. He doesn't blow his horn loud enough.

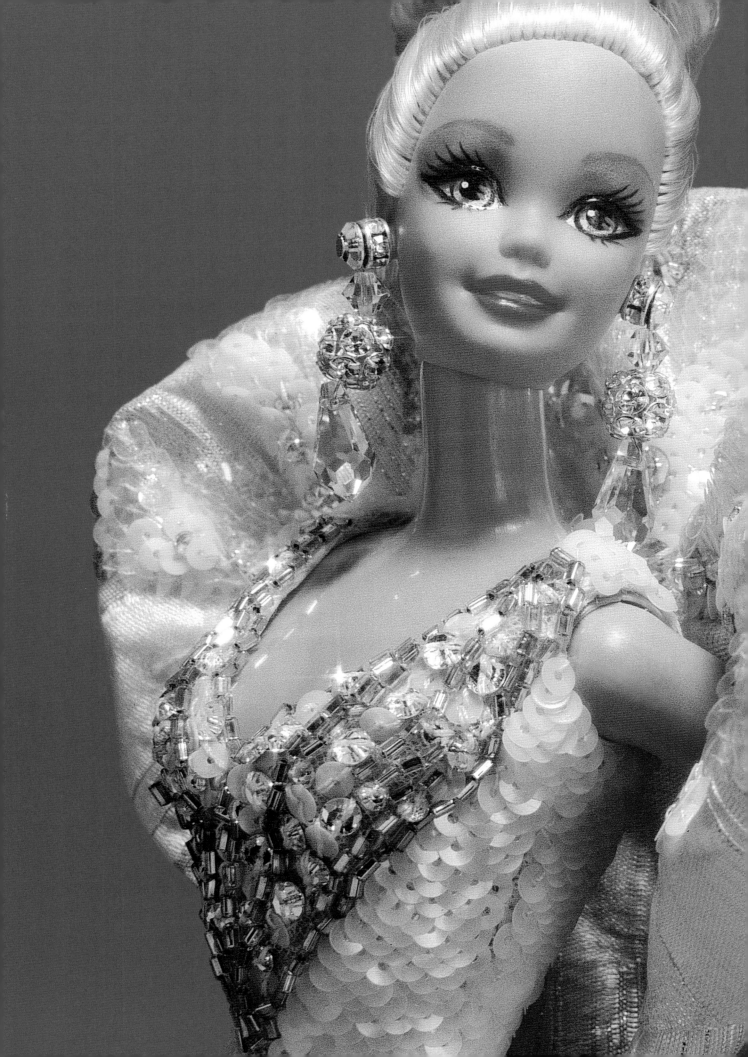

Barbie

Bob Mackie's designs for America's favorite doll represent the most exciting work he has done in the nineties. Only twelve inches tall, Barbie has proven to be Mackie's greatest model since Cher first slipped into a sequined loincloth. **F**or almost a decade, the designer has outfitted the now forty-year-old plastic plaything in luxurious clothes that recall some of his most famous creations—taken one step further. Barbie as the Queen of Hearts. Barbie as a Neptune Fantasy. Barbie as a Moon Goddess. "It's a weird thing for a grown man to be designing Barbie dolls," Mackie says. But he has produced each one with the same enthusiasm he had when he dressed Jayne Mansfield for the Art Student's Ball at Chouinard all those years ago. **W**ith playful names like "Diamond Dazzle" and "Madame du Barbie," his fantastical designs have helped establish the collectible Barbie doll market, and helped rank dolls as the second most popular collectible in America behind stamps. The tradition of glamour Mackie forged with Cher, Carol Burnett, and other celebrated performers is carried on in such dolls as the 1995 "Goddess of the Sun Barbie," wearing a gown encrusted with 11,000 hand-sewn sequins and beads, and the 1992 "Empress Bride Barbie," with an explosion of tulle beneath her brocade overskirt. **T**oday, Barbie has joined the list of stars who have become known as "Mackie's Women," spurring the designer on to greater flights of fancy, coaxing even more screams of delight from his fans with each over-the-top creation. Asked in 1999 about the wealth of creativity upon which he has drawn for nearly forty years—the storehouse of ideas that produced Starlett O'Hara's curtain rod dress, Laverne Lashinsky's tiger-striped catsuit, and Barbie's 18th-century makeover—Mackie had this to say: "How do I think of all those things? It's like a really demented mind."

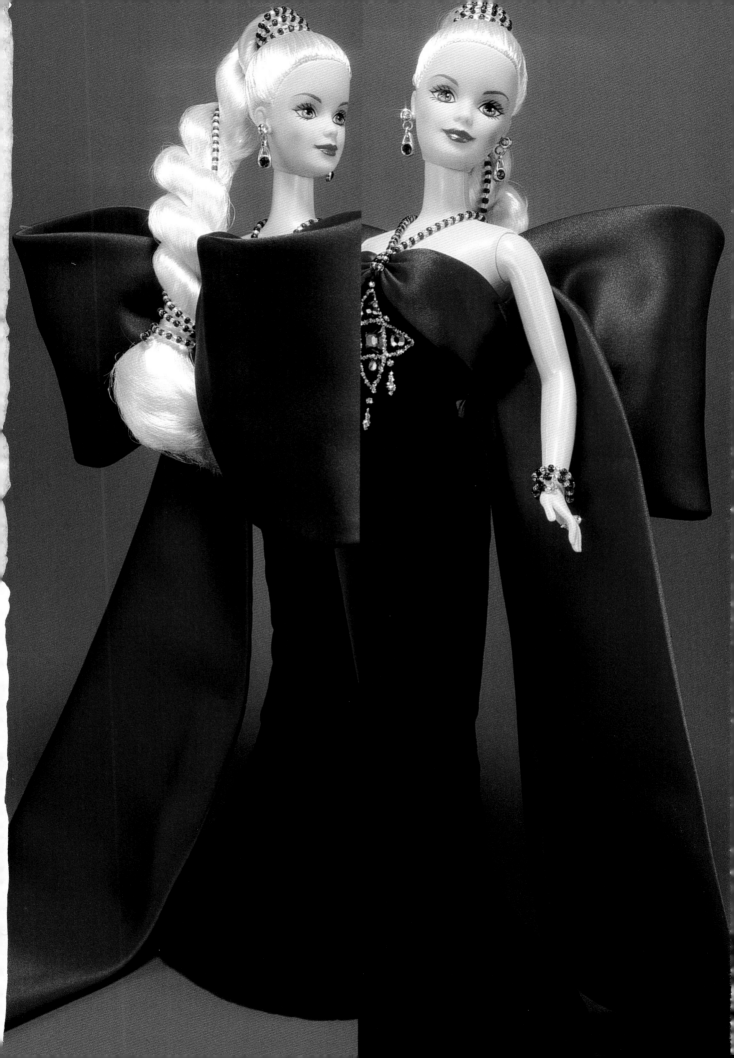

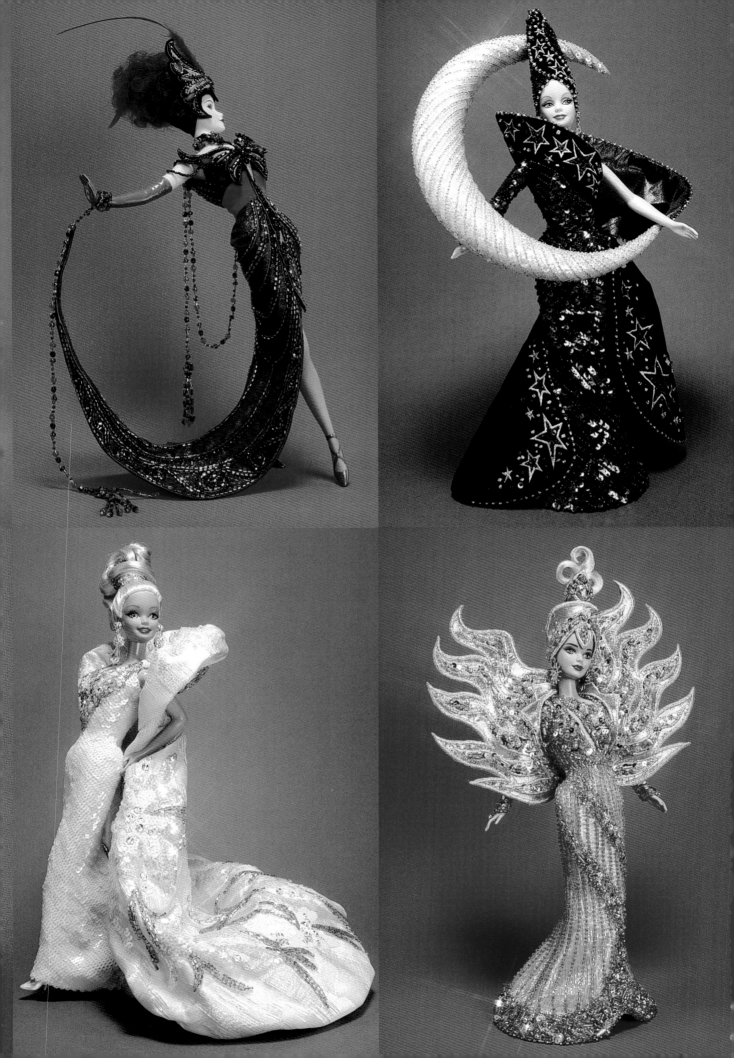

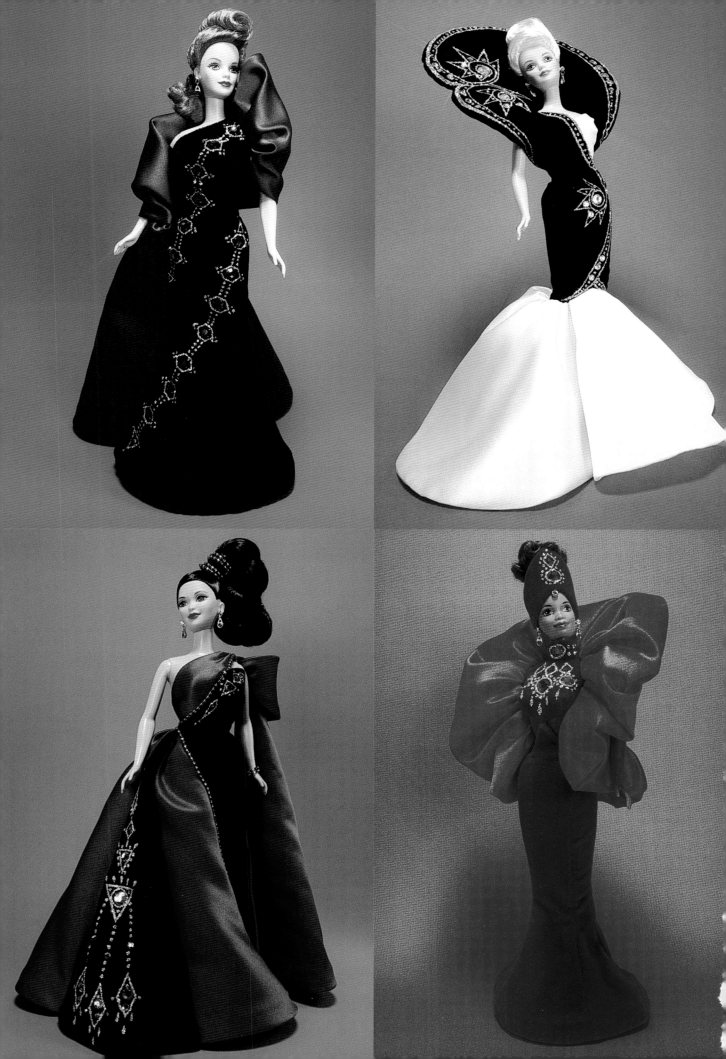

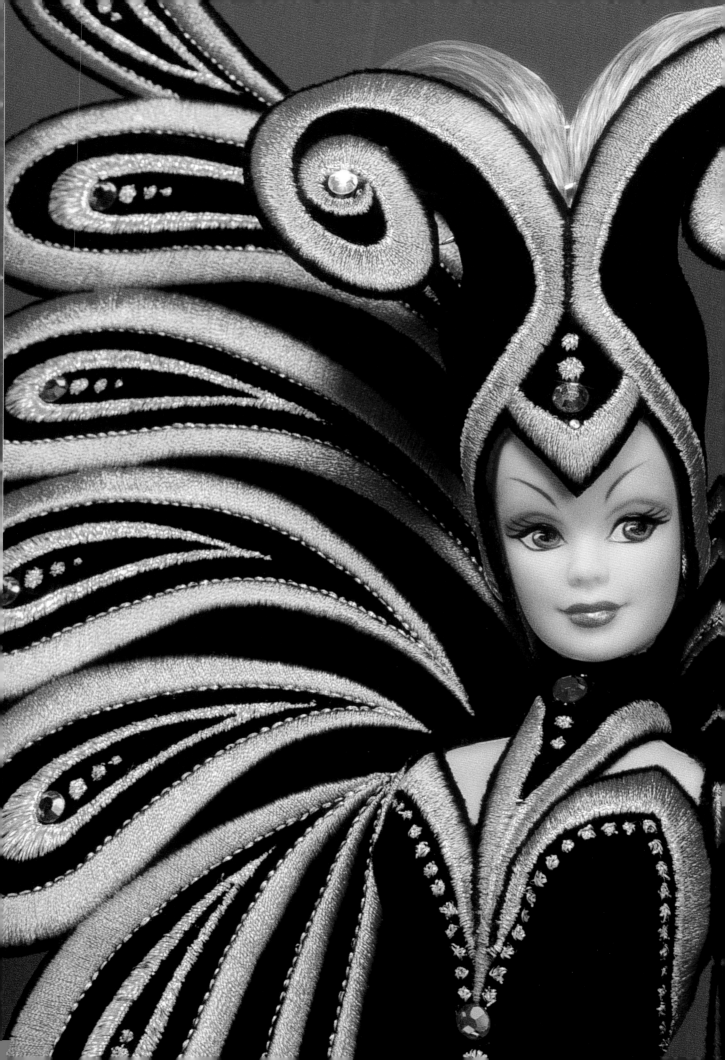

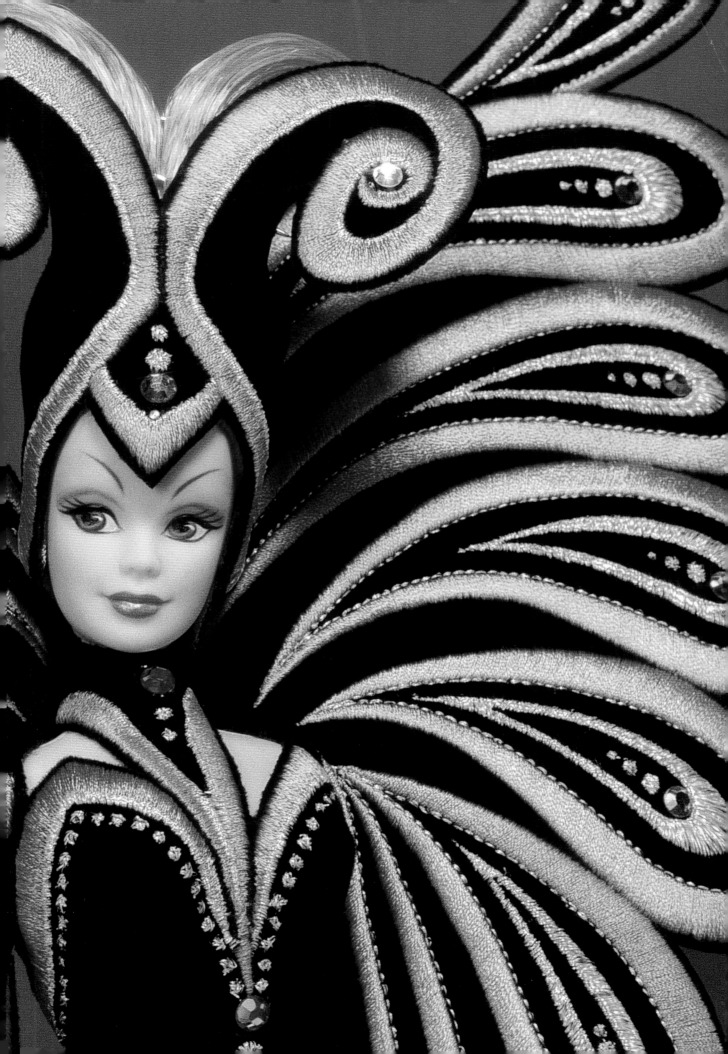

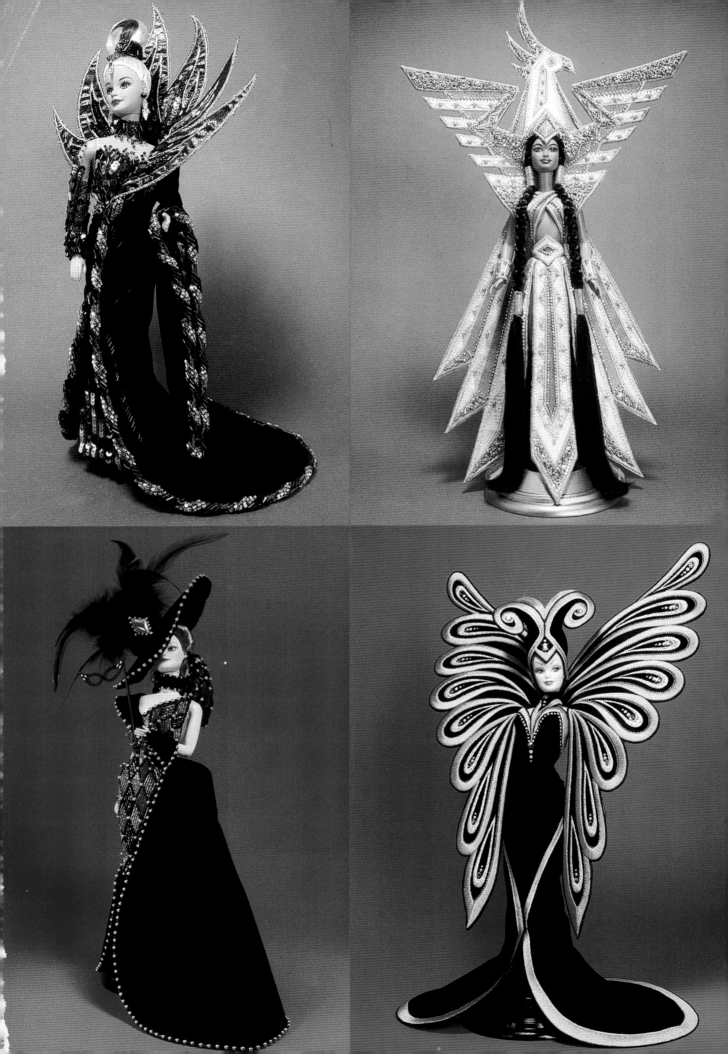

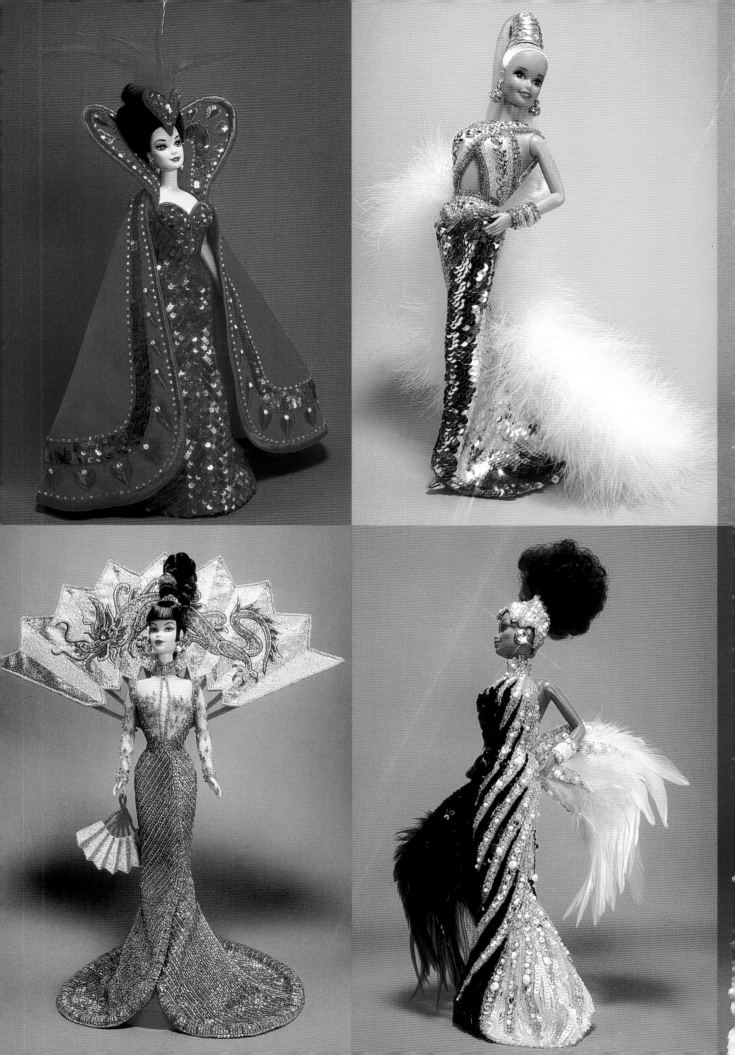

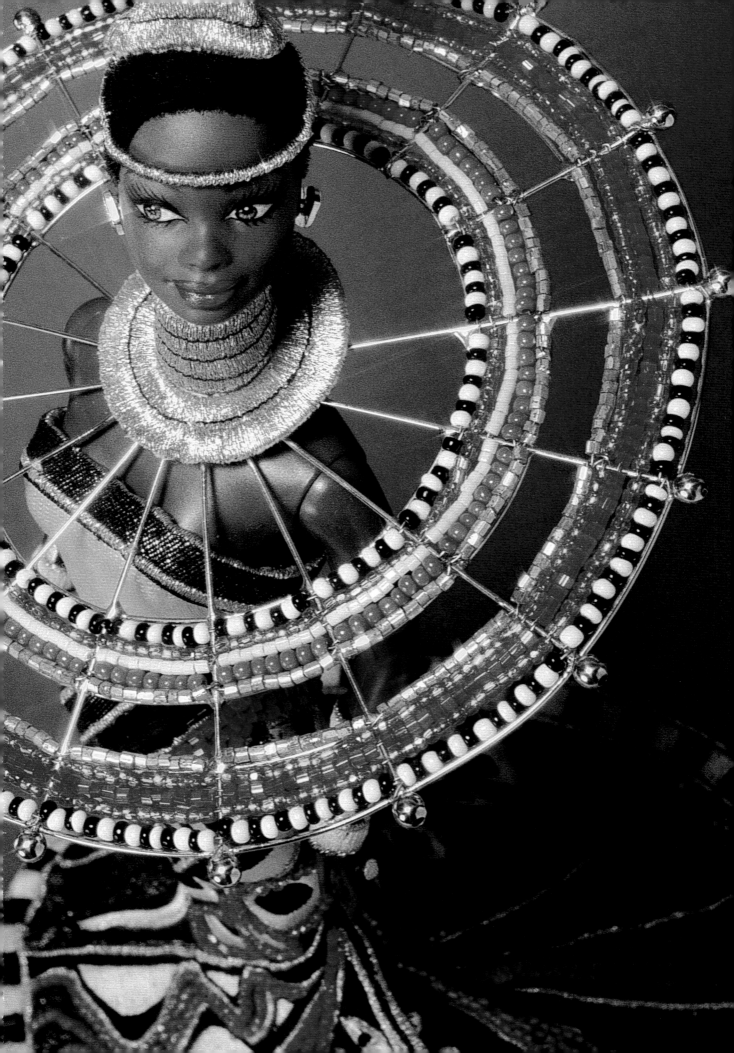

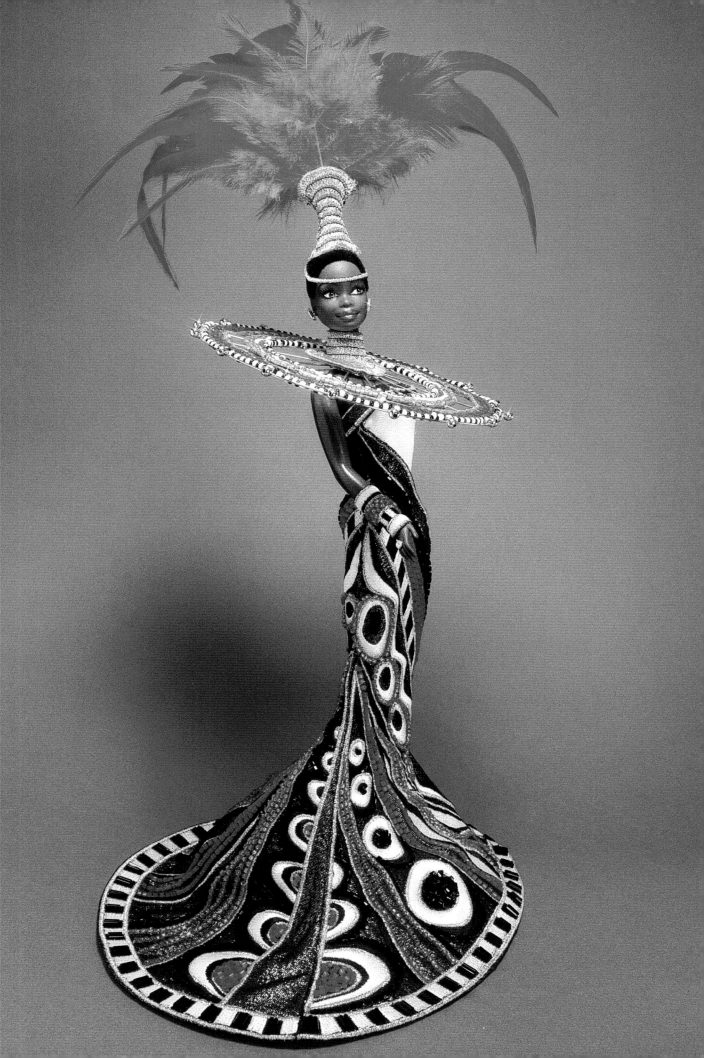

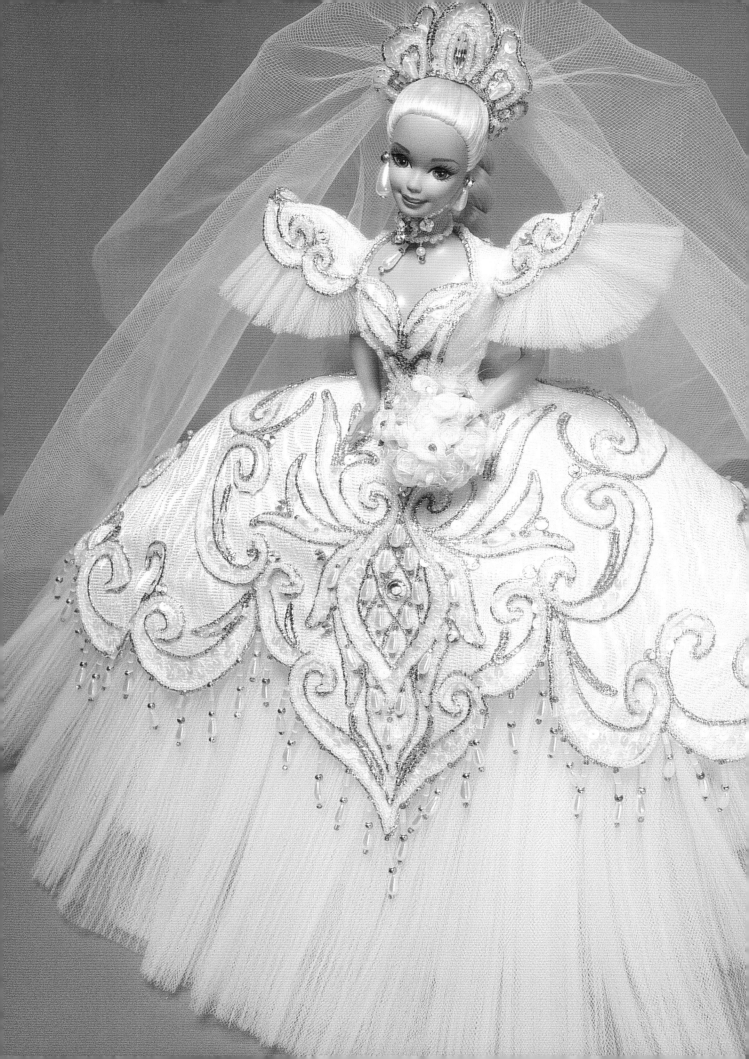

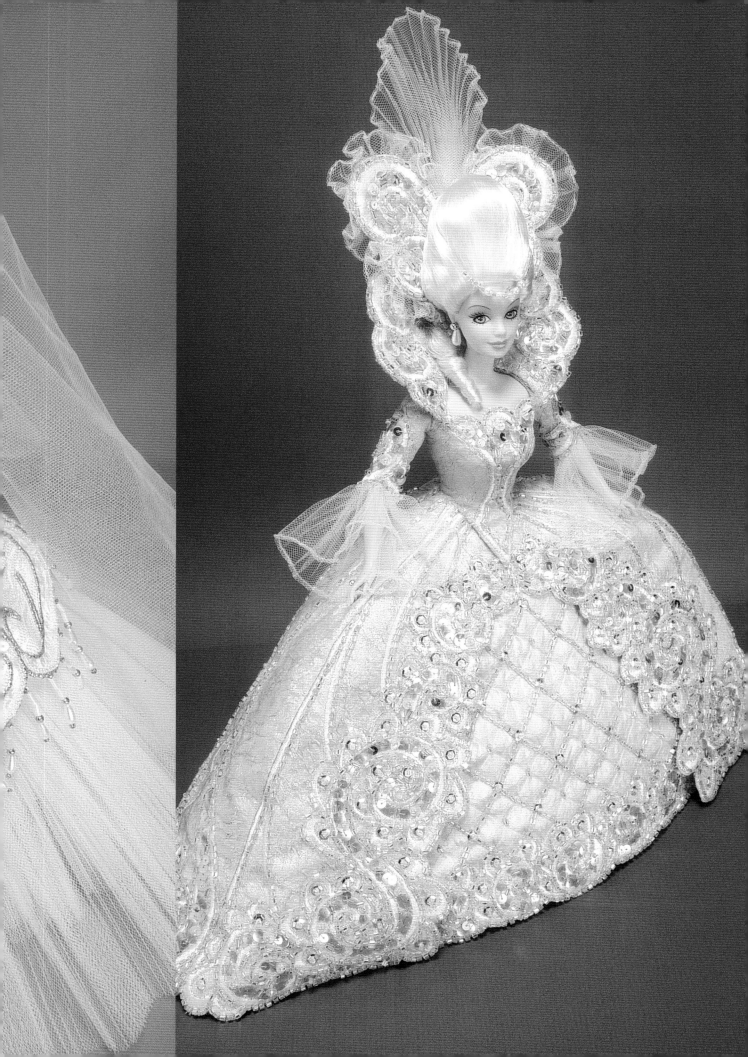

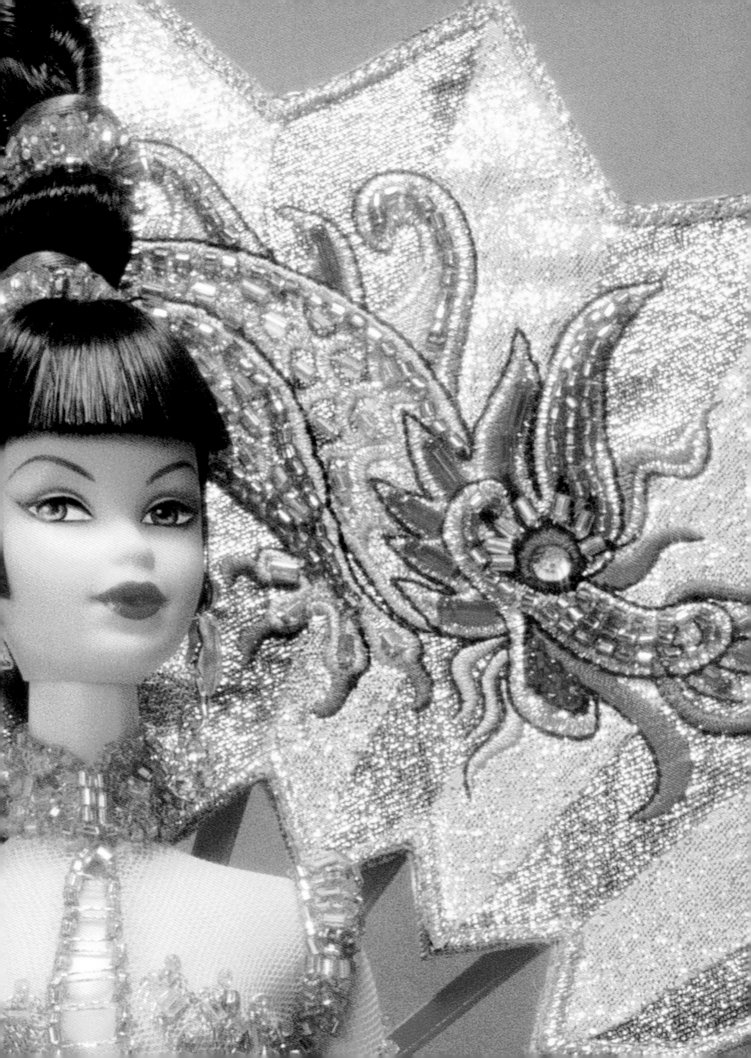

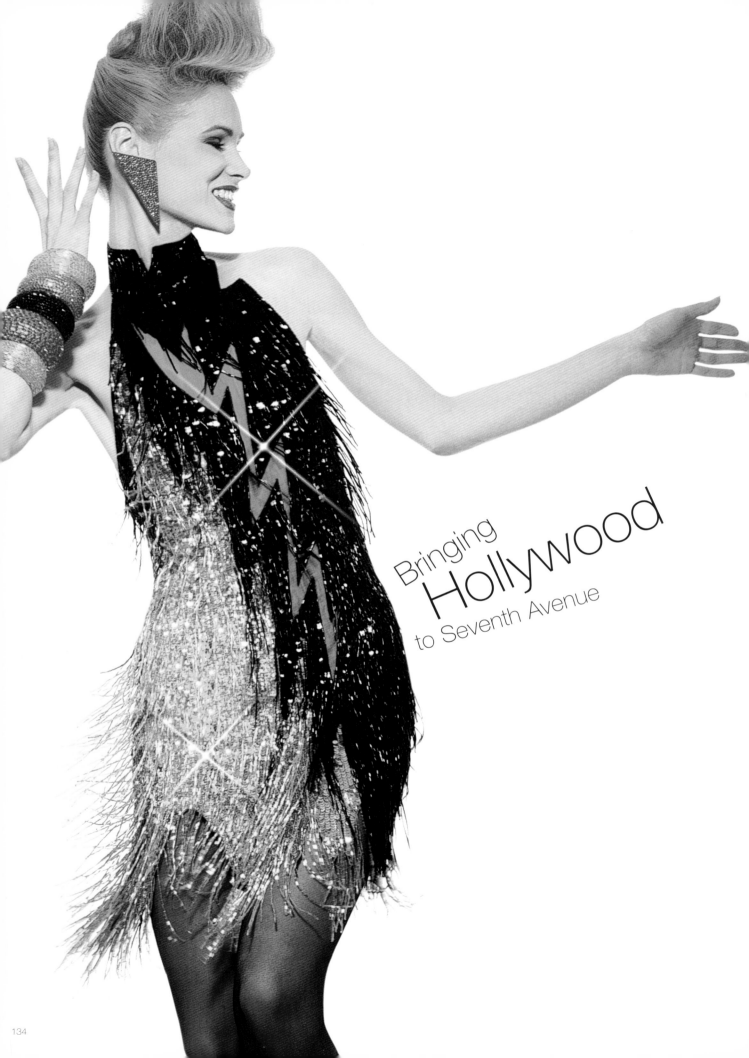

Bringing **Hollywood** to Seventh Avenue

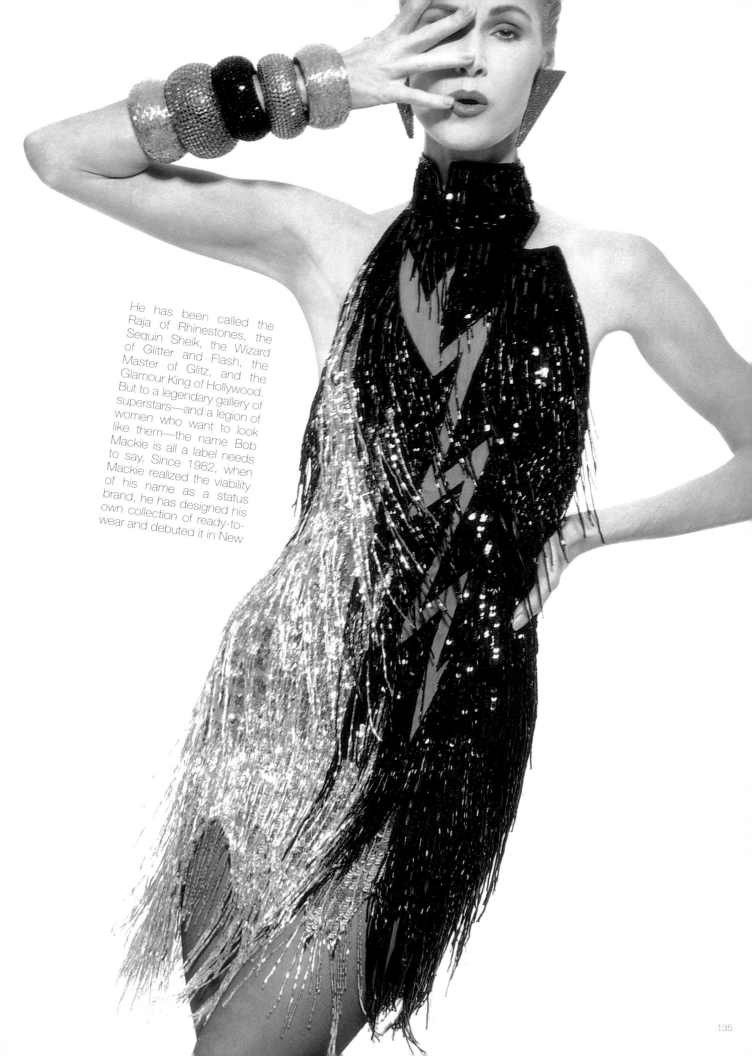

He has been called the Raja of Rhinestones, the Sequin Sheik, the Wizard of Glitter and Flash, the Master of Glitz, and the Glamour King of Hollywood. But to a legendary gallery of superstars—and a legion of women who want to look like them—the name Bob Mackie is all a label needs to say. Since 1982, when Mackie realized the viability of his name as a status brand, he has designed his own collection of ready-to-wear and debuted it in New

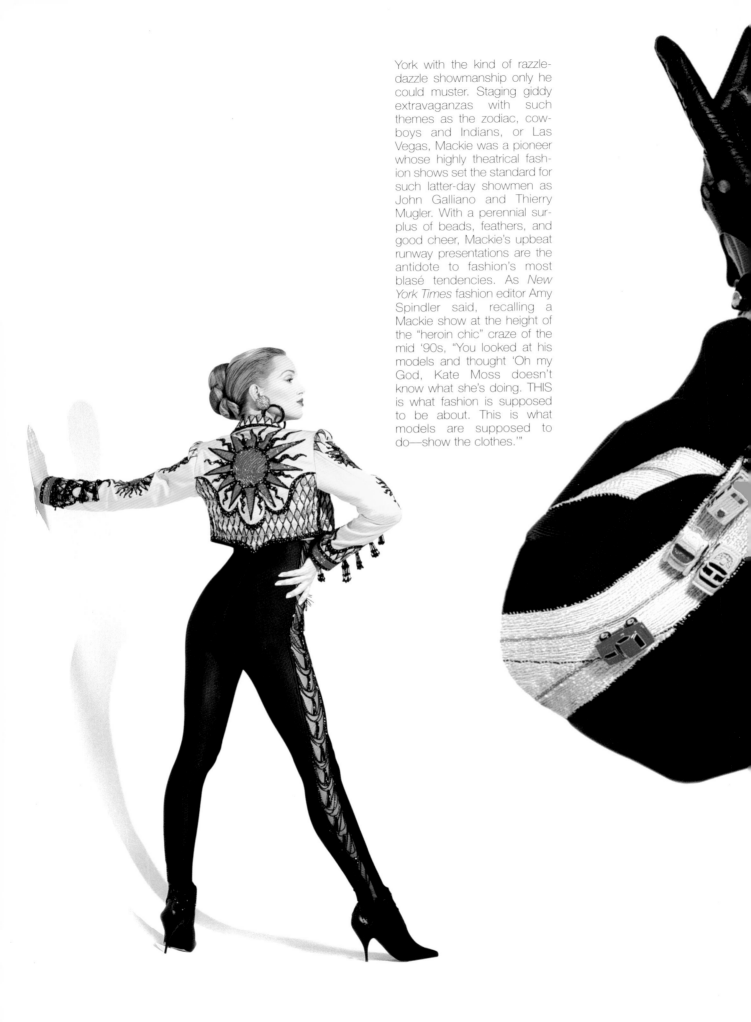

York with the kind of razzle-dazzle showmanship only he could muster. Staging giddy extravaganzas with such themes as the zodiac, cowboys and Indians, or Las Vegas, Mackie was a pioneer whose highly theatrical fashion shows set the standard for such latter-day showmen as John Galliano and Thierry Mugler. With a perennial surplus of beads, feathers, and good cheer, Mackie's upbeat runway presentations are the antidote to fashion's most blasé tendencies. As *New York Times* fashion editor Amy Spindler said, recalling a Mackie show at the height of the "heroin chic" craze of the mid '90s, "You looked at his models and thought 'Oh my God, Kate Moss doesn't know what she's doing. THIS is what fashion is supposed to be about. This is what models are supposed to do—show the clothes.'"

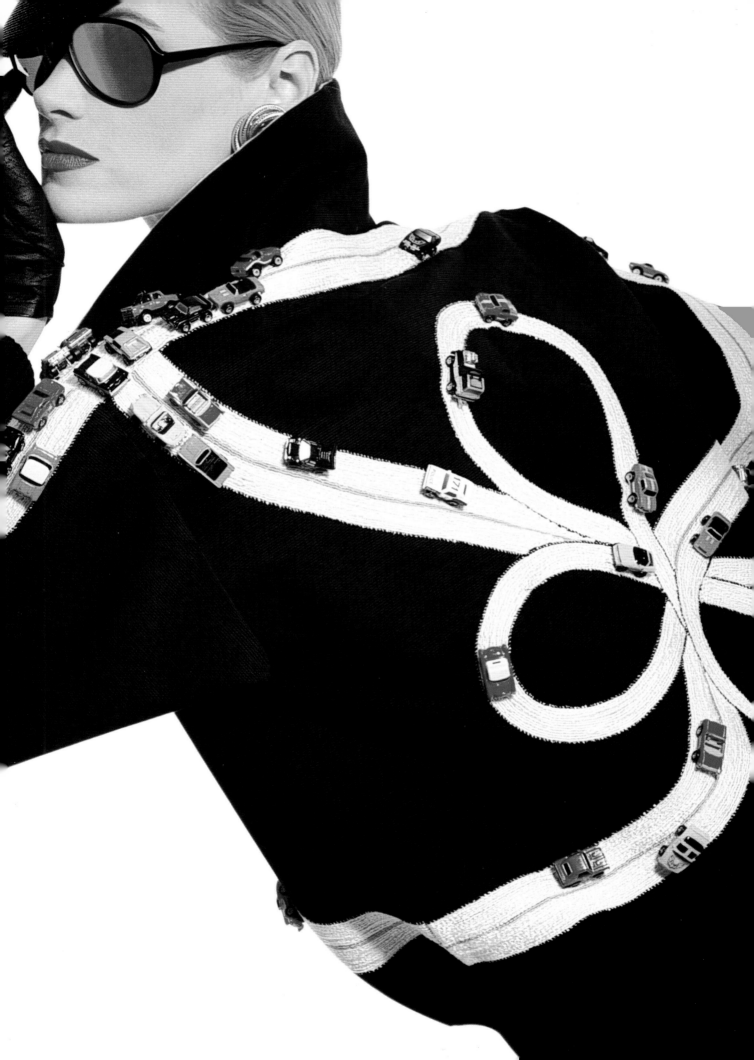

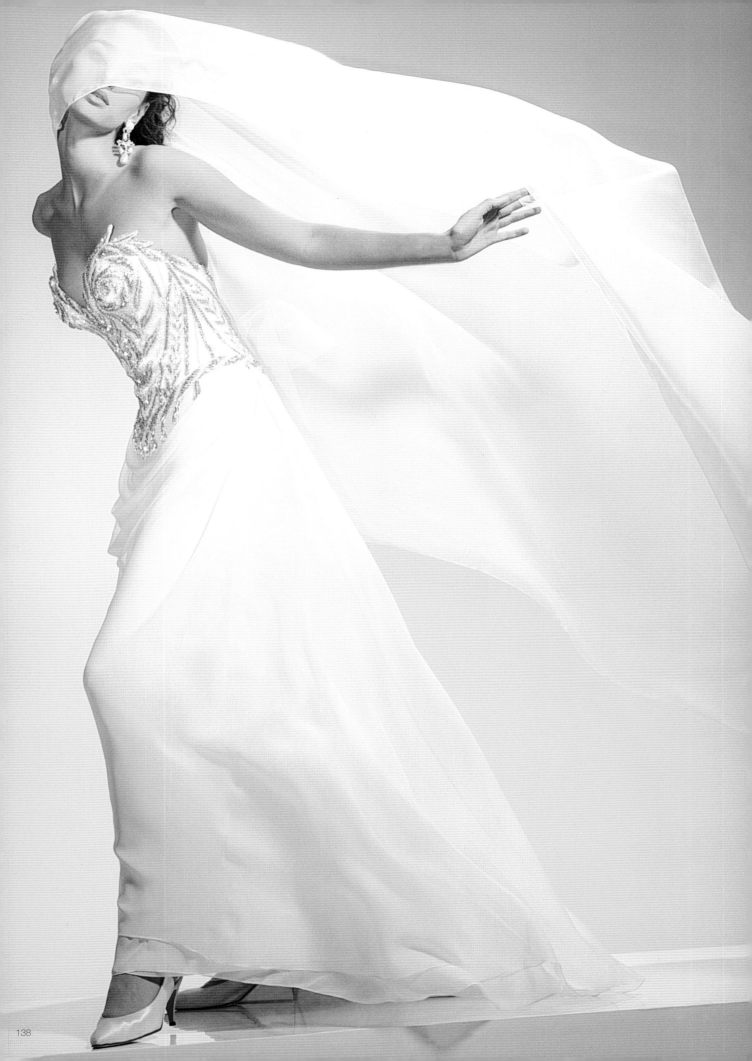

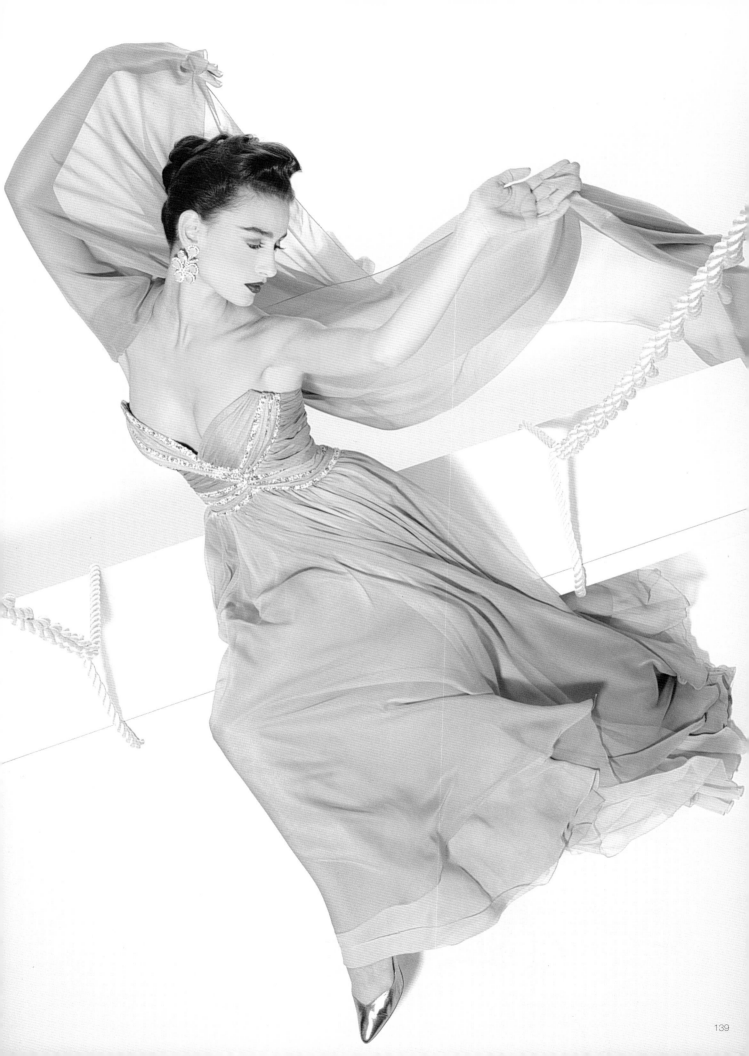

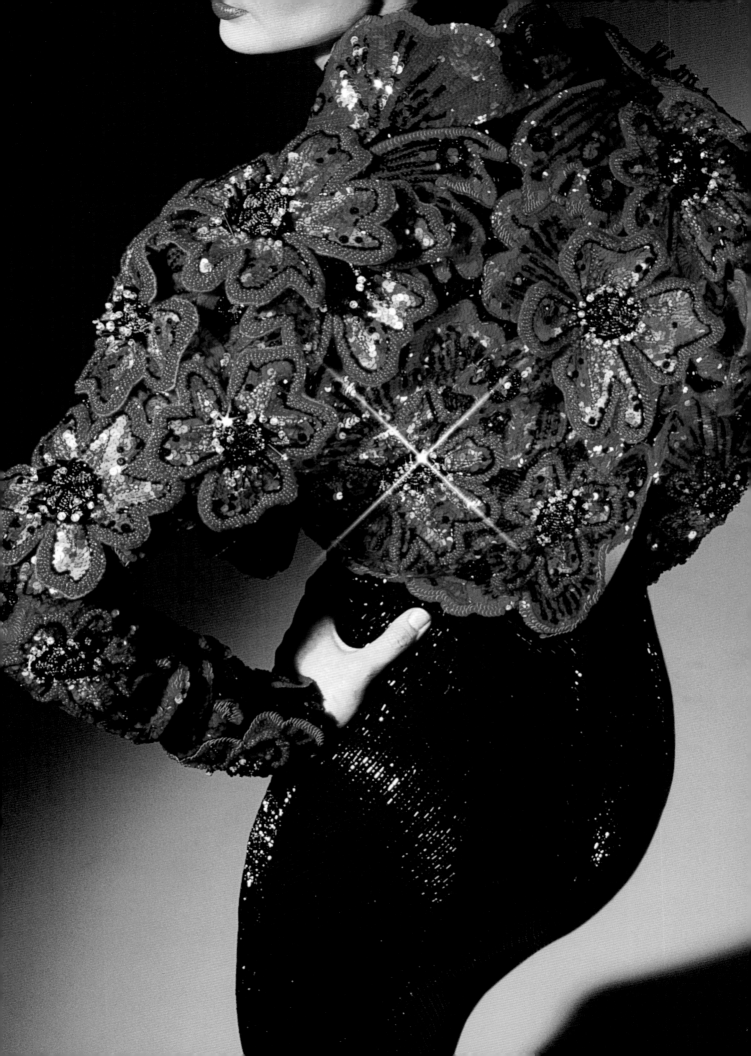

Although Mackie today eschews big fashion shows to concentrate on his thriving made-to-order business, his influence on style extends to fur, fragrance, furniture and more through a dozen or so licenses. "I'm an old fashioned designer—I just want to make flattering clothes for women," Mackie says. But there's more to it than that. "He represents everything good about fashion," says Spindler. "It's fringe and tassels and gold and brocade. It's everything dressing up was supposed to be when you were a kid. That's why drag queens and show people love him. He can make anyone look glamorous."

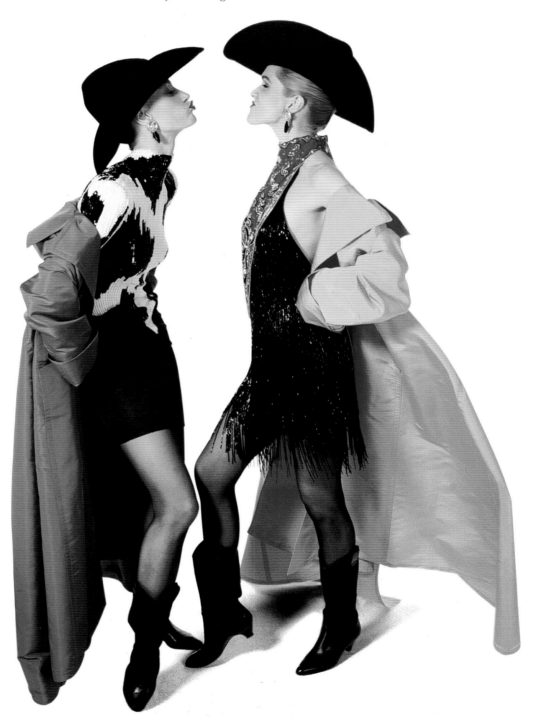

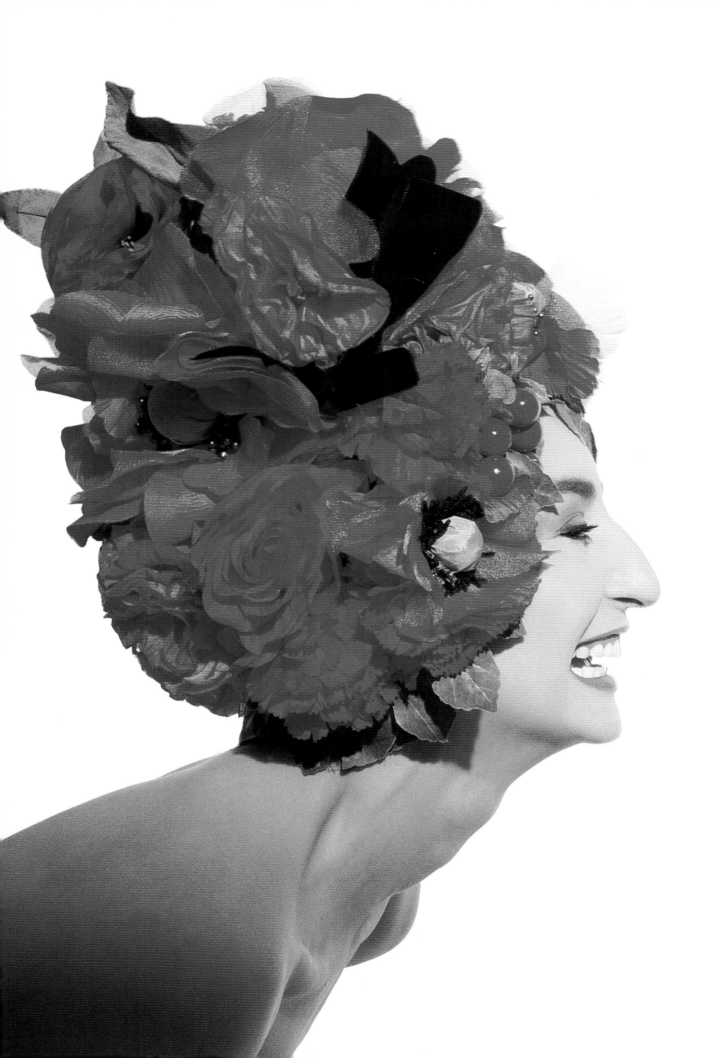

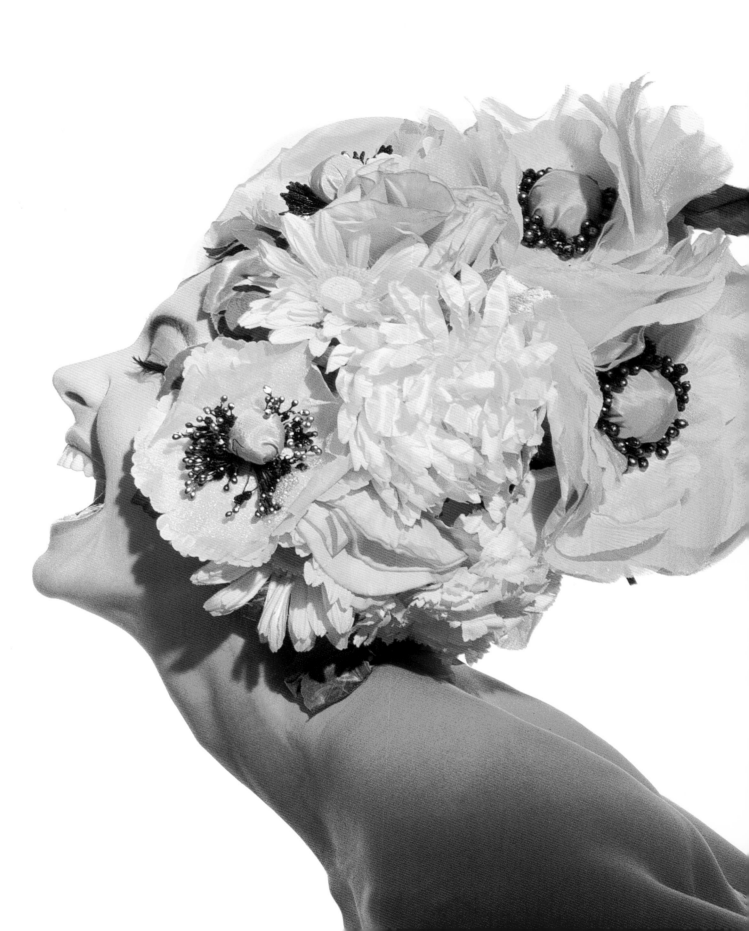

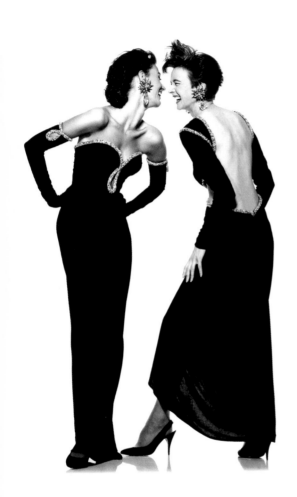

Credits

All photographs and collages by Gideon Lewin, unless otherwise indicated.

Front and back covers model: Anna Hickman; hair and makeup: James Bishop *Page 1* model: Lu Sierra; hair and makeup: Joseph Boggess *2* photo: Bob Mackie collection *3* model: Lu Sierra; hair and makeup: Joseph Boggess *4–5* model: Lu Sierra *7* photos: courtesy CBS *10–11* models: Shoshana, Juliette, Jo Jo; hair and makeup: Joseph Boggess *12* model: Ellena Kondoura; hair and makeup: Mark Sephton *13* model: Jenny Heyman; hair and makeup: Mark Sephton *19* photo: Bob Mackie collection *22–23* model: Terri May *24* model: Juliette *26* model: Ally Dunne; hair and makeup: Akira *27* top photo: Bob Mackie collection *30* photos: Harry Langdon *31* photo: courtesy CBS *Gatefold 1* Bob Mackie photo: Hoyningen-Huene; Carol Channing photo: Bob Mackie collection *33–35* photos: Harry Langdon *37* Whoopi Goldberg photo: Long Photography; hair: Julia Walker; makeup: Mike Germaine *40–43* photos: Skrebneski *44* photo: Harry Langdon, courtesy Neal Peters *46–47* models: Terri May and Andrew Burnstein; hair and makeup: Mark Sephton *48–49* photos: courtesy NBC *51–52* photos: courtesy CBS *54–55* Liza Minnelli and Goldie Hawn photos: Jim O'Daniel; all other photos: Bob Mackie collection *58* photos: Bob Mackie collection *59* bottom photo: Tony Esparza *62* photo: Richard Avedon for Time Inc. *63* photo: Harry Langdon *Gatefold 2* Cher photo shoot photos: Harry Langdon; Cher

"Egyptian" photo: Harry Langdon *68* model: Juliette *69* photo: Bob Mackie collection *70–71* model: Terri May; hair and makeup: Akira *73–90* photos: courtesy CBS *94* photo: courtesy MGM Grand *Gatefold 3* production photos: courtesy MGM Grand; model, showgirl from back: Lu Sierra *95–97* model: Lu Sierra *98* photo: Albert Sanchez *100–101* model: Stella *102* model: Terri May *104* photos: courtesy Motown Productions and Paramount Pictures *106–107* photos: courtesy Columbia Pictures and Rastar *108–109* photos: courtesy MGM *110* photo: courtesy Paramount Pictures *111* photo: Harry Langdon *112* models: Stella, Ally Dunne; hair and makeup: Joseph Boggess *113* photo: Seawell *116* top photos: Bob Mackie collection; bottom photo: Joan Marcus *117* photos: Michael Lamont *119* photo: Bob Mackie collection *122–123* photos: courtesy Cleveland/San Jose Ballet *134–135* model: Jan Strimple *136* model: Terri May *137* model: Jan Strimple *138* model: Ally Dunne; hair and makeup: Akira *139* model: Ally Dunne; hair and makeup: Joseph Boggess *140* model: Shoshana; hair and makeup: Joseph Boggess *141* models: Ally Dunne and Dianne Dewitt; hair and makeup: Joseph Boggess *142–143* models: Shoshana and Zornista; hair and makeup: Joseph Boggess *144* models: Ally Dunne and Stella; hair and makeup: Joseph Boggess.

Separations by Flatiron Graphics. Photo assistance by Peter Killelea.